IDOLS+BELIEVERS

JOCELYN BAIN HOGG

ÉDITIONS INTERVALLES

PETER HAMMILL

WHAT YOU SEE IS WHAT YOU GET

Skin. That's what the believers want. Ideally, impossibly, unblemished, unbroken, untrue.

So the shine, the salt, the sweat. So the slow accretion of the carapace from the what is done, to the what is, to the what alone.

Everything drifts out towards, becomes, the surface until the whole structural personality is exoskeletal. Hard, but brittle. Reflective, but with no space or time for reflection.

What the believers see – what they want to see – is untainted by the messiness of reality, the complication of personality. What they imprint their desire and devotion onto is, of course, the Hollow Man or Woman.

No nasty human interchange can impinge upon the dance of the epidermis.

And then that outer layer can be peeled off, transfer-like, and applied to whatever is needed: a poster, a t-shirt, a key-ring. Or taken and laid out flat in chemical interchange with the print, or in digital interface with the screen. Even taken apart to the dot and the pixel the DNA of the idol will ring true... as true as this can get.

A seamless and sexless exchange. An image gravely ungraven.

And the idols stand, only the eyes giving away the going-through-the-motions interior monologue, the life-there-somewhere but I'm-not-here-and-nor-are-you mood of the moment.

Only waiting to get back to the solitary and naked privacy of the hotel- or dressing-room. Strip off the clothes, peel off the skin to glimpse, in the mirror, what's left of the human within.

What passes for a private life, that the camera hasn't claimed, that the camera can't catch.

Down, down deep in the pupils.

To disappear, and to leave the image behind, as thick, as thin as skin.

Yes, at the darkest times this is what's wanted by both the idols and the believers.

LIMELIGHT

When I was seven, I starred as Robin Hood in my primary school play. I remember standing centre stage, lights bright, as I beamed at my mother in the front row. I also remember the effect of attention – not an obvious requisite in a subsequent career forged by documenting the lives of others standing in the limelight.

I was an only child, brought up solely by my mother (my father had died when I was a baby) and growing up in a genteel seaside town in Britain during the transient seventies. My post-Robin Hood imagination was fuelled by devouring adventure stories and taking every opportunity to glue myself to our new colour TV. I was mesmerised by *The Flashing Blade*, scared by *Dr Who*, in awe of *The Virginian*, and aspired to the unruffled daring of the bowler-hatted Avenger John Steed. I hoped for rain on a Sunday so that I could lose myself in the *Two o'Clock Matinee* on BBC1, especially if it starred Errol Flynn, Gregory Peck, Cary Grant or Richard Widmark. My first outing to the cinema was to see *Diamonds are Forever* and the die was cast. I memorised the names of all the actors and their characters, from Lana Wood's Plenty O'Toole to Leonard Barr's Shady Tree. A smart and cool new vista had opened up before me.

From a secure preparatory school I went to the bear-pit of Lancing College, a Sussex boarding school, and acting in the college theatre became a way of escaping this new, brutalising environment. I had realised that the icons of my imagination were flesh and blood and my pre-pubescent fantasy world had metamorphosed into a way of survival and a prospective career. I won the prestigious House Colours for my convincing portrayal of "Phyllis the maid" in a 1920s farce. And a year later, encouraged by a far-seeing English master,

INTRODUCTION

01

I applied to the National Youth Theatre of Great Britain, a renowned breeding ground for fledgling, teenaged actors from the length and breadth of the UK. I performed my two audition pieces – a Shylock speech from *The Merchant of Venice* complete with cod accent, and a very British interpretation of the Second Knight's speech from *Murder in the Cathedral*. Weeks on tenterhooks went by and then a letter of acceptance arrived. I knew then that life would change. Here was access to the world (a stage) that I wanted. But all was not as I'd have liked. The Youth Theatre's schedule clashed with my important exam term. Since I had already failed in mathematics twice, my headmaster and teachers all conspired to advise me that I'd never get into Oxford University and succeed in life if I failed maths again. Acting could wait and I could re-apply for the next season. I acquiesced to their wishes, passed maths but failed entry to the Youth Theatre the next year. By then however, I had unearthed my dad's old Rolleiflex during the spring holidays and things didn't seem so bad.

With photography came new access. My traditional all-male public school had moved with the progressive seventies and was accepting girls into the senior years, and the camera was the perfect way to meet, photograph and get to know the new breed of students. Consequently my stalled acting career did not seem so catastrophic and I immersed myself in photography, reading as many books on the subject as I could and eventually convincing the school to allow me to take an exam in the subject. I became editor of the school magazine, conniving a vehicle for my photos of the college (and the girls) and documented the rarified atmosphere of boarding school with avid eyes. Then I saw Jurgen Schadeburg's *Kalahari Bushmen Dancing*, and Mary Ellen Mark's *Falkland Road*

and the shutters lifted. I was so profoundly affected by these documentations of real life in all its rawness, so far from my closed experience, that the magic and potential of photography hit me like a Born Again's conversion. All thoughts of a life of make-believe in the acting world faded and my path was set.

I sought advice from the names I'd read about. I gleaned valuable knowledge from Lord Snowdon who, on meeting, told me to shut my eyes and tell him what I'd first observed on walking into his studio. All I could answer was that his walls were white! In my sixteen-year-old naïvety I bowled into the Fleet Street offices of John Hillelson, the Magnum agency rep in London, where photographer David Hurn happened to be sitting. He constructively advised me to create a narrative and put my pretty pictures "in a box and show them to my girlfriend". Emboldened, I documented the lives of the girls at school, not just their adolescent beauty, and aged eighteen, my first story was published in *Harpers and Queen*. The *British Journal of Photography* also ran a feature on my public school pictures with a front cover of Jane Cullis, the college's locally famed beauty. My excitement knew no bounds as I looked at Jane pouting from the newsagents' stands. I felt I had arrived in the world.

After my final exams for entry to Oxford I took day trips from school to London, to pester picture editors. Michael Hardy of the *Sunday Telegraph* magazine gave me film, encouragement and my first commission, and the legendary Colin Jacobson of the *Observer* magazine pointed me in the direction of David Hurn's Documentary Photography course at Newport Art College. I applied, was accepted and turned my back on Oxford.

I worked during my summer break between school and college for David Puttnam's Enigma film company, photographing additional stills on *P'tang Yang Kipperbang*, one of the first movies made for Channel 4. Six weeks later I was asked whether I would be interested in a career in movies. But I knew that still photography

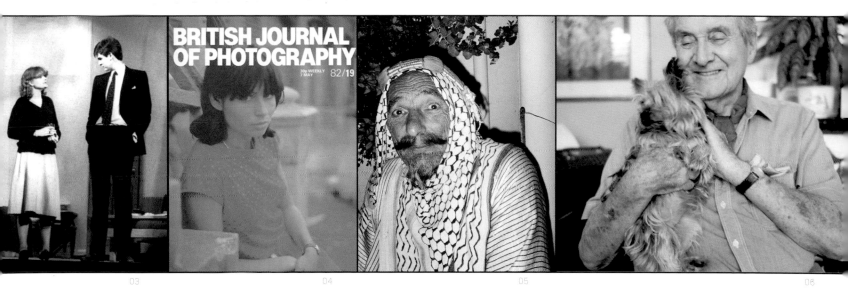

03 04 05 06

had consumed me and would be my passport to move freely and document the world without the intervention of camera crews, set designers, bulky equipment and, above all, the necessary contrivance of film-making.

After learning the language of documentary photography at Newport, I moved to London and at 21 got my first (and only) regular job working as a publicity photographer at the BBC. Close once more to actors, I spent nine months supplying the national press with pictures of diverse characters from Sir John Gielgud to glamour model Samantha Fox, and learnt a great deal about the machinations of television and the power of publicity. I left to work as a unit photographer on a movie set in Spain and on returning took the opportunity to take fashion pictures for a friendly designer I had met during my BBC sojourn. During the hedonistic late eighties and early nineties I enjoyed fifteen minutes of fame being classified as "one to watch" as a fashion photographer, taking pretty pictures again and partying hard with London's glamorous crowd of models, designers and actors. I lost my way.

At thirty, life changed again. Like many adopted children of the sixties, and sanctioned by my long-suffering and tolerant mother whose dreams of an Oxford-educated son at the BBC had been well and truly shattered, I went in search of my birth-father. Our first meeting was like an out-take from a clichéd spy movie: a cautious greeting one drizzly March evening on Kew Bridge in west London, followed by hours of broken chatter in a nearby pub over many whiskies. This stranger, my natural father, with similar mannerisms and facial expressions to my own, was an actor. He had spent the sixties performing on TV and in musical comedies on the West End

stage, appearing in Lionel Bart's *Blitz* and the London premiere of *On The Town* (and in the second row against the Black and White Minstrels rugby XV). Among his many TV roles he played a villain in *The Avengers* through a family connection with my childhood hero, John Steed himself, Patrick McNee.

Serendipity and chance are stocks-in-trade for photographers, who deal in moments, but in that first meeting these coincidences of my birth matched my psyche. The urge to perform was explained.

My days as a fashion photographer were ending with the surge of post-modernism in British magazine illustration; stylists held more sway than photographers and "cutting edge" was the required approach. A long term relationship with my model girlfriend was on the rocks and all things pointed to eschewing the creatively fallow and ultimately flimsy fashion world. I returned to the real adventure of discovery through photographs.

Working for *Scene*, an influential London style magazine, afforded the opportunity to document again, and the forward-looking art director, Gerard Saint, commissioned me to photograph the nineties' great media frenzy, Princess Diana's funeral.

As I stood in London's Mall from 3am, the germ of an idea for this book struck me. Why were these thousands of people gathered for the funeral of a stranger? Why was the populace so obsessed with this fairytale, a woman mythologised to the point where many believed they knew her? What is fame and why do we adore some people? Conceptual thoughts aside, I photographed the event but could not capture the eerie silence as the massed crowd stilled on hearing the cortège clip-clop solemnly down the packed malls of old Empire. I wondered whether this mass grief and reverential national outpouring was a unique phenomenon. Not entirely: state funerals are major events and Sir Winston Churchill's internment had apparently generated similar reactions decades before. But Churchill had saved a nation. He had been a great leader and diplomat, famous for his actions and political aptitude, with a lifetime of public service to commend him.

Princess Diana, tellingly "royal", had caught the public's imagination for her beauty, circumstance and tribulation. A modern icon, her premature death ensured her place in a firmament of eternal stardom. She would now be adored forever, frozen in her prime. As the nation wallowed in a strange atmosphere of exaggerated reverence and false memory, recriminations, rumours and circumspect gossip about Diana's life fuelled circulation of the world's fame-driven media rags. The re-wording of Sir Elton John's Marilyn Monroe anthem, "Candle in the Wind", to mark the tragic death of "England's Rose", confirmed the passing of the torch from one twentieth-century icon to the next; while the celebrity industry, realising it was bereft of its major cash-cow, and fearful of falling sales, looked for new gods and goddesses. As I thought about the potential for this photographic project on fame, I realised that this event was the turning point in contemporary celebrity obsession and something new and all-consumingly exploitative was stirring in the recesses of our media's corporate black heart.

Sure enough, the late nineties saw a slew of celebrity-driven publications hit the news-stands, responding to the public's perceived need for new godheads, while television discovered "reality" programming with *Big Brother*, *Fame Academy* and many others. These hugely successful and cheap-to-make TV sensations spawned a popular press response with banner headlines trumpeting the antics of hitherto unknown boys- and girls-next-door, and the nature of fame and celebrity was redefined for a new century. Endless sequels and spin-offs of these programmes now dominate the world's living-rooms and this global marketing of mindless palliatives seems to hold sway in our increasingly troubled world. With a "cash-crop" attitude, the fame industry touts more and more celebrities, reporting on the minutiae of their lives writ large, then relishing their Icarus-like descents only to move swiftly on to the Next Big Thing.

In this, I saw the social documentary work I had returned to dwindle to almost nothing. With even the "quality" magazines and papers becoming celebrity-driven, I felt witness to a queasy sense of absolute shallowness where only the trivial appeared important; and became more impelled than ever to distil and explore this phenomenon in photographs. For if the camera was not focusing on the implications and participants of this frenzy, the permanent record of this era decades from now would be vapid, self-serving "celebrity" pictures packaged and released by an ever more controlling and cynical industry.

Remembering my childhood preoccupation with those sixties and seventies stars, and my recently discovered heritage, I tried to see the differences between "then" and "now" and to realise a structure for this project. I started to seek commissions from the larger-circulation women's magazines, whilst also working on my first book about Britain's underworld, *The Firm*. *Elle* magazine employed me to photograph their new vehicle, "The *Elle* Style Awards", a fanfare of a party festooned with celebrities receiving awards for their snappy dress sense voted for by *Elle* readers. Whilst photographing this, über-celebrity photographer Richard Young was

asking me who some of these stars were. Neither of us knew, and I quickly realised that any project about modern fame or celebrity could not depend solely on so-called famous faces. There are too many "stars" for most people to recognise and most do not cross borders. For this project to succeed it would have to transcend nationalities, and although Britain appeared to be at the hub of the new celebrity culture, the phenomenon was an international one.

I determined to look at the roots. To begin with the star-struck child, not unlike my younger self, dreaming of being Schumacher or Beckham, Beyoncé or Nicole; the "carnival queens" of small towns across the world with their taste of local glory; impressionable pre-teens with adulation of the latest boy- or girl-band heroes in their eyes and hearts. I looked at the local heats for the "World's Strongest Man" and karaoke competitions. I found "lookalike" conventions and documented struggling actors casting and rehearsing their audition pieces in the coffee shops of LA, readying for their personal National Youth Theatres. I looked at the eager crowds queuing for their chance to become contestants in reality shows, and the instant fans of the occupants of the *Big Brother* house. I documented a symbolic progression, from childhood through adolescence and adulthood to old age. My eye encompassed both the idols and believers; the aspirants and the reality of the sour, down-side of fame – the aspiring rock star lost in a puff of crystal meth, and the lookalike characters whose lives are taken over by the heroes they seek to emulate.

As this journey progressed from my own seaside town roots through the London parties and the red carpets of Cannes and Hollywood to the gilded trappings in Monaco and Beverley Hills, I watched and photographed the new machinery of fame. I glanced sideways at my own breed, the media world of producers, editors, photographers, TV presenters and their crews, cue-card operatives, publicists and security people who control the way we perceive "the money", the stars. Words from an Oscar commission ring in my ears – "No pictures of the Talent". Too late, I'm a documentary photographer after all, and a quick one. I determined that any "star" in this project should be regarded as a cipher and pictures of them in this book are about their situation in the panoply, not their image. I am not, after all, a "celebrity photographer".

Stars of the calibre of Cary Grant and Richard Widmark are long gone and a massive industry now controls and coerces a willing public into buying familiar sequels, blockbusters and remakes. "The Talent" is more marketable than ever. I have documented the trappings and the evidence of modern fame and I have explored our need for idols. That need, expressed in the faces in the photographs of this book, has probably not changed in essence since Roman times. The only difference appears to be that there are now more famous people around, more salespeople, more buyers, and that absolutely anybody can now share the limelight.

In California I sought out my own childhood hero, Patrick McNee, and found a charming and contented old man, Etonian accent and manner intact, solicitously enquiring whether I, an unaccustomed Brit in the broiling Palm Springs summer sun, would care for a glass of water. He could not remember my father.

JOCELYN BAIN HOGG
LONDON, 2006

01. As Robin Hood, aged 7
02. First published picture: Prince Charles visiting Lancing College
03. Acting in Harold Pinter's *The Lover*, Lancing College
04. First front cover: Jane Cullis
05. My natural father Tom Kyffin in *Arabian Nights* costume at his seventieth birthday, September 12, 2001
06. Patrick McNee and Lucy, Palm Springs

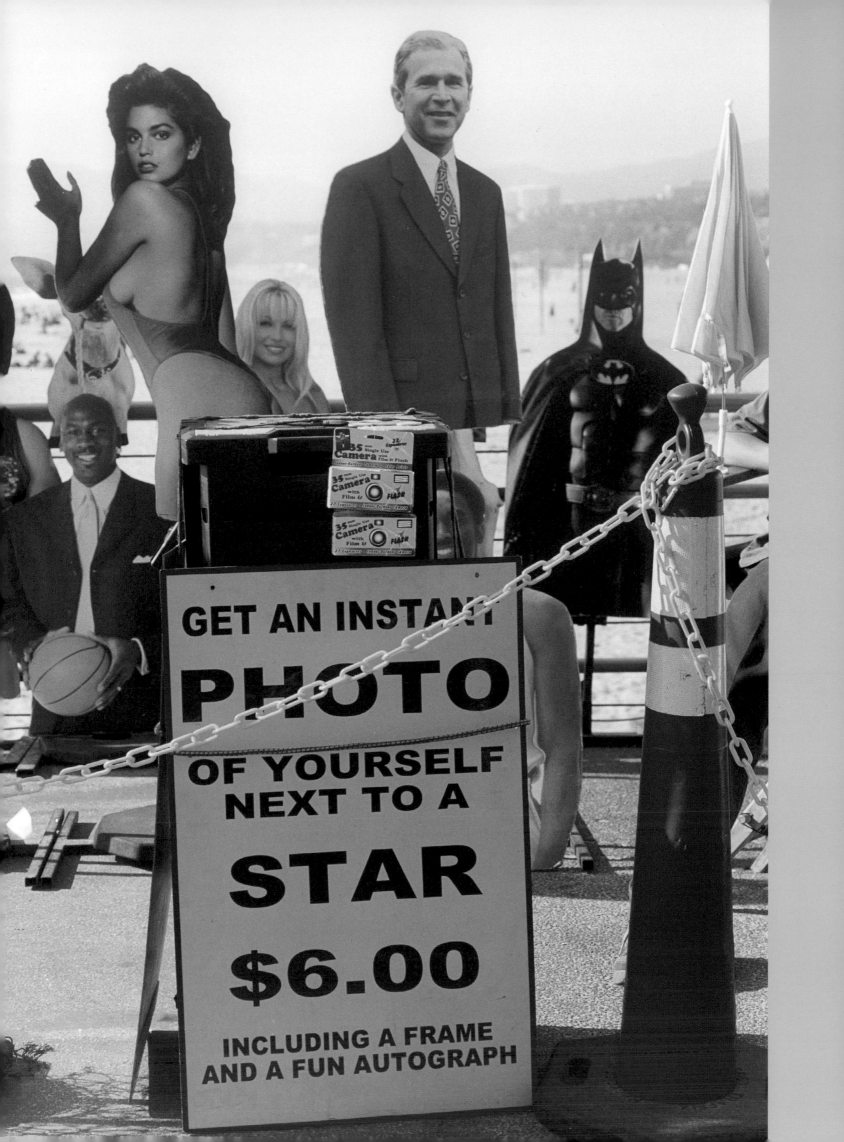

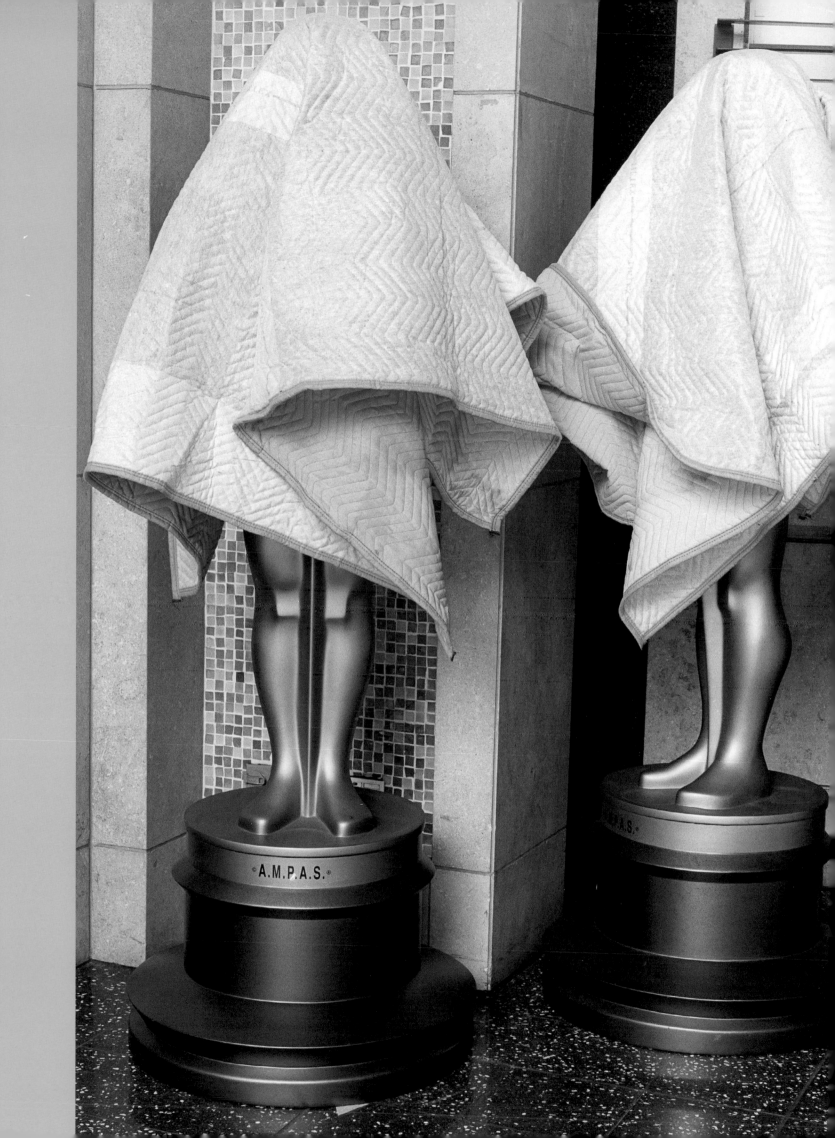

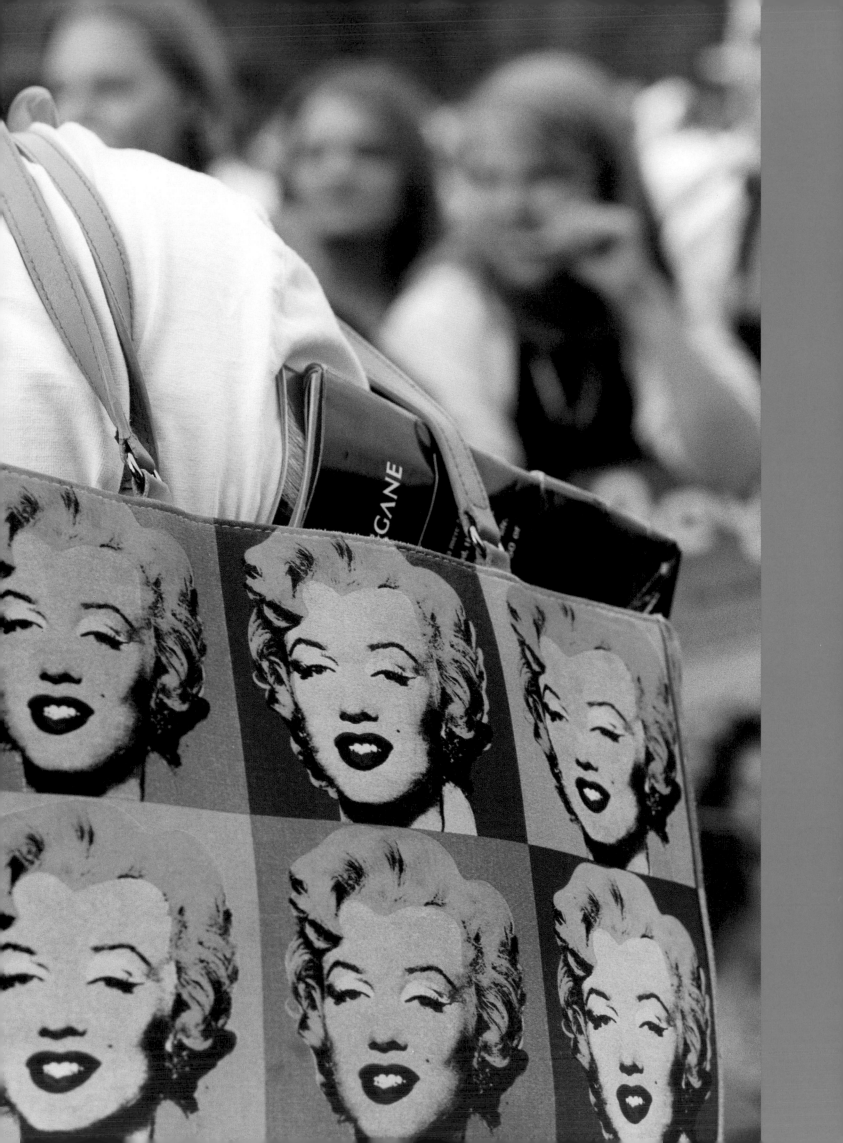

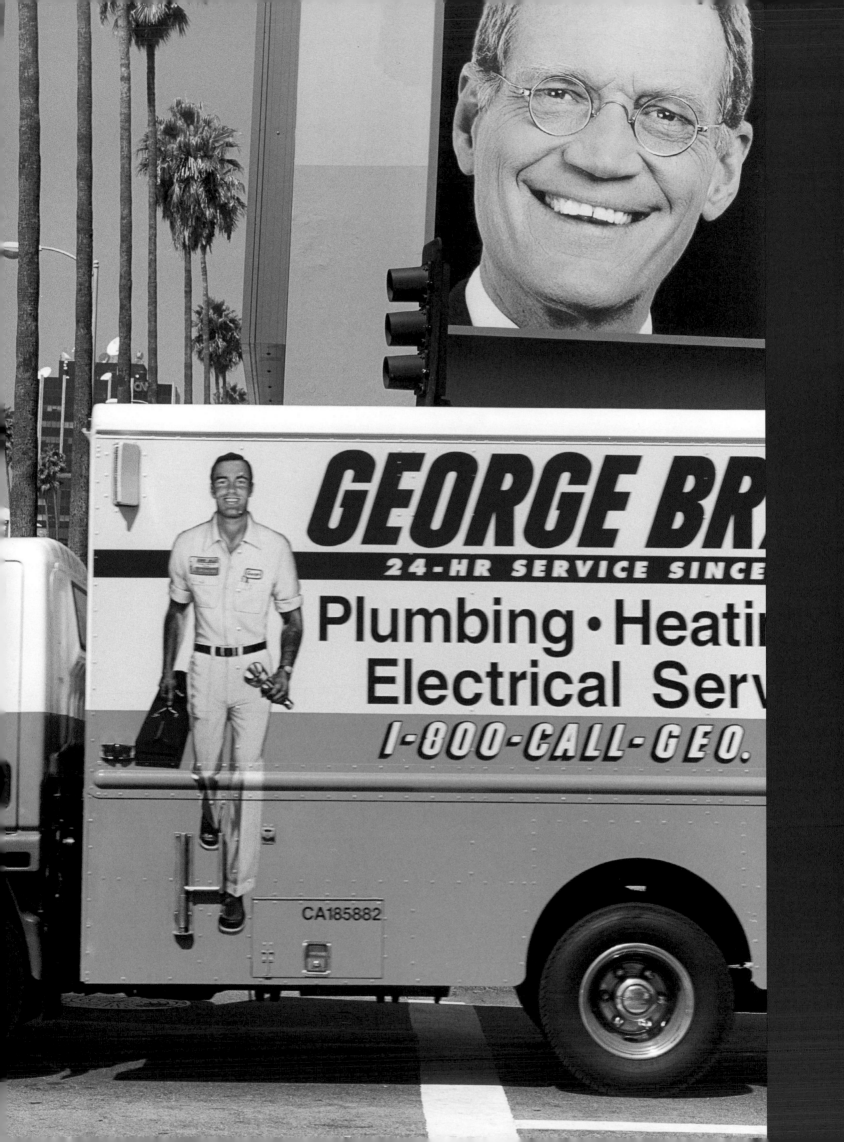

About McCormick

Nestled in the rolling hills of northwest Missouri you'll find the Platte Valley home of McCormick Distilling Company ... where the aroma of handmade charcoal-aged bourbon sweetens the air. We still make our famous whiskey the same old fashioned way our forefathers did—a painstaking process that produces only 24 barrels per day, 120 days per year. We're proud of the fact that our distillery, established in 1856, is the oldest and smallest in the country and is listed on the national register of historic sites.

Since 1856, the same exacting and critical standards we apply to the production of our sour mash bourbon have been transferred to the design and production of our ceramic decanters. You can be assured that each decanter is a hand-painted, limited edition item and sealed by hand in Weston, Missouri.

Exclusive Producers of

AMERICANA PORCELAIN

McCORMICK DISTILLING COMPANY

J.R. EWING

J.R. EWING

As seen on the hit TV series

"DALLAS"

"EVERY TWO YEARS I KNOCK OFF FOR A WHILE. THAT WAY I'M CONSTANTLY THE NEW GIRL IN THE WHOREHOUSE."

ROBERT MITCHUM

"EVERYBODY WORSHIPS ME, IT'S NAUSEATING."

NOËL COWARD

"THE WORST THING I CAN BE IS THE SAME AS EVERYBODY ELSE. I HATE THAT."

ARNOLD SCHWARZENEGGER

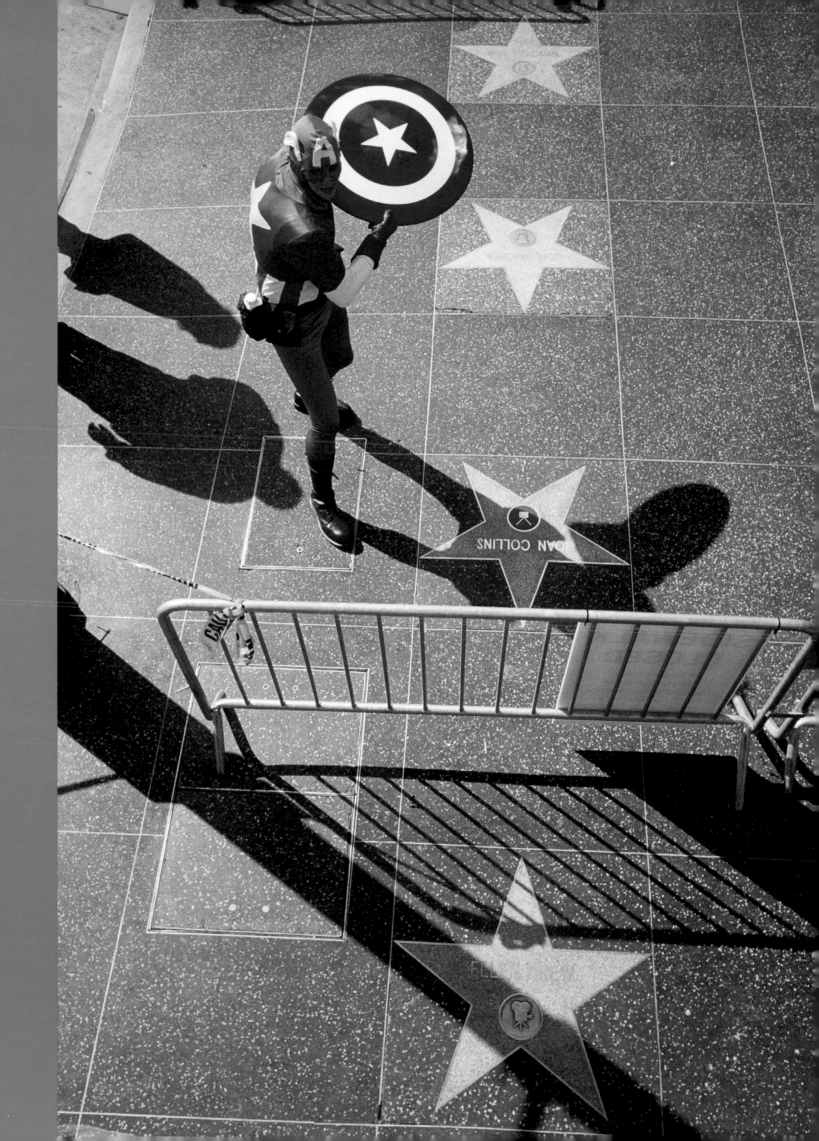

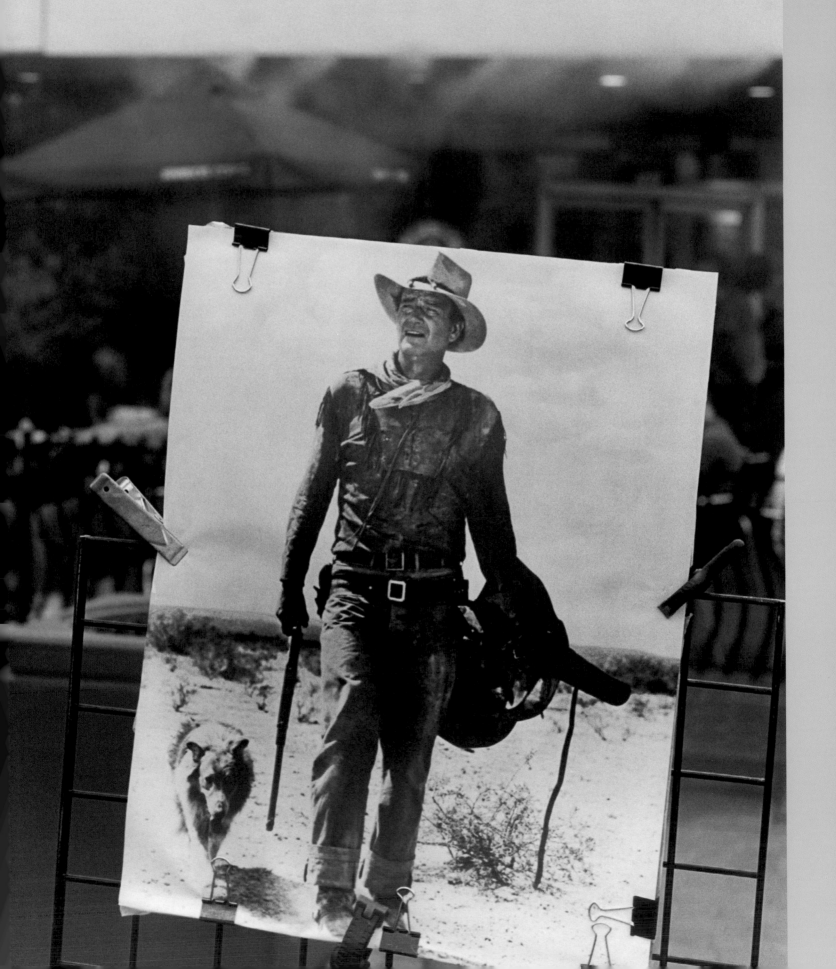

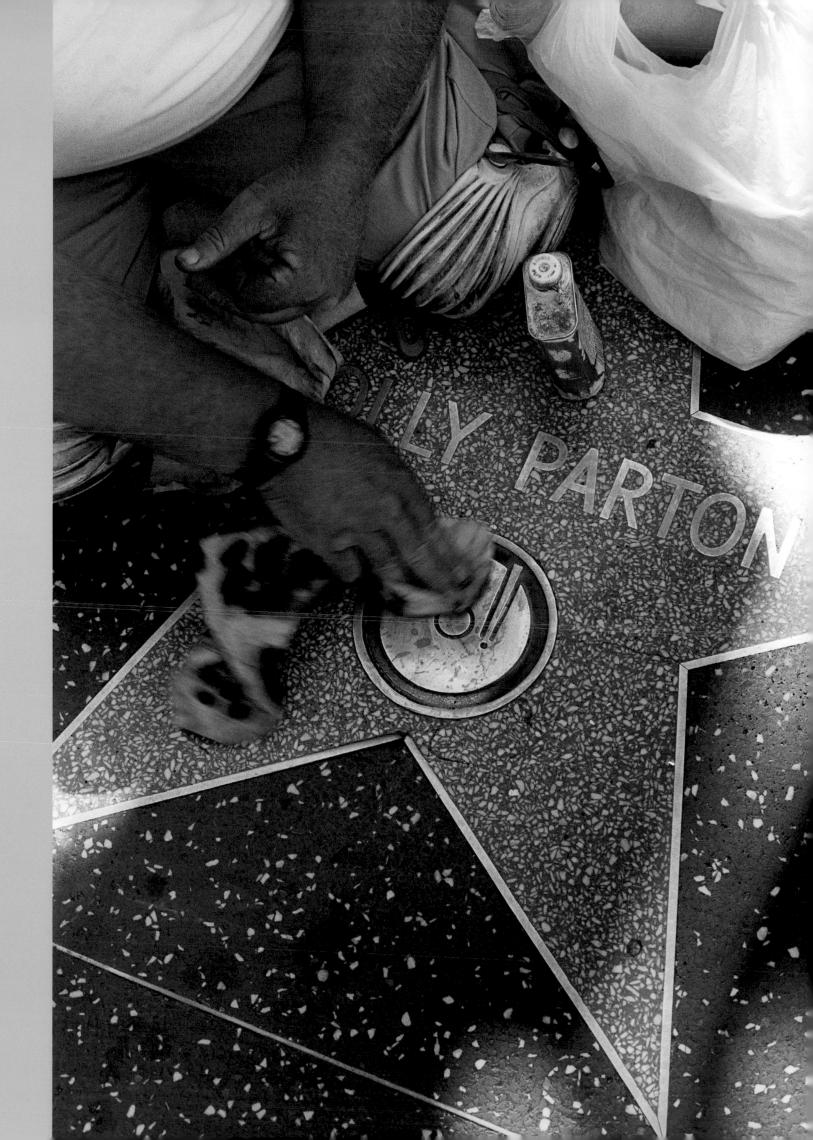

"I'M AN INSTANT STAR. JUST ADD WATER AND STIR."

DAVID BOWIE

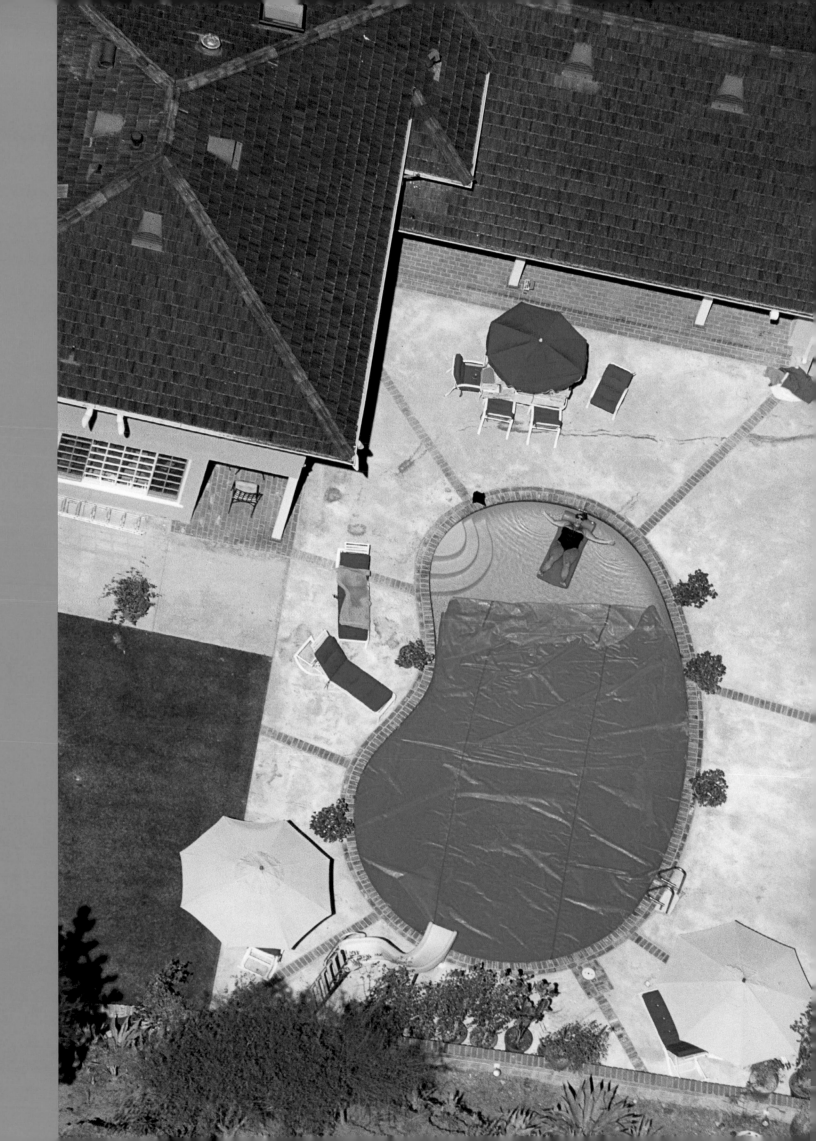

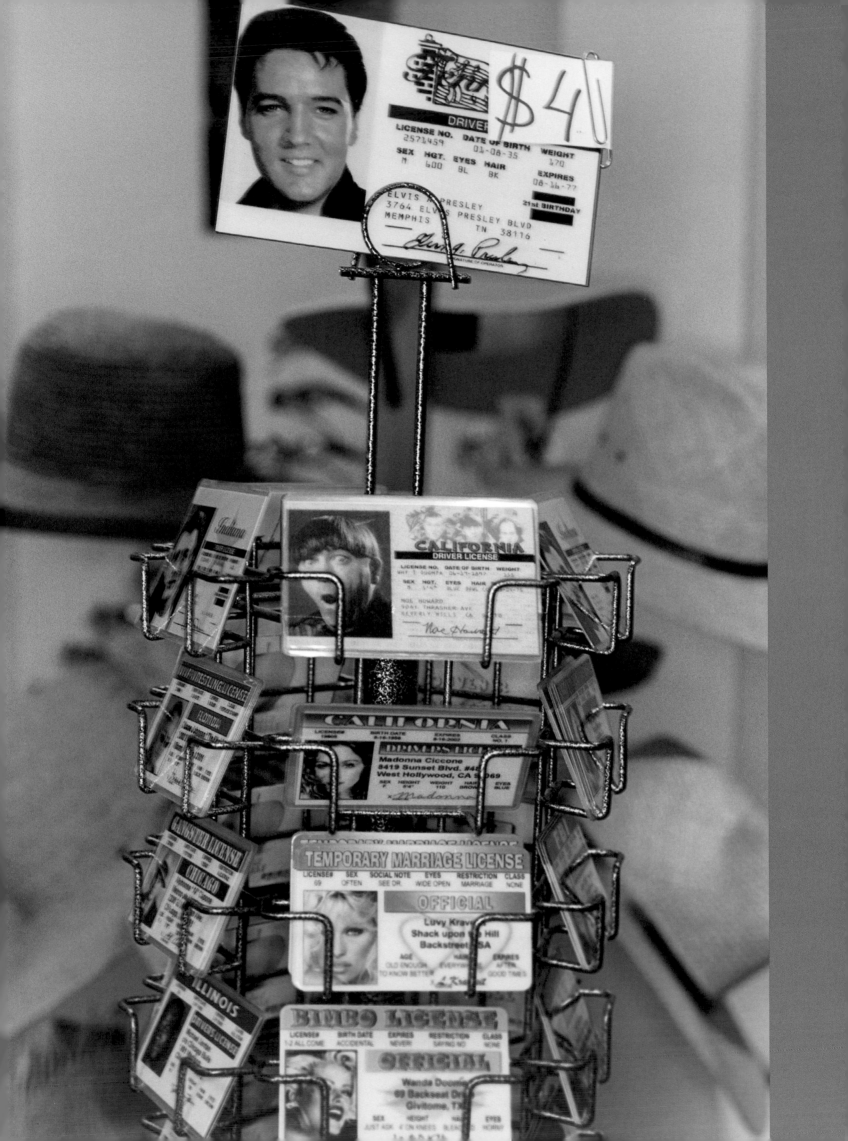

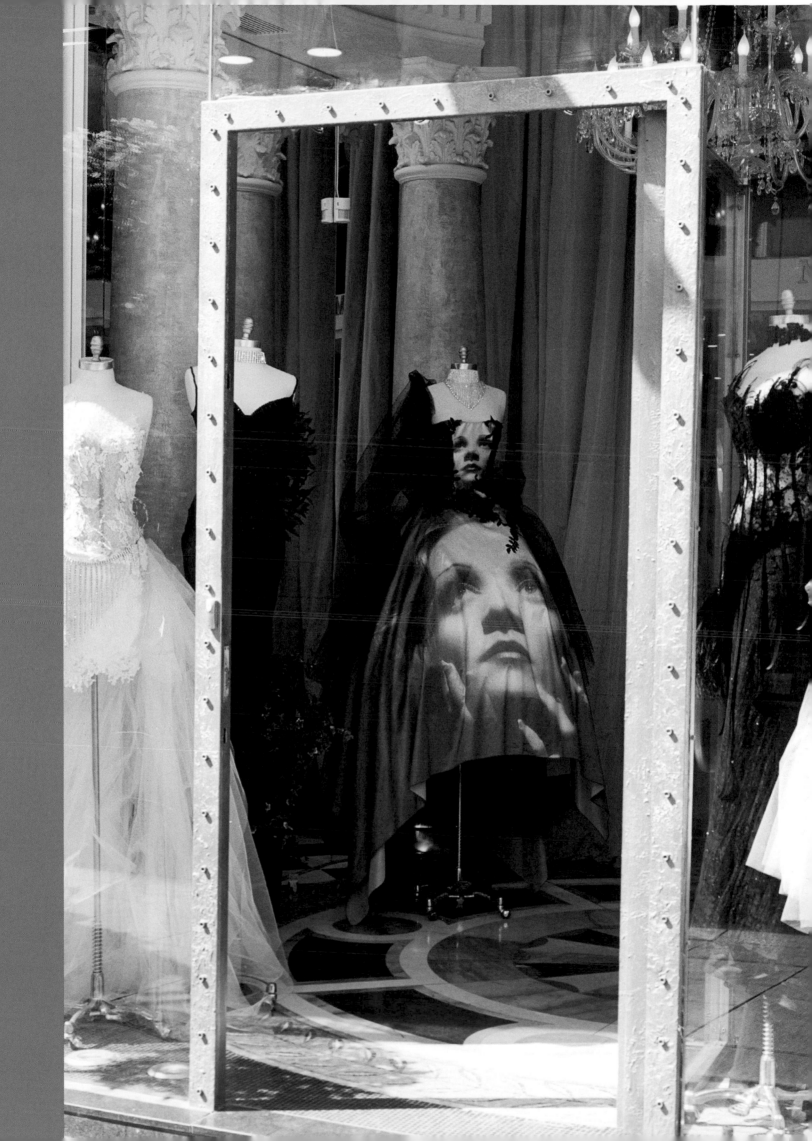

"I COULD GO ON STAGE AND MAKE A PIZZA AND THEY'D STILL COME TO SEE ME."

FRANK SINATRA

"ALL PUBLICITY IS GOOD, EXCEPT AN OBITUARY NOTICE."

BRENDAN BEHAN

"IF I'M SICK OF ME, I CAN ONLY IMAGINE HOW OTHER PEOPLE FEEL." **KEVIN SPACEY**

GONNA MAKE YOU A STAR

Long before my career as writer and editor afforded me a laminate access pass into the world of celebrity journalism (in which your correspondent has at times found herself receiving a consoling shoulder rub from Jennifer Aniston or, in bolder moments, stroked the fur lining of Lenny Kravitz's bedroom walls), I made my living as a rookie reporter on a British women's weekly rag. In those days, the sexiest, most newsstand-titillating stories came under the category "Real Life"; little tales of woe, told in the first person vernacular of the story's protagonist. The magazine, it should be said, also published tales of hugely substantial woes, although I personally preferred to avoid the housing estate murderesses and *What's Eating Gilbert Grape?* obesity cases, rather choosing to recount the heroic deeds of domestic pets, or the quirky romance stories of, say, identical twins, spliced to blood brothers, who'd fallen in love on the same factory floor.

Gathering story fodder was an oddly poignant affair. I never liked cold-calling the poor souls whose sorry narratives we'd find buried in the grimy newsprint of some local freesheet. For the most part, however, our real-life heroes and heroines volunteered themselves by way of intense, handwritten letters expounding their curious circumstances in the hope that they could appear in our pages. There were modest financial rewards (a £25 cheque that might save the Electricity from being cut off). But it wasn't really about money. Fame – the glitter of local celebrity – was the spur that prompted the letter-writing, justified the hours posing for photographs and spilling the editorially-required "womb-trembling" quotes to writers like me.

One of my favourite assignments from this period found me in an Oxfordshire village reporting the story of a cat, let's call him "Snowy", who'd survived an entire washing machine cycle (saved by some kind of air pocket in the folds of a voluminous duvet cover). The photographer on the job, Richard, had a facility for making cats do what he wanted – he'd learned a trick or two as a *Photolove* snapper, training his own cat to follow tearstained lovers into torrid sunsets by smearing trails of Kit-e-Kat in the middle of the street, should the script require it. Richard fancied a dramatic portrait of Snowy inside the washing machine drum and lured the hapless beast back in with tidbits. The story was a sensation.

Memories of Snowy (the innocent artifice!), have occasionally crossed my mind during some of the more excruciating longueurs in the celebrity photo sessions I have attended as writer and editor of fat, glossy fashion magazines. The stakes, like the production costs, stratospherically higher. The access exquisitely negotiated, yet so much more slim. The agendas ever subtly clashing: the actress prefers not to smile for her cover shot, as she is an artist, not a model. Ah, but the actress must spread her lips, for the difference between a smile and a pout typically averages 20,000 sales on newsstand. Oh, for the days when a can of kitty chow could get you satisfaction. Instead, imagine thousands of dollars of West Hollywood's finest catering spread before you; cakes custom-ordered without flour, cakes without eggs, cakes that cannot, under any circumstances, be eaten in front of the talent. Inevitably, on these occasions (after the primping, the prepping, the eleventh-hour permit-purloining) the cityscape backdrop that everyone craved will suddenly look ugly and sour and diktats will be issued that it must be carefully erased by the post-production elves. Multi-thousand dollar dresses, sent in hopeful optimism by the fashion department, will be swiftly and discreetly dismantled by tailors; and, just as quickly, the actress fitted back inside, laced up the back with criss-crossing ribbon and an arsenal of vicious-looking bulldog clips. Such is the making of beauty.

Back on the kinds of weekly mags where I cut my teeth, it's not the unexpected tales of ordinary folk that rock the newsstand these days. Forget the humble civilian in the spotlight, what the public wants is real stars, only deconstructed: celebrities showing their clay feet (plus, ideally, their dodgy breast augmentation, ill-chosen outfit and flesh puckered by cellulite). American magazine *US Weekly* showcases its best ass-scratching,

sweatsuit-wearing snap-and-runs of the famous in a section entitled "They're Just Like Us". The dirtier the realism, the better the sales figures. Reality has taken on a whole new meaning in the world of entertainment, describing a genre of high-concept TV game shows, that present contestants from the quotidien universe in highly artificial, manipulated documentary formats, as freaky versions of genuine experience and spontaneous human interaction. "Reality" programming is so successful that it has spawned its own star system. The standouts, such-and-such from *Big Brother*, the kid from *The Apprentice*, earn themselves the chance to pop up in *US Weekly*, have their car followed and attend flashy launches of new vodka imports: real fame. And it's not just the nobodies who get fast-tracked to Somebody status in these shows. Reality formats also provide pleasingly ironic vehicles for fading personalities to come back, to have another go, to appeal to the public to fall in love with them all over again (with maximum pathos please). How meta, you might say, how masochistic, how very Pop Will Eat Itself.

In Jocelyn Bain Hogg's multifaceted portrait of fame, fame looks hot, voracious, poignant and lonely. So many of the images suggest an inescapable heat. The red carpet in Cannes – flanked by a glamorous, predatory army of paparazzi in their black-tie evening suits – looks like it could singe flesh. Like Jocelyn, I have spent many a day in May working the Croisette in Cannes, charting the megastars and the brazen wannabes at the Festival du Film. It's one of the few occasions on earth where fame looks like you always hoped it might: Monica Bellucci in full plunging Dolce & Gabbana siren-wear slinking up the steps to the Palais in blazing six o'clock sunshine, the decorous French autograph-hunters, clustered patiently around the entrance to the Majestic hotel. The whole spectacle oozes a nostalgic allure, a sense of Galella glamour. Ron Galella being the vintage US paparazzo, and consummate fan, who from 1955 stalked and snapped his idols Jackie O, Liz and Dick, Robert Redford... and who now finds himself feted by the likes of Tom Ford and Michael Kors for his role in defining American glamour. In his 70s now, Galella has said he doesn't care so much for contemporary stars, finding their look too coarse, the restrictions around them too tiresome. But if celebrities have changed, so have the paparazzi. The explosion of celebrity media has meant wildly escalating fees for snatched images and all the intrusive and desperate tactics you'd expect to go with that. Outside the Château Marmont, Cameron Diaz and Justin Timberlake physically attacked the "stalkerazzi" who laid in wait for them. Any gentlemanly contract between idols and believers has apparently expired.

It's a question often asked: are we, in our fame-obsessed culture, skewing our own sense of reality, brainwashing little schoolchildren to aspire to become footballers and pop singers as opposed to anything of "true" value? Or is it the rampant commercialisation of fame – the endorsements, the licensing deals – that's the problem, degrading the pleasure of being a fan, making the experience of looking less enjoyable? As for the famous themselves – would they be happier if they could turn fame on and off, like a tap? Maybe, but that's just not possible. Celebrity is a two-way relationship. John Updike called fame "the mask that eats the face". How cruel that the thing so hotly pursued, that signifies success and recognition, that validates the ego, is the very thing that threatens to erase the self.

Recently, I interviewed Demi Moore, famous since she was 16 years old, who gave up her career for several years to raise her daughters in Idaho. It was "a huge thing to sit all by myself with. To ask, 'If I never worked again, would I be okay? Would I feel like I was enough?'" Of course, Demi did return to Hollywood and her persona as a famous person, only this time with a civilian's-eye view on things. "It [celebrity] can be very altering to a really honest sense of self," she says. "It's nice. You get the great tables at restaurants, you get ahead of the line at Disneyland, but it's a level of temporary fulfilment. You have to have a lot of deeper effort and soul-searching to figure out why you're where you are and what you're really here to be doing."

SARAH BAILEY

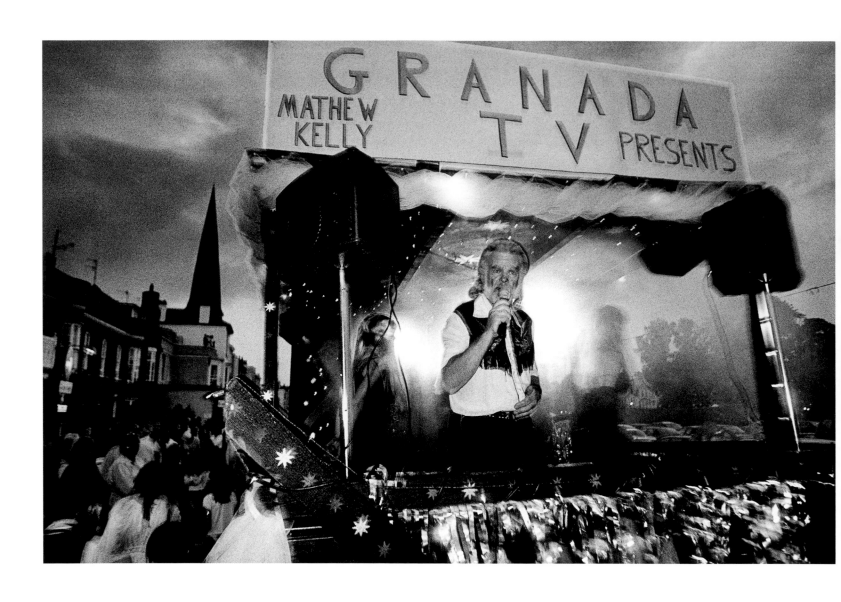

Karaoke Club float, Dawlish Carnival

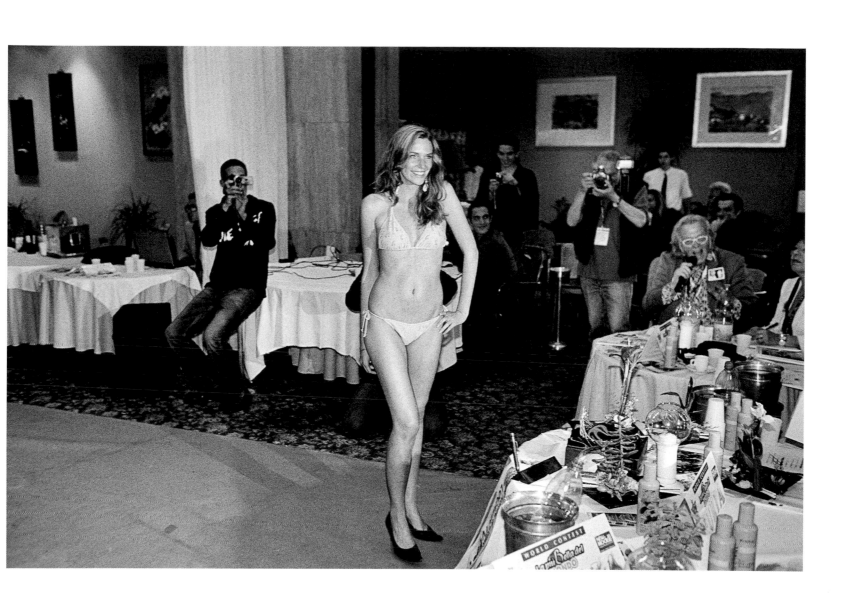

La Piu Bella del Mondo beauty contest, Cannes

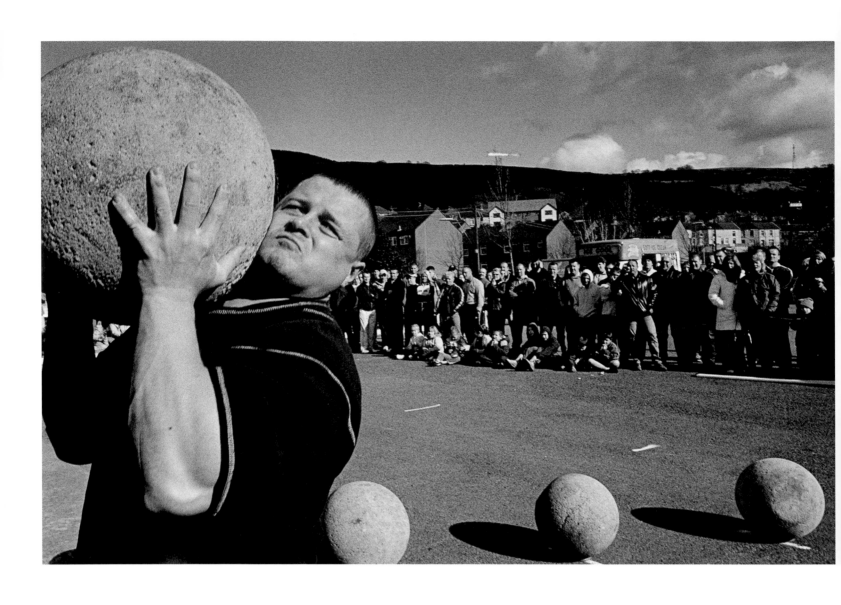

The World's Strongest Man competition, Aberdare

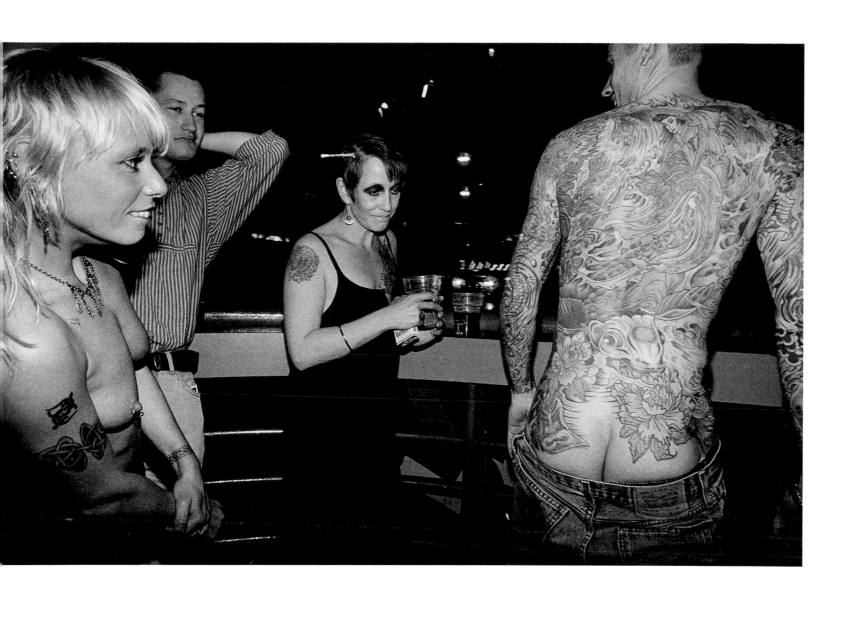

Tattoo and body-piercing convention, Hammersmith

(Overleaf) Fans sleep outside Westminster Abbey on the eve of the funeral of HM Queen
Elizabeth, the Queen Mother; Autograph hunter outside The Ivy restaurant, London

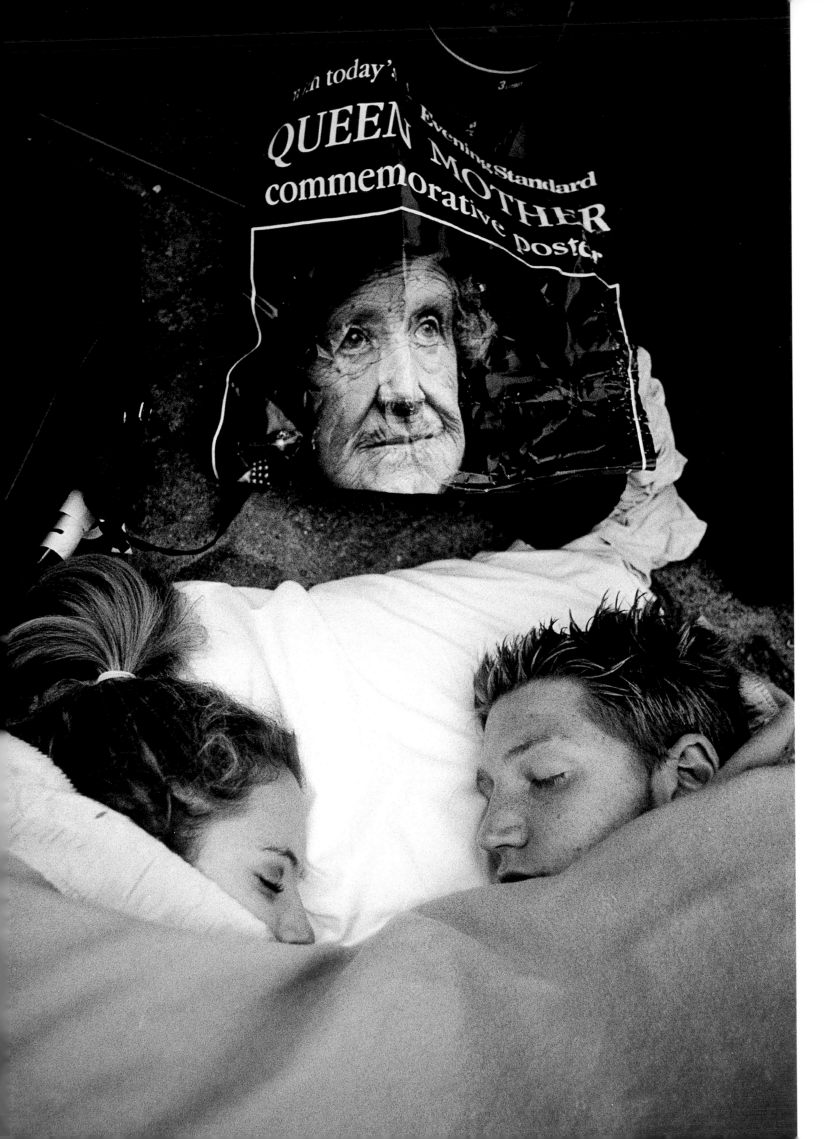

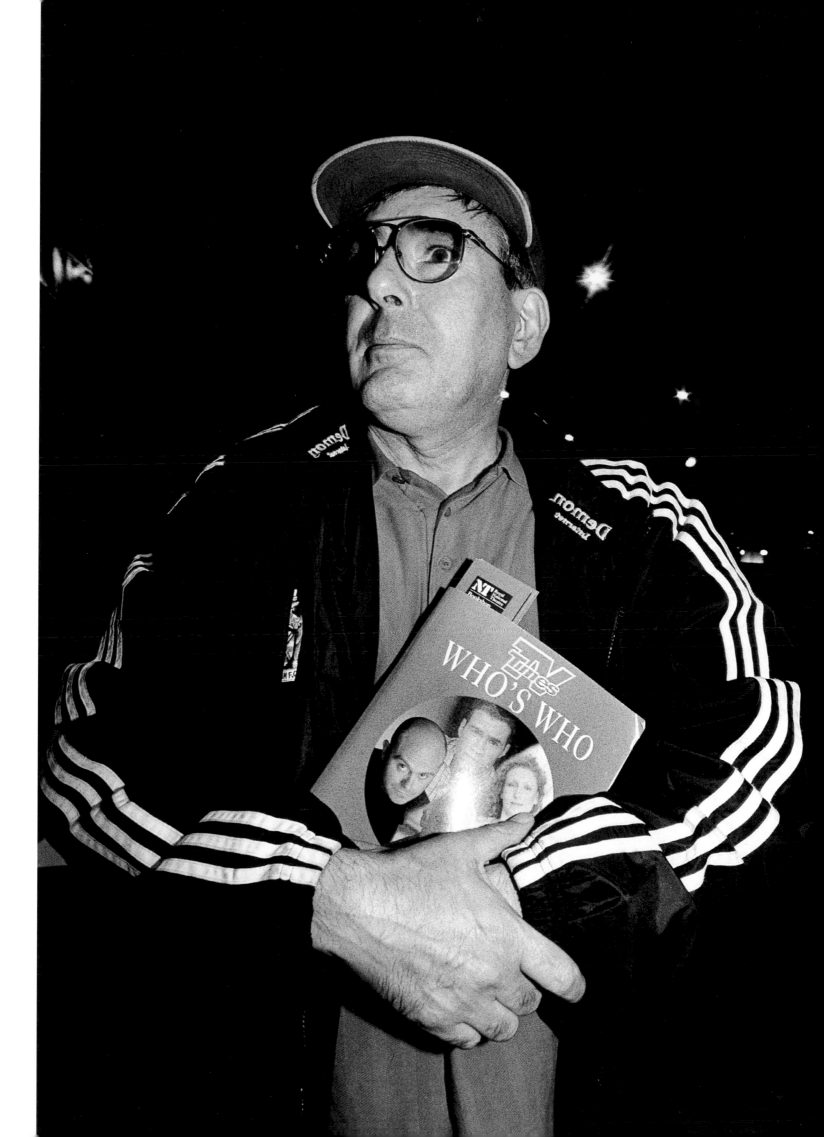

Photographing a triumphant junior soccer team, Bournemouth

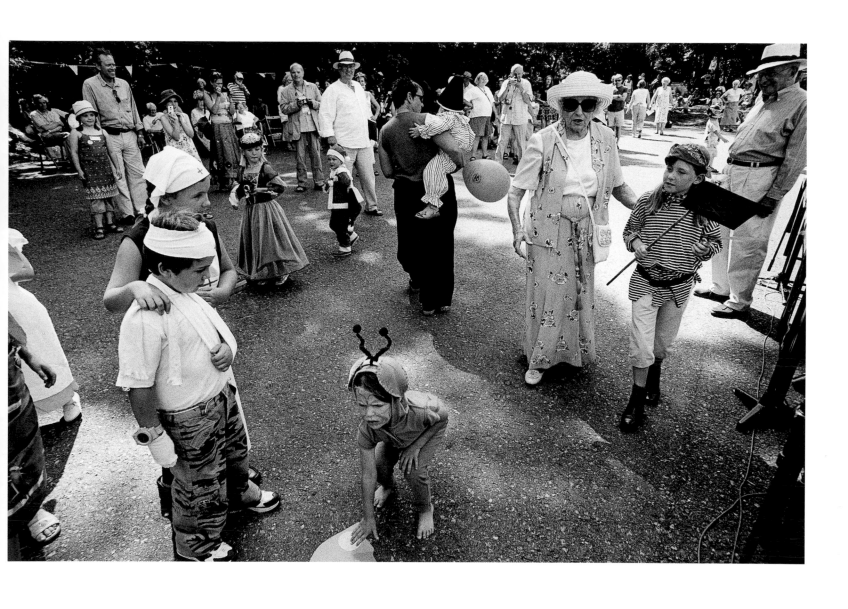

Dame Vera Lynn judges the under-8 fancy dress contest at the Streat village fête

DAME VERA LYNN

CARRYING ON

I don't know half the people that people talk about now, "Oh you must know them?!" Well no, I've never heard of them. It depends on whether you're working, I suppose, and I never have time to go to the cinema.

Kids these days when they're interviewed say, "Oh yes, I want to be famous, I want to be a star." They don't ask "What talent have I got, what can I do?" or "What groundwork should I do?" I mean I was doing working men's clubs from when I was seven to when I was sixteen. A friend of ours who was an entertainer was doing a concert at one of the clubs and knew I could sing. He asked me to sing at a party and so I considered myself a professional! But I had all those years' background, singing in clubs full of smoke. You couldn't see anybody for smoke, and just a piano and either someone who could play or someone who couldn't! You used to do cinema – between the two films they'd have an act – and during the school holidays, the troupe that I was in used to do the stage act. All live of course and no microphone.

The advice I give to anybody wanting to be a pop star is to analyse themselves and find out what they've got and to work at it. Don't expect to make a hit record to start with, you know, you've got to get some groundwork in, get some practical experience, take anything that comes along, no matter if it's paid or not paid, instead of listening to other people singing. Don't do that, develop your own style so that when your voice is heard they know immediately who it is.

In my early days, I went for an audition at the BBC and I was told my voice was wrong and I just accepted it. I thought, well, it had the wrong tone or it had something wrong, you know, because in the early days they were all crooners and I wasn't exactly a crooner. I used to just belt out, you know. I probably blasted off the microphone! But you don't stop because of that, you carry on.

Being well known is part of your life really and as the years go by people get used to you, and you get accustomed to it.

Fame has got a lot to do with people. Inferior singers have been big stars and loved for donkeys' years and people with beautiful, beautiful voices out of heaven have disappeared. So I think it's something to do with personality, whether it's an obscure personality or whether it's someone people can connect with and like. I'm sure it's something to do with the person themselves.

Whatever career you choose, you've got to follow it. For me, nothing could top singing outside Buckingham Palace with the Royal Family with thousands upon thousands of people lining the mall on the 50th anniversary of VE day, surrounding the place. Well, I thought, that was one of the biggest audiences I'll ever sing to. And that's when I decided to stop singing, while I really still could. I was 78.

The Ipplepen Carnival Queen, her princesses and their mothers, Dawlish

Daniel O'Donnell fans wait to meet their idol at the signing of his autobiography, London

(Overleaf) Hopefuls queue for the auditions of *Billy Elliot – The Musical*, London

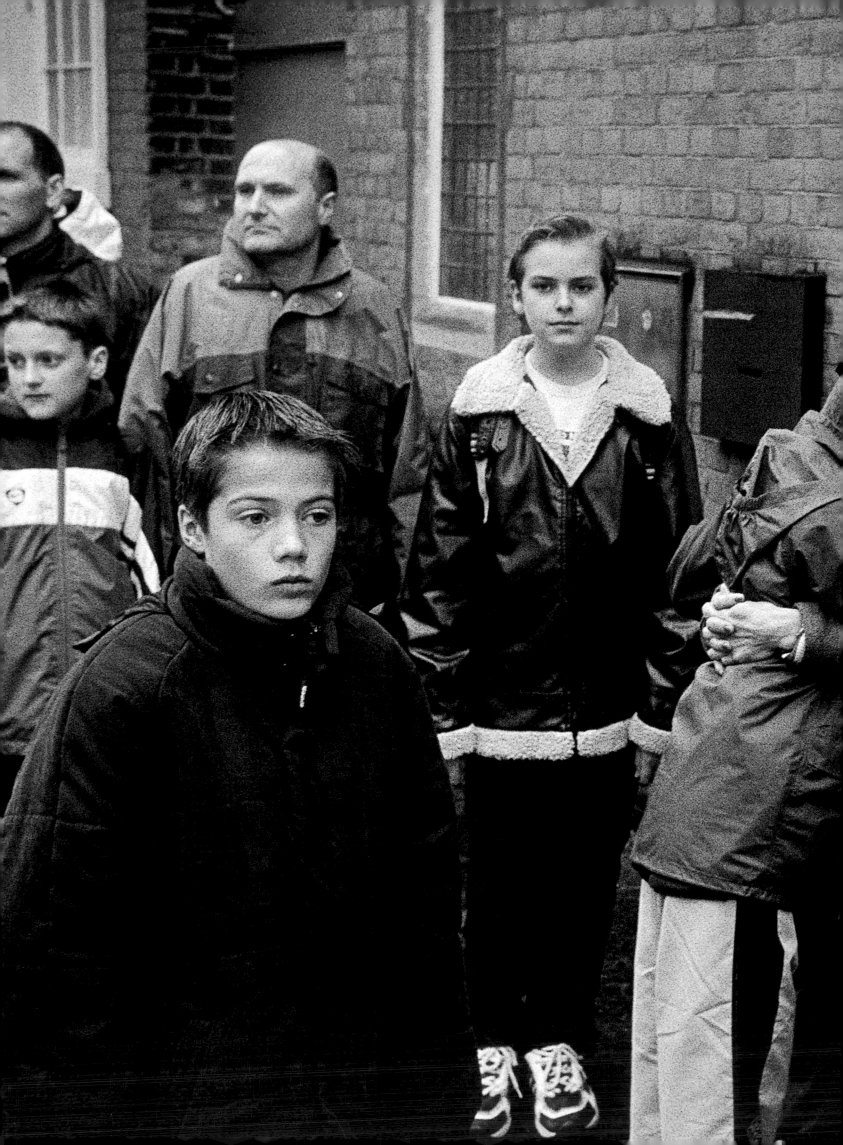

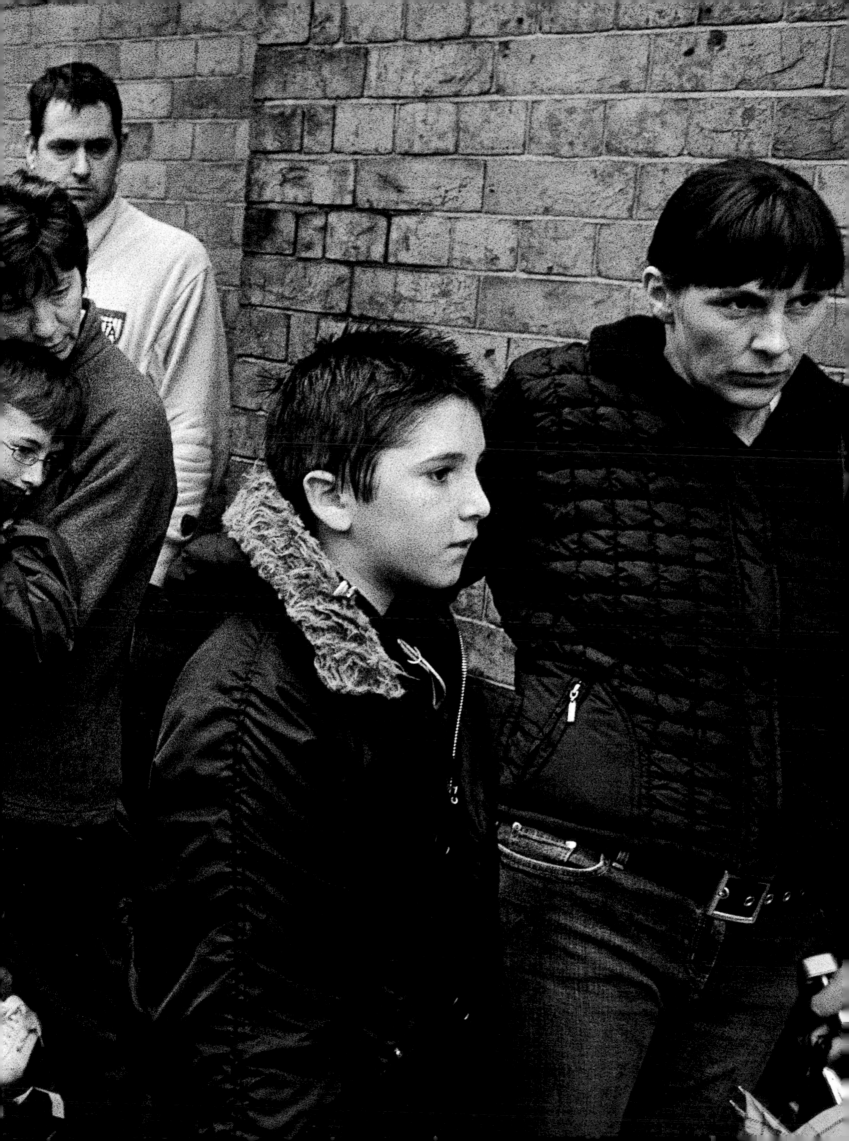

The Guinness World Records' "most pierced woman" Elaine Davidson, London

(Overleaf) London *Evening Standard* commemorative edition on the day of Princess Diana's funeral, Hyde Park

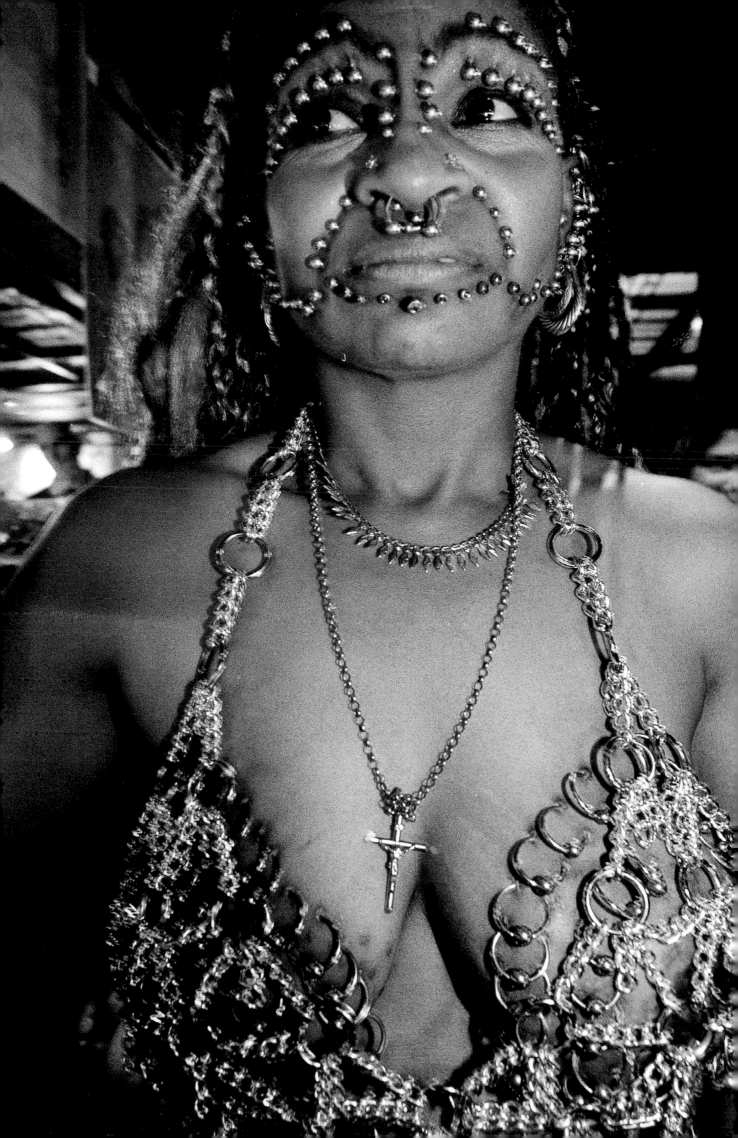

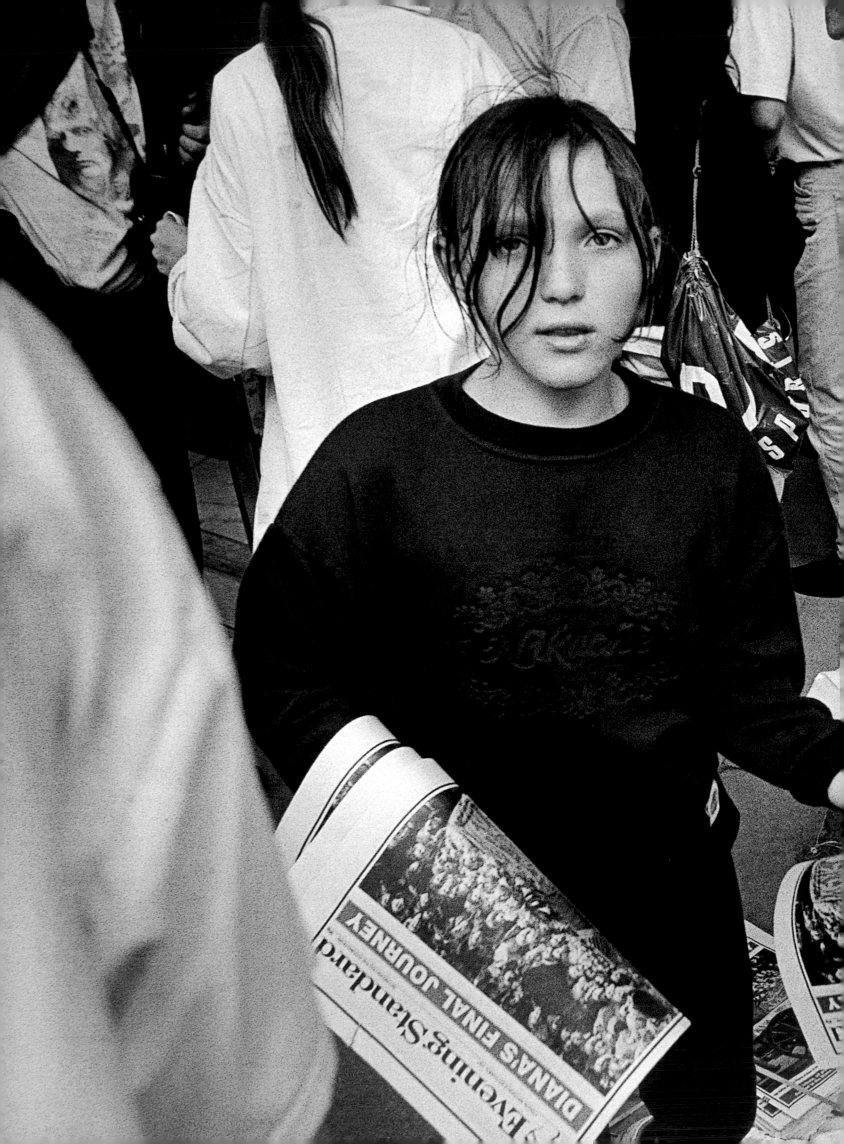

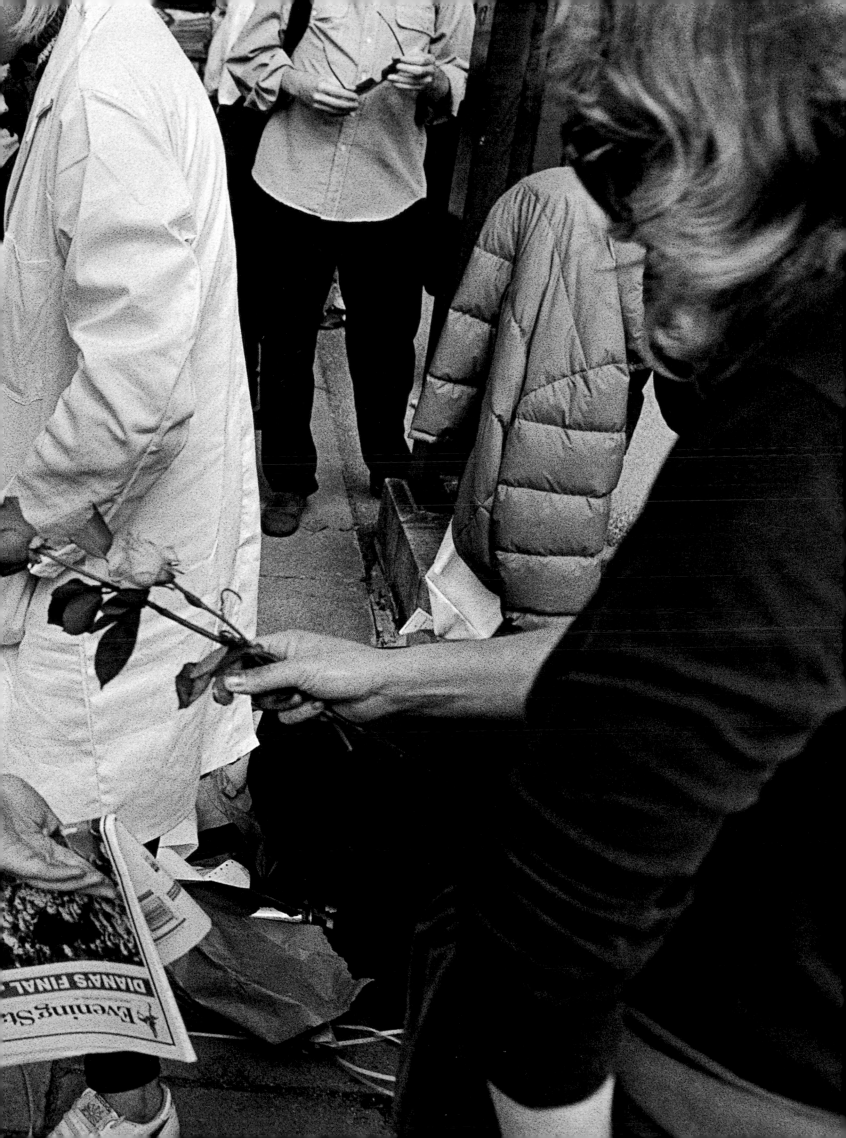

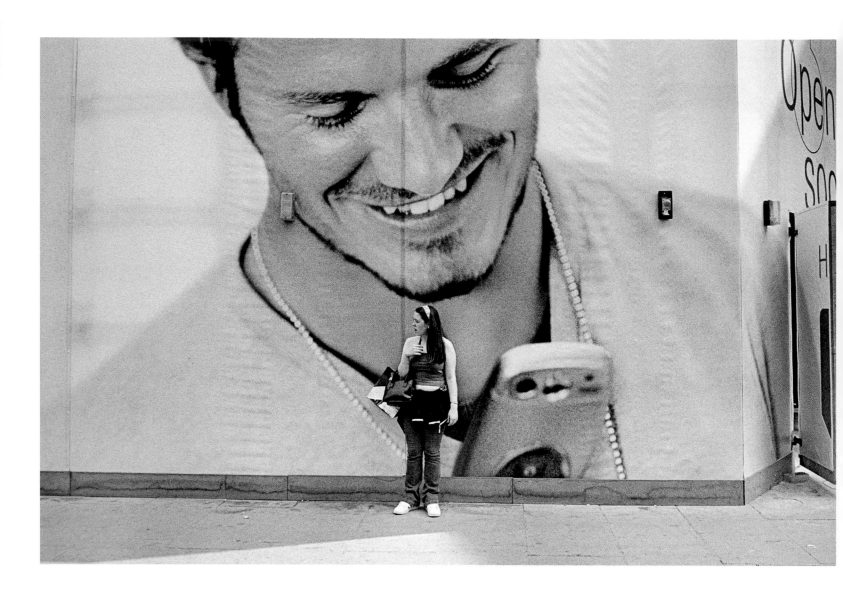

David Beckham poster, London

Irish rugby star Keith Wood delights a fan, Twickenham

(Overleaf) Fans glimpse the Monaco Grand Prix through a crack in the four-metre perimeter fence; Electric Kingdom float, Love Parade, Berlin

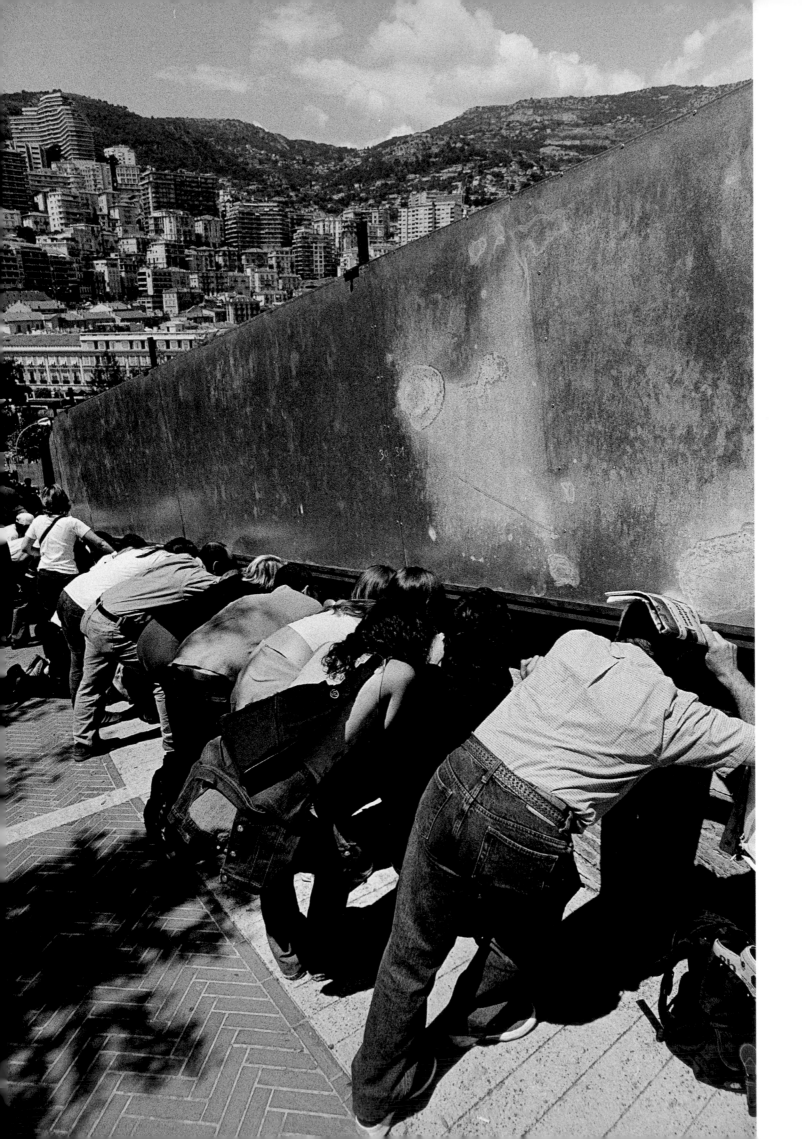

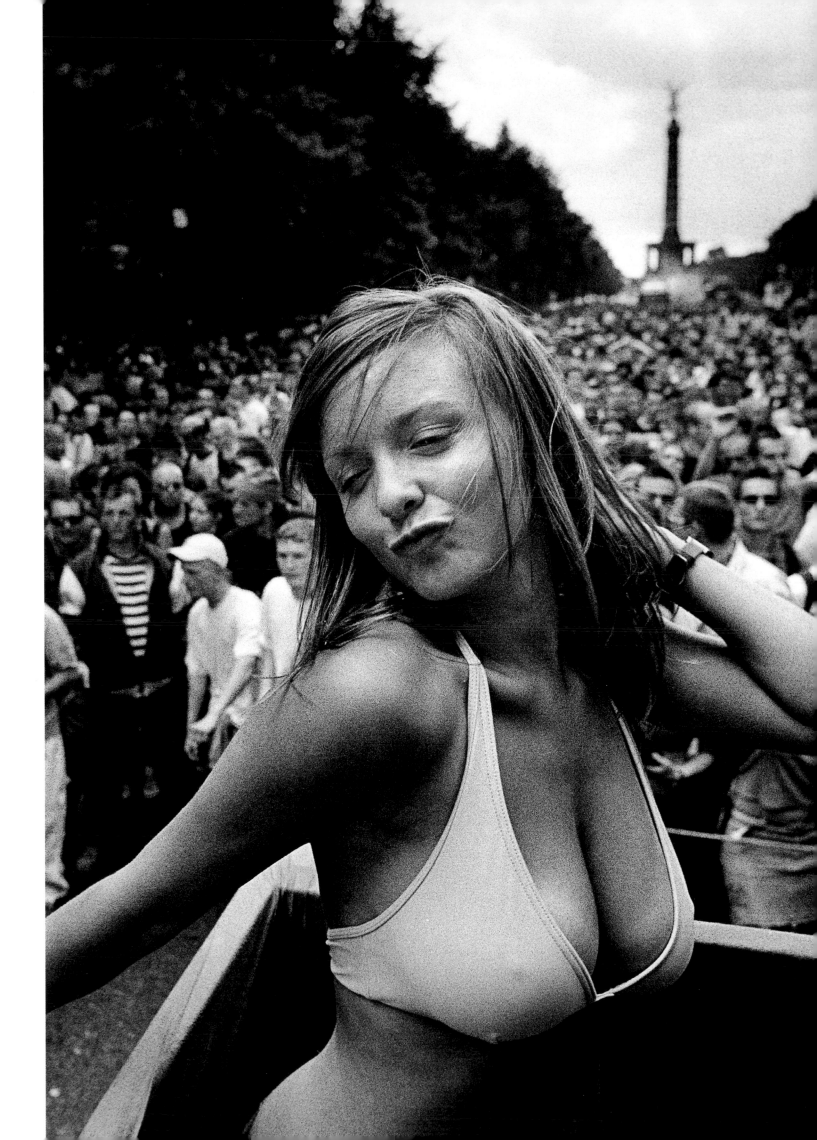

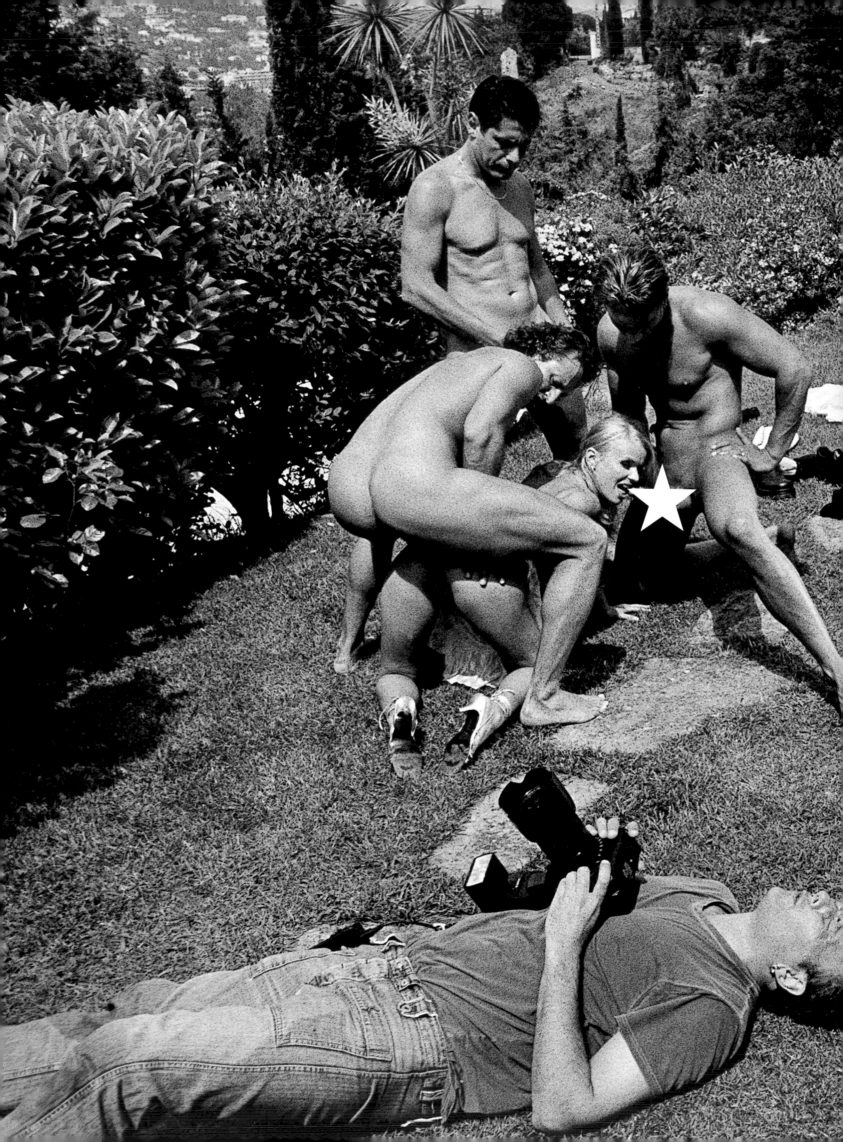

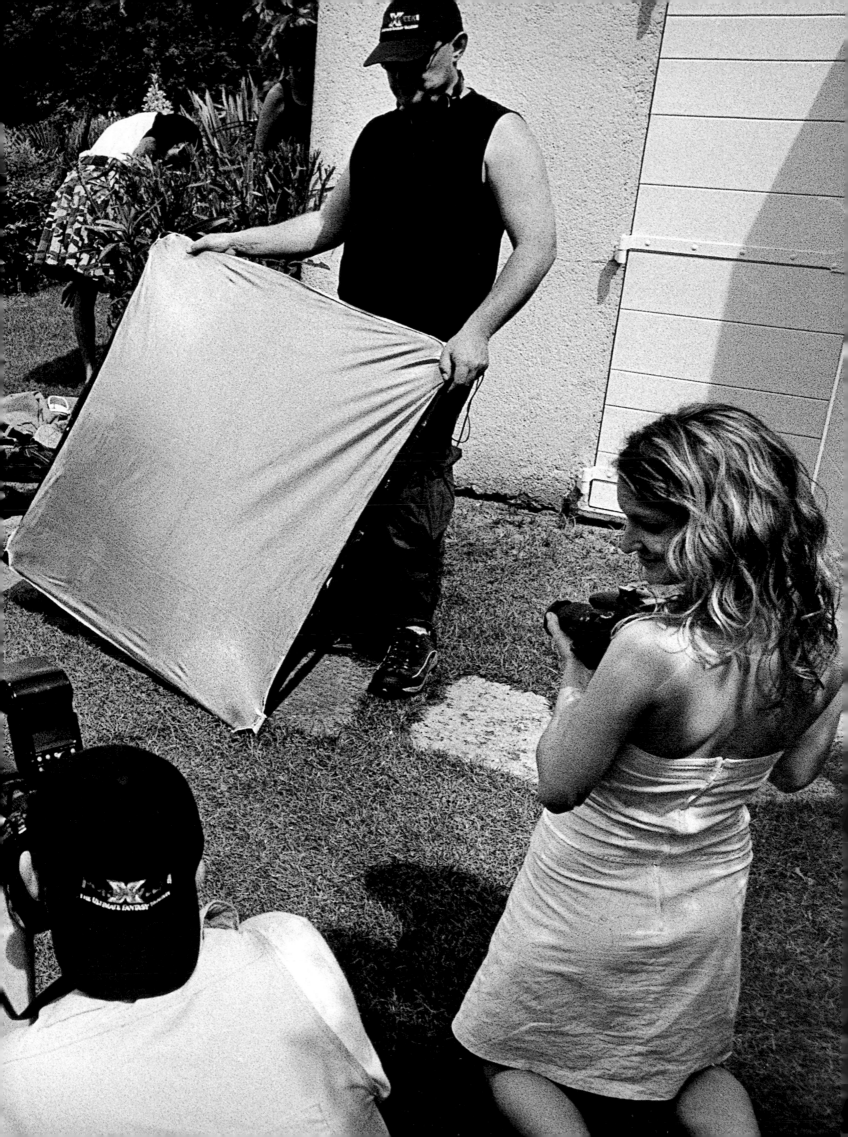

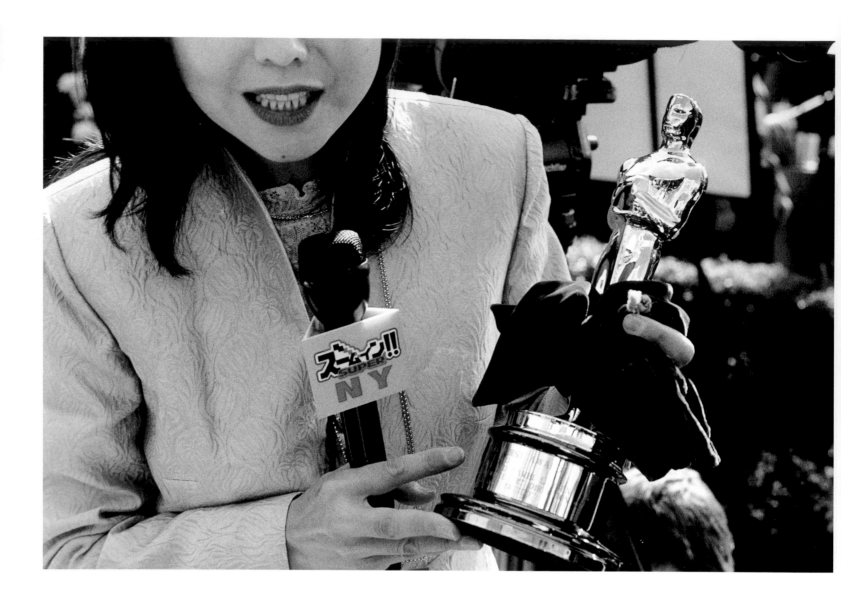

Japanese TV presenter with Oscar the morning of the ceremony, Hollywood

(Previous page) Porn star Dora Venter smiles for her close-up, Cannes

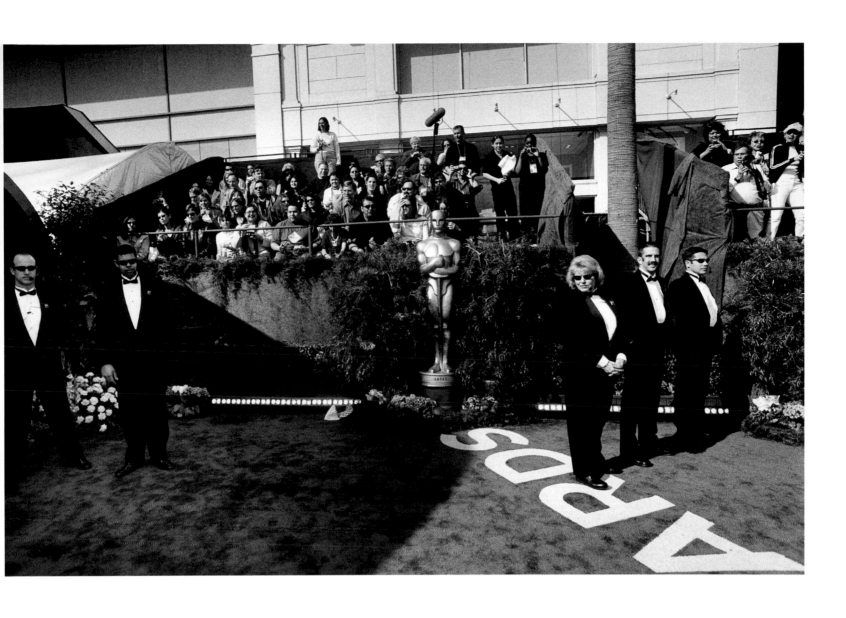

Security and fans on the bleachers at the Oscars ceremony, Hollywood

Cue-card rehearsals, Hollywood
(Overleaf) Nicole Kidman looks down on the red carpet, Cannes

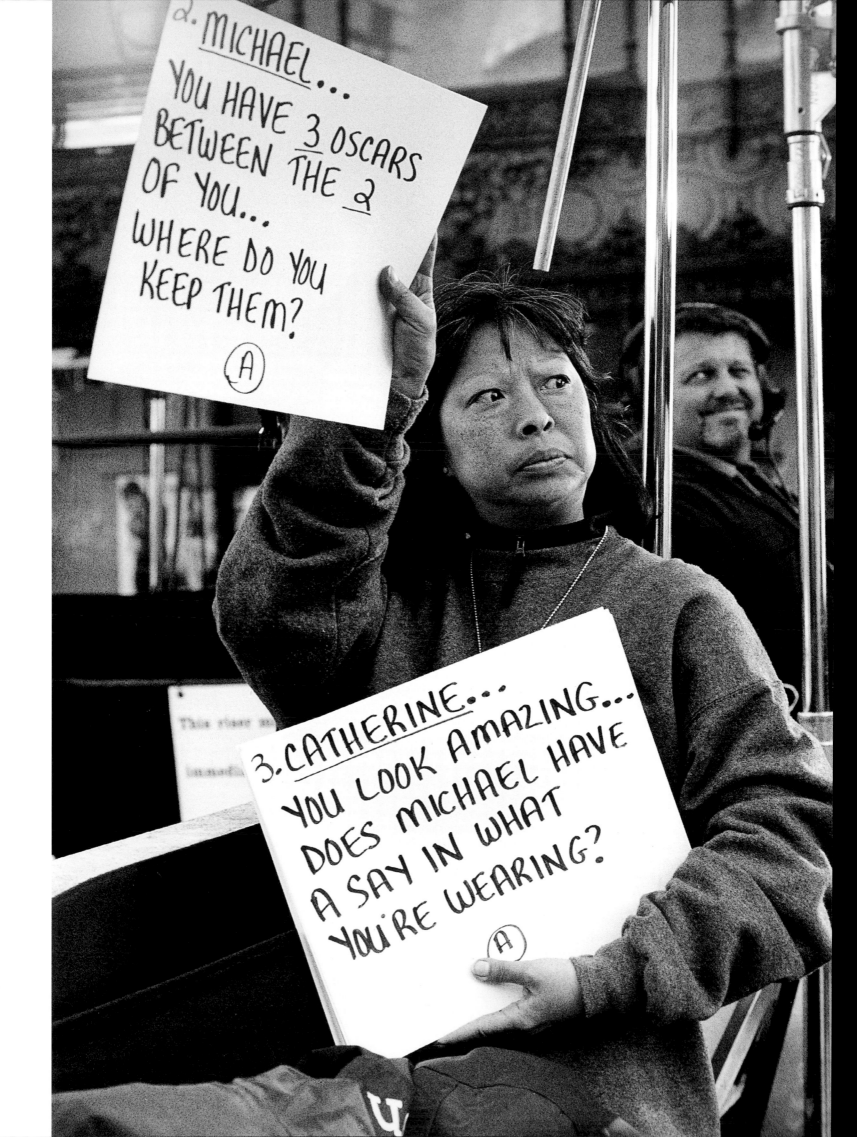

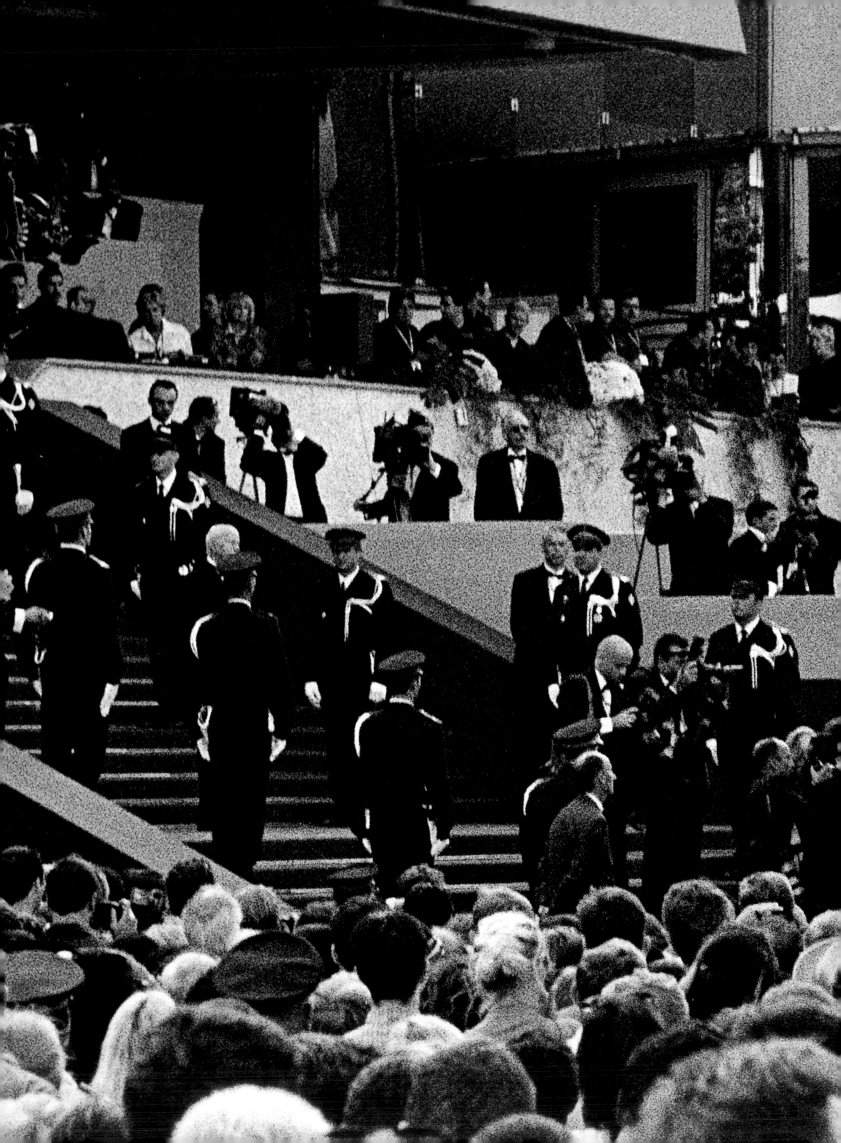

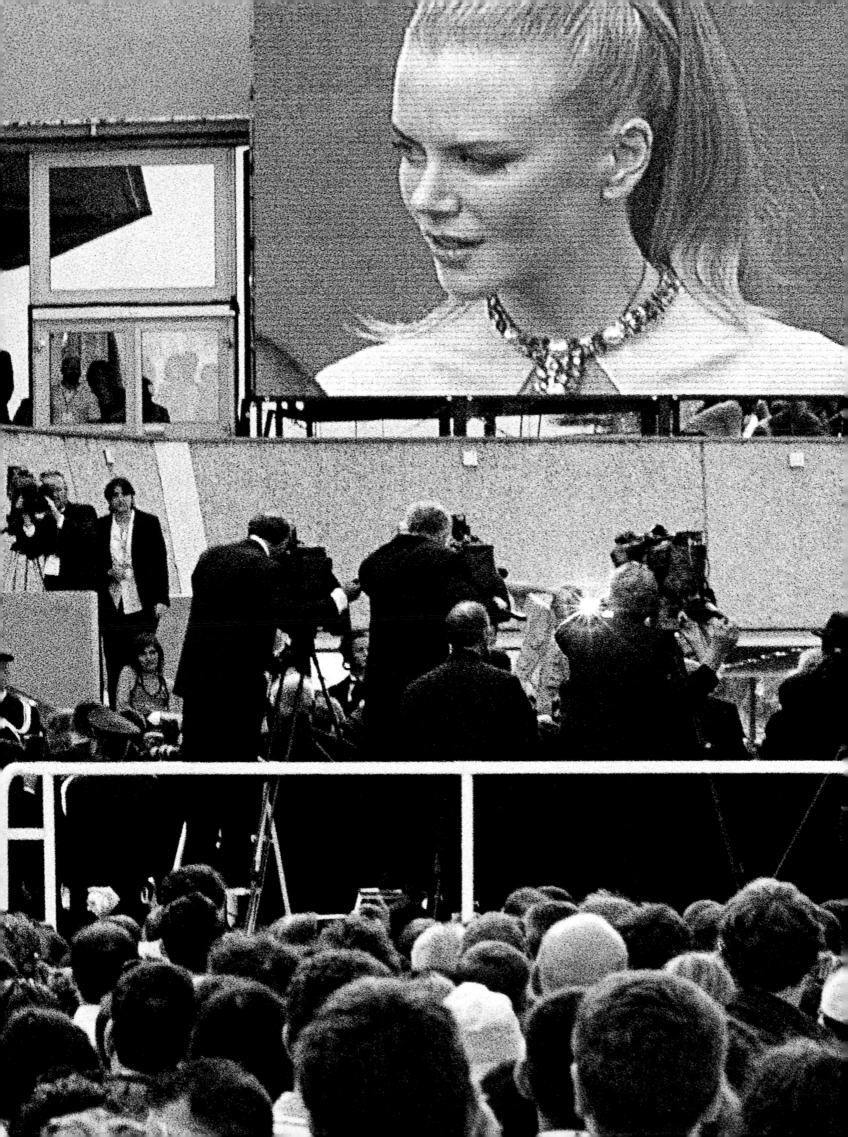

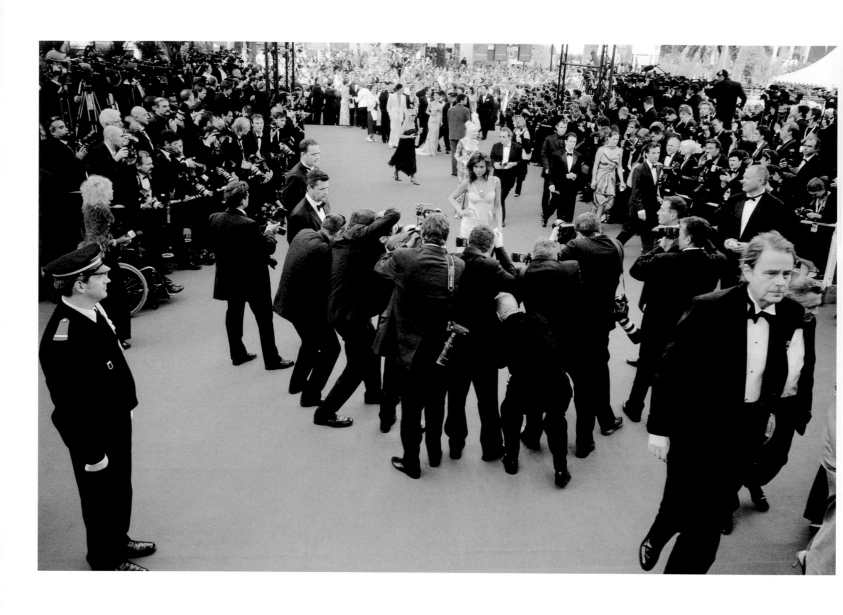

Official photographers block the path of a starlet, Cannes

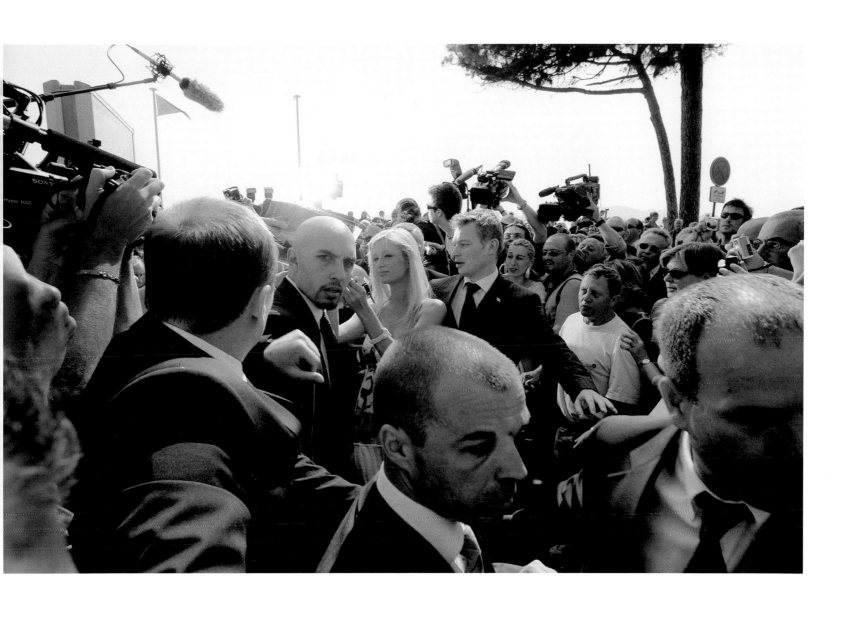

Paris Hilton and her bodyguards, Cannes

(Overleaf) Jean Rochefort greets fans on the way to a premiere, Cannes; (Page 76) Alice Braga on the Croisette, Cannes

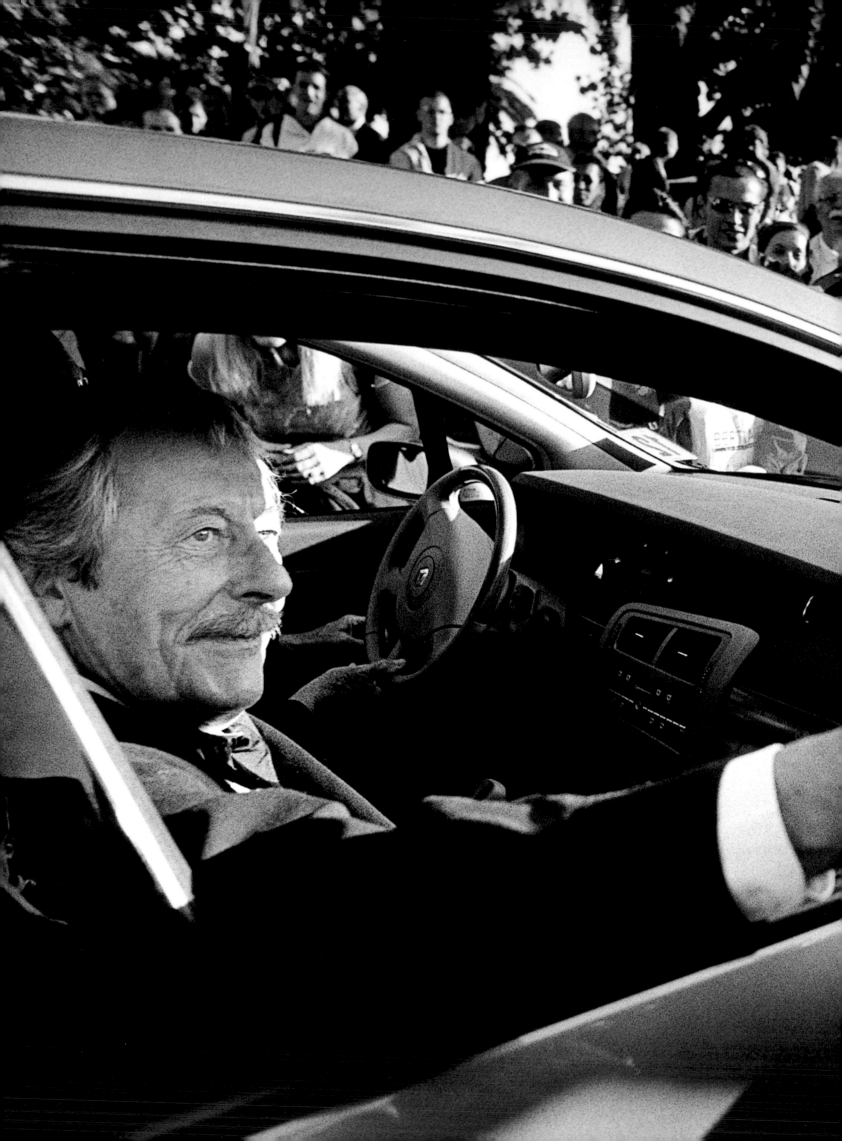

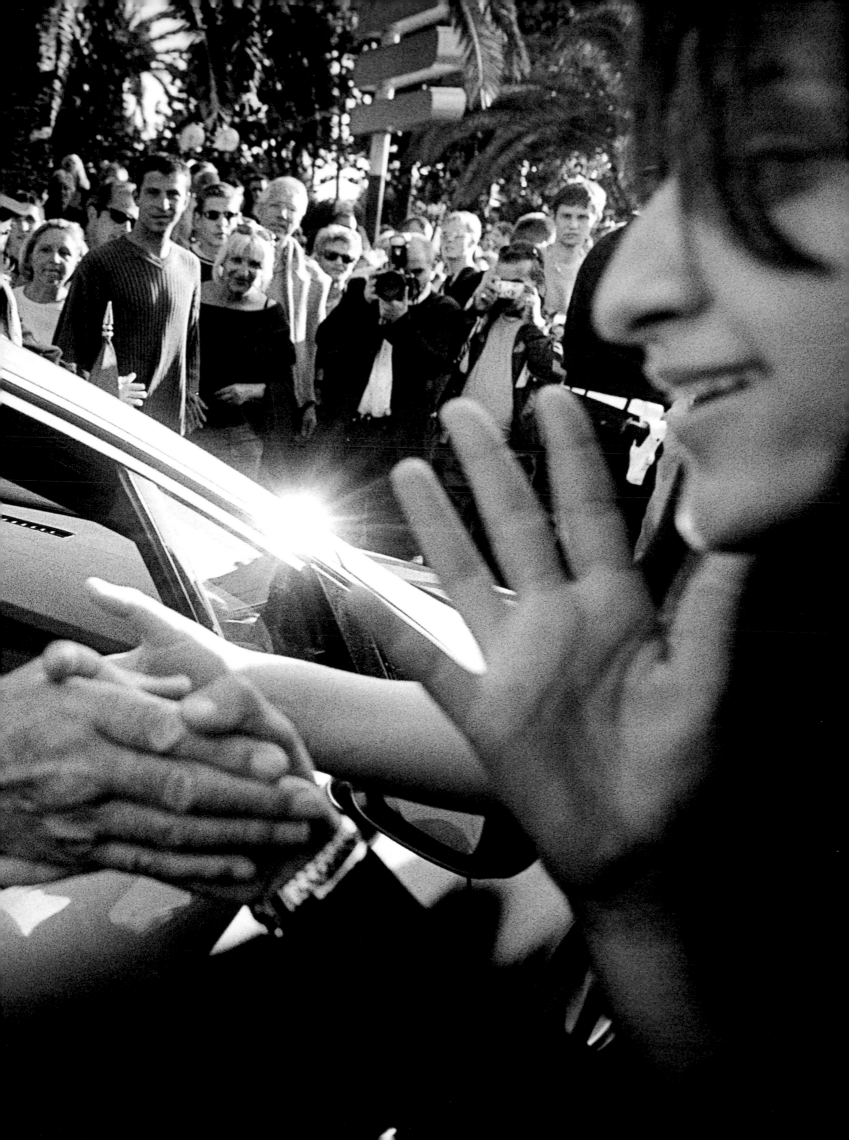

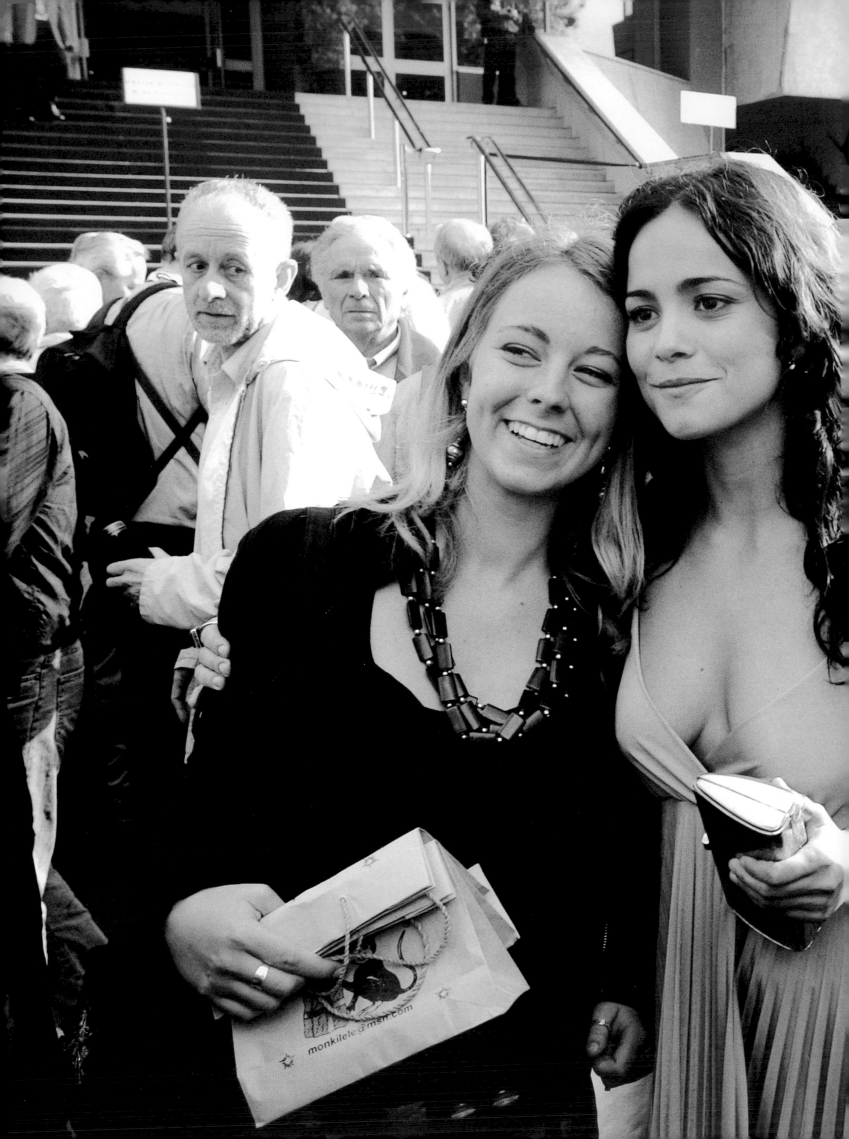

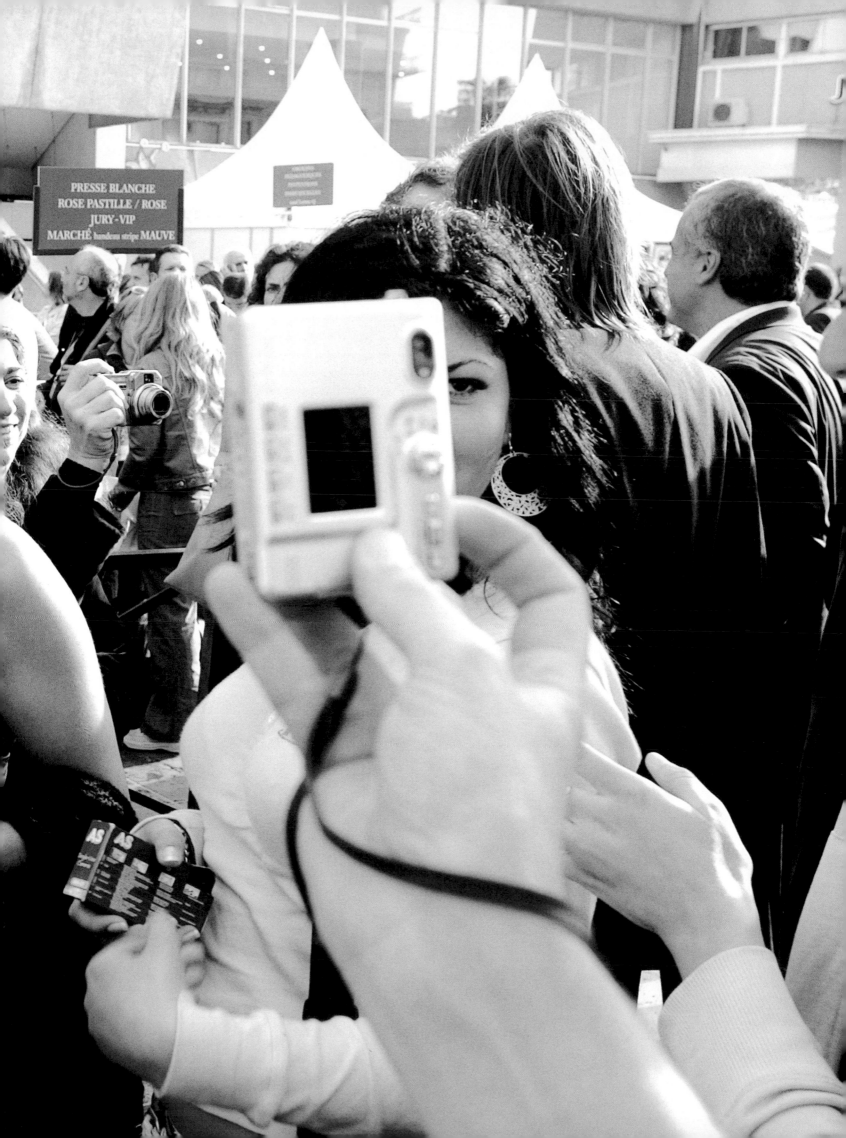

ALICE BRAGA

WONDERLAND

For me acting is not just about feeling, it's about going for a dream. Believe in it and realise.

Going to Cannes made me feel like Alice in Wonderland. It was like falling in the hole, without fear, into a new world – Wonderland, a smiling cat, a crazy queen – and to find out there are many ways to get there.

There ?

Where ?

Well, there.

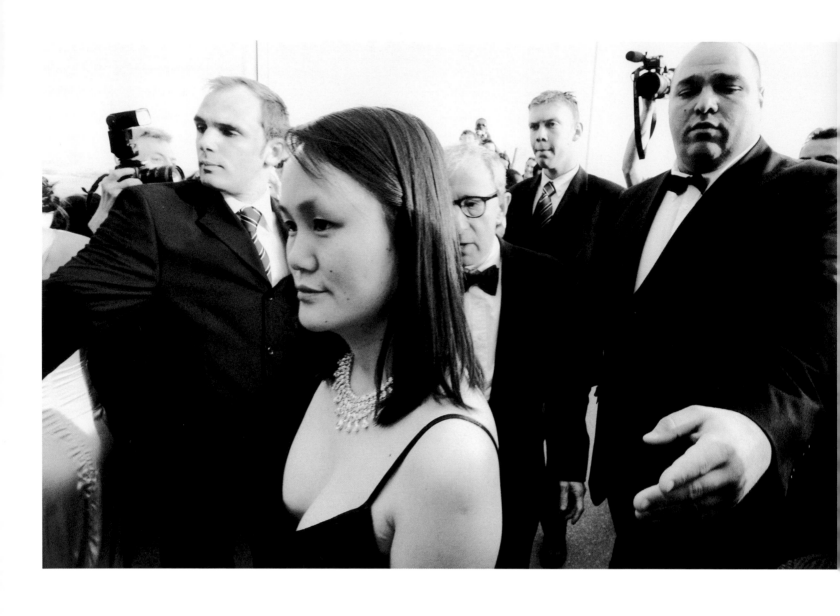

Woody Allen and Soon-Yi Previn, Cannes
(Previous page) Angelina Jolie, Cannes

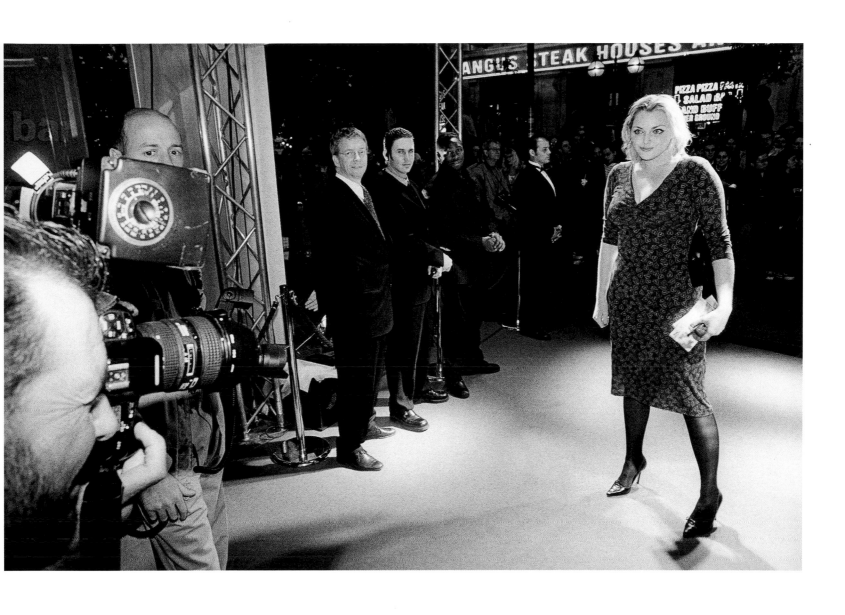

Supermodel Sophie Dahl makes an entrance, London

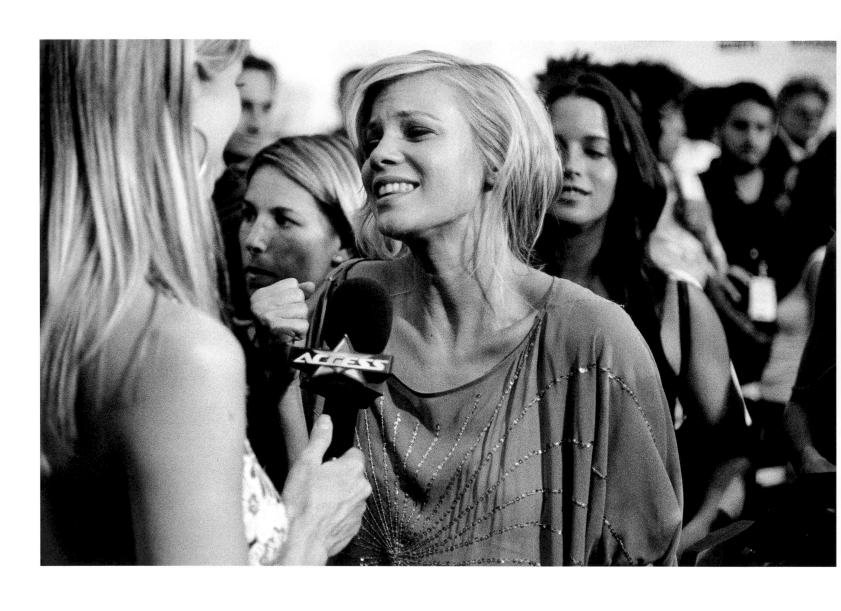

Actress Amy Smart speaks to All Access TV, Universal City, LA

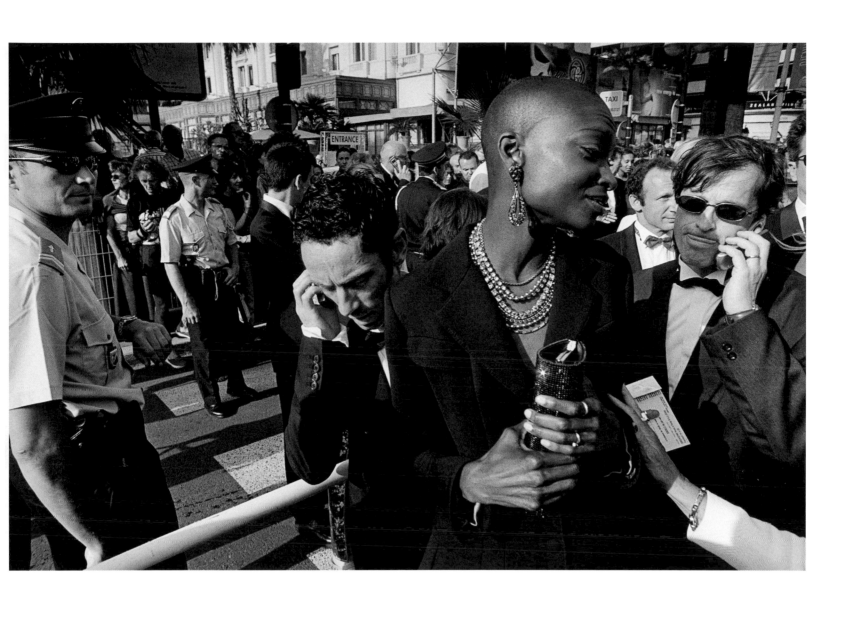

Dressed to kill for a film premiere, Cannes

(Overleaf) Star spotters, Cannes; Street photographer, Cannes

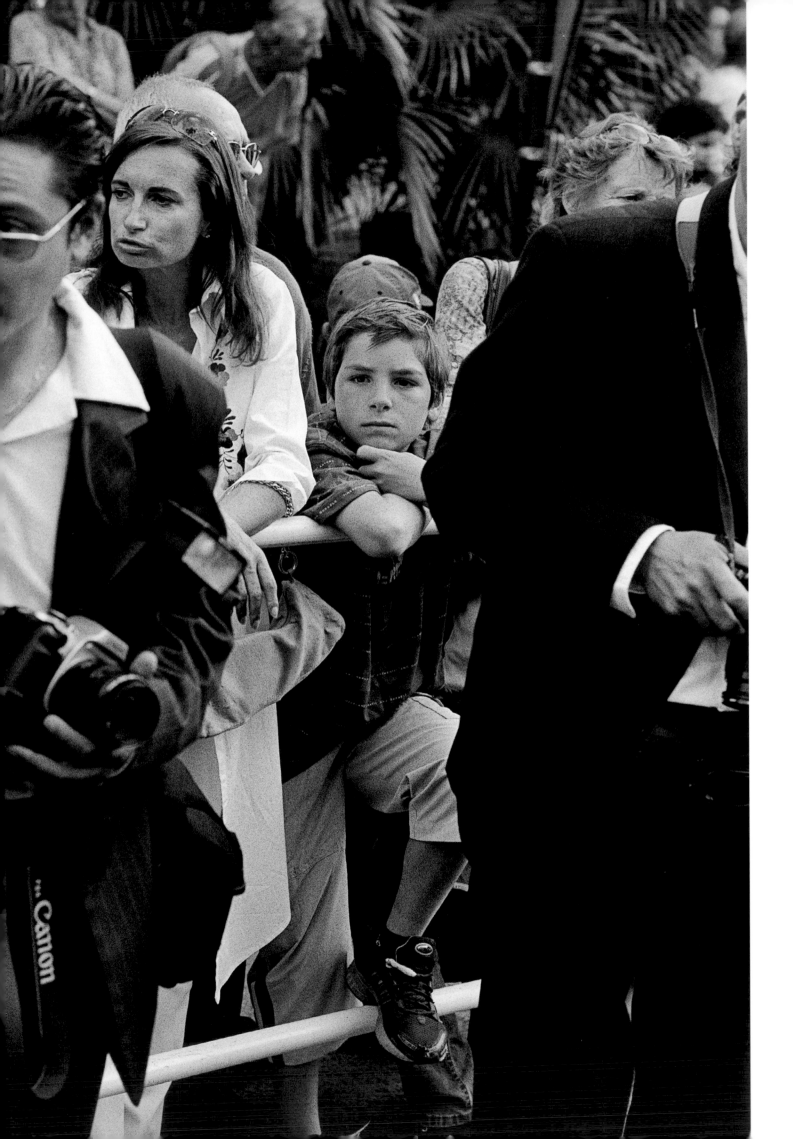

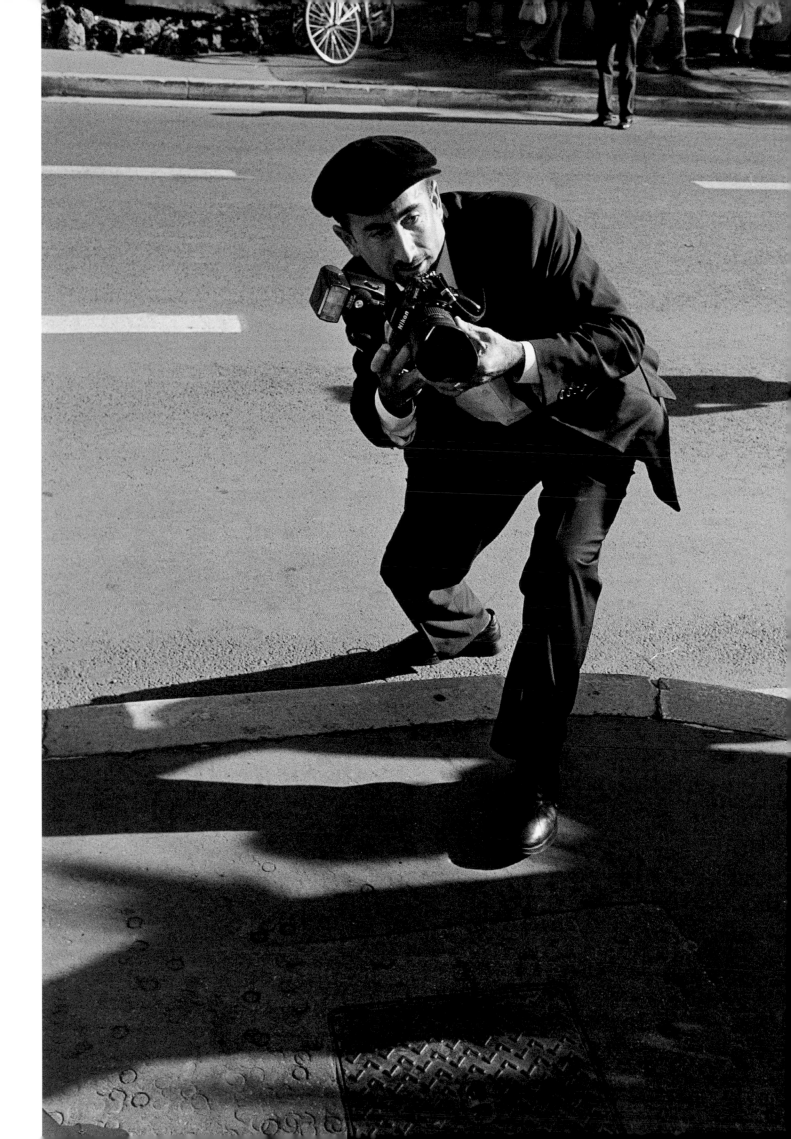

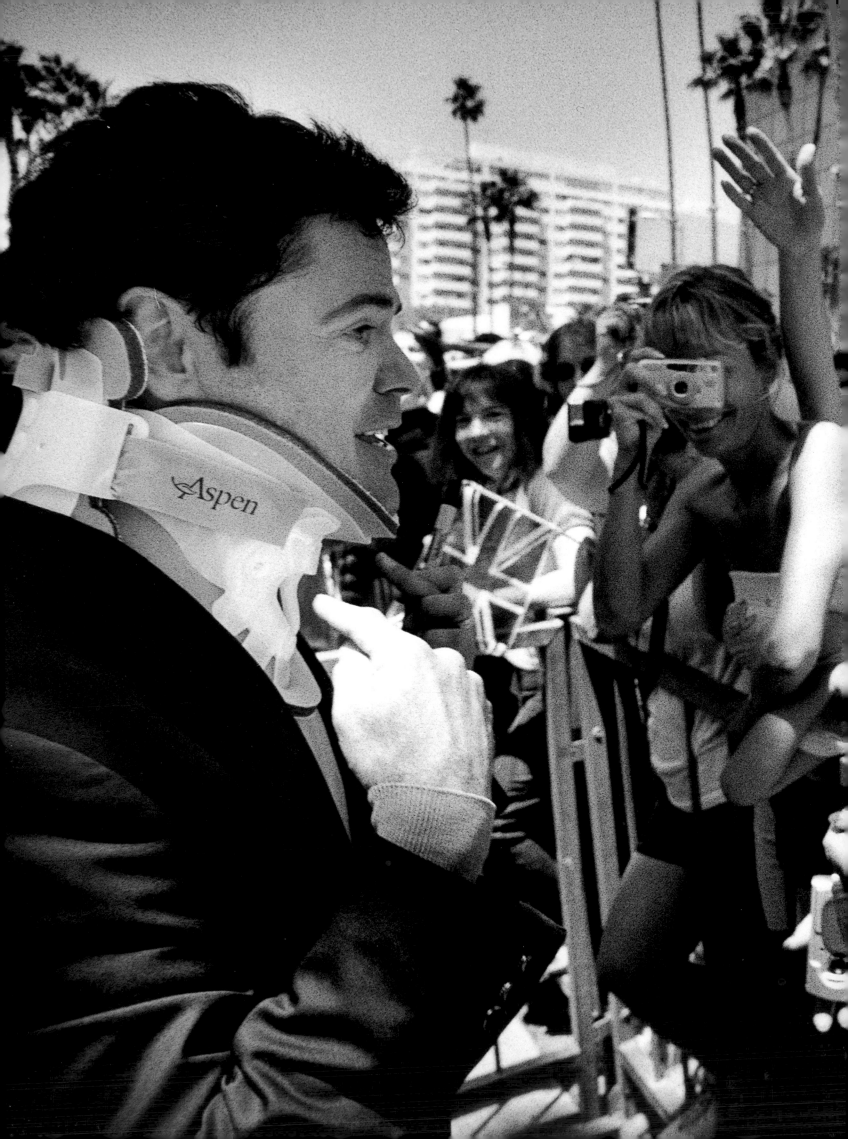

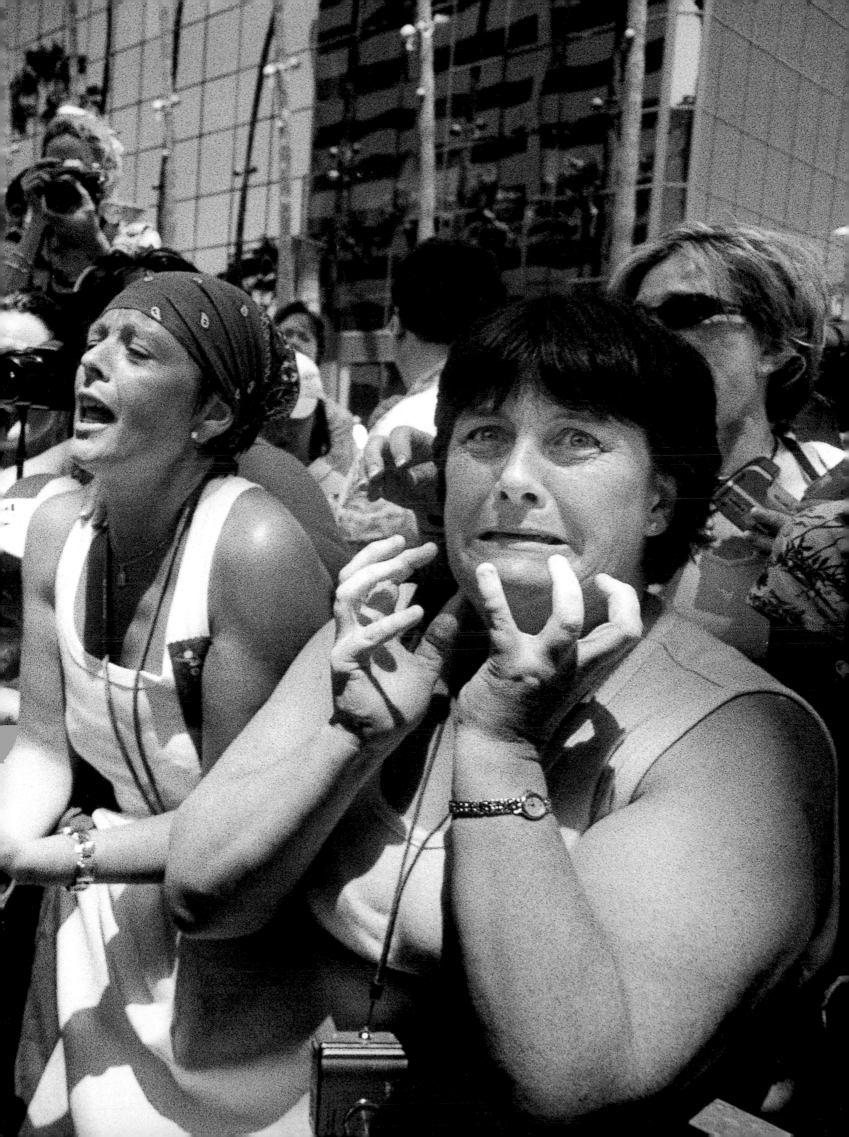

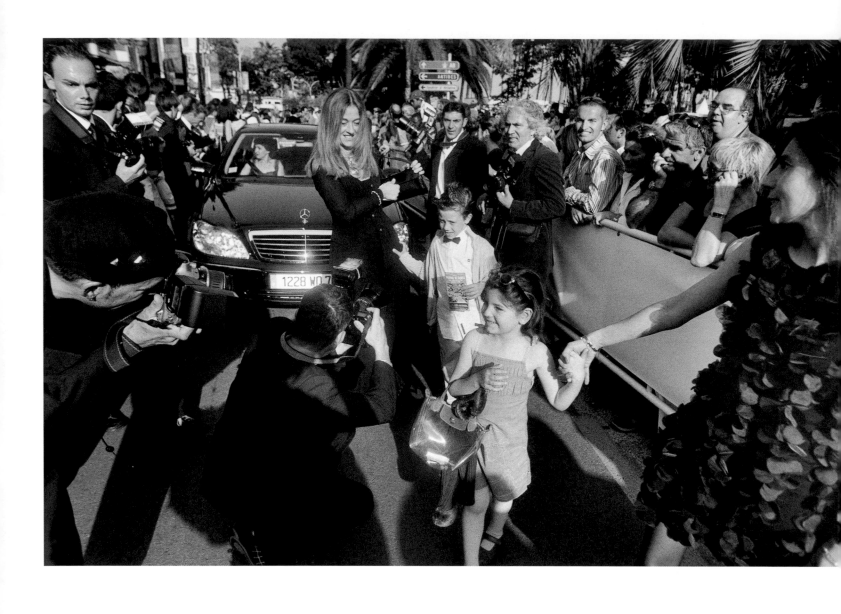

Junior celebrities, Cannes

(Previous page) Former teen star Donny Osmond meets his grown-up followers, Hollywood Boulevard

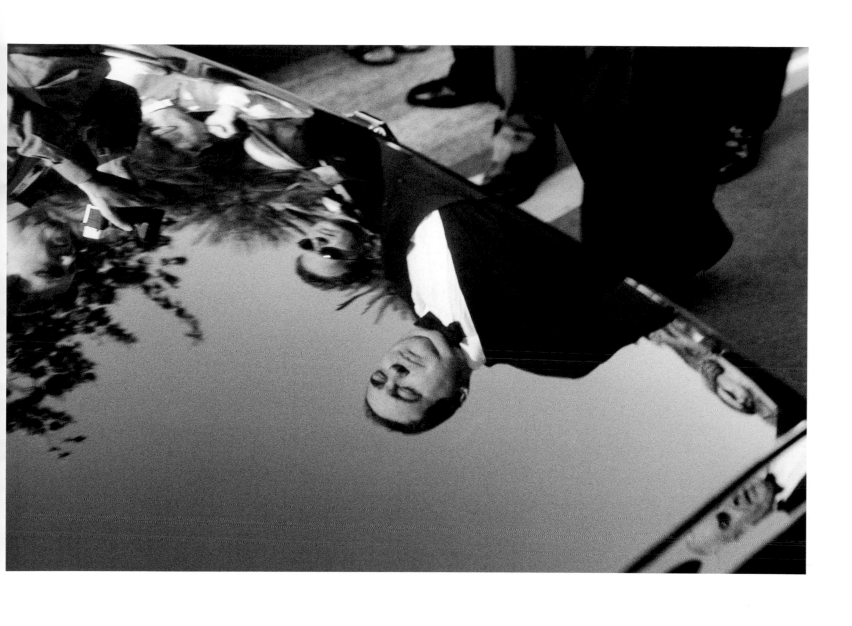

High-gloss limo, Cannes

(Overleaf) Beyoncé's father hands out posters to fans, London

Beyoncé
dangerouslyinlove
the debut album 23rd June
includes the massive forthcoming single crazy in love feat. jay-z
plus the top ten hits work it out and 03 bonnie & clyde

Arnold Schwarzenegger drops in, Cannes

(Overleaf) Security guard at Fouquet's restaurant, Cannes; Guestlist check at the Elton John AIDS Foundation Oscar Party, Hollywood

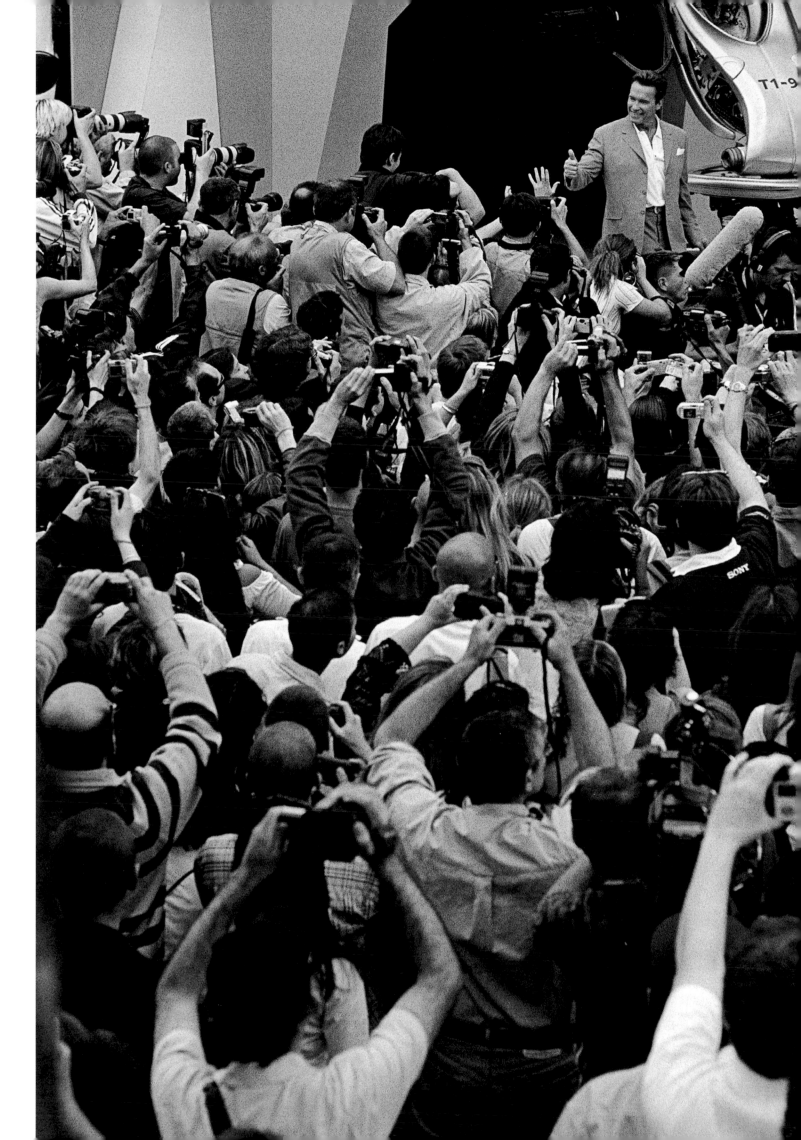

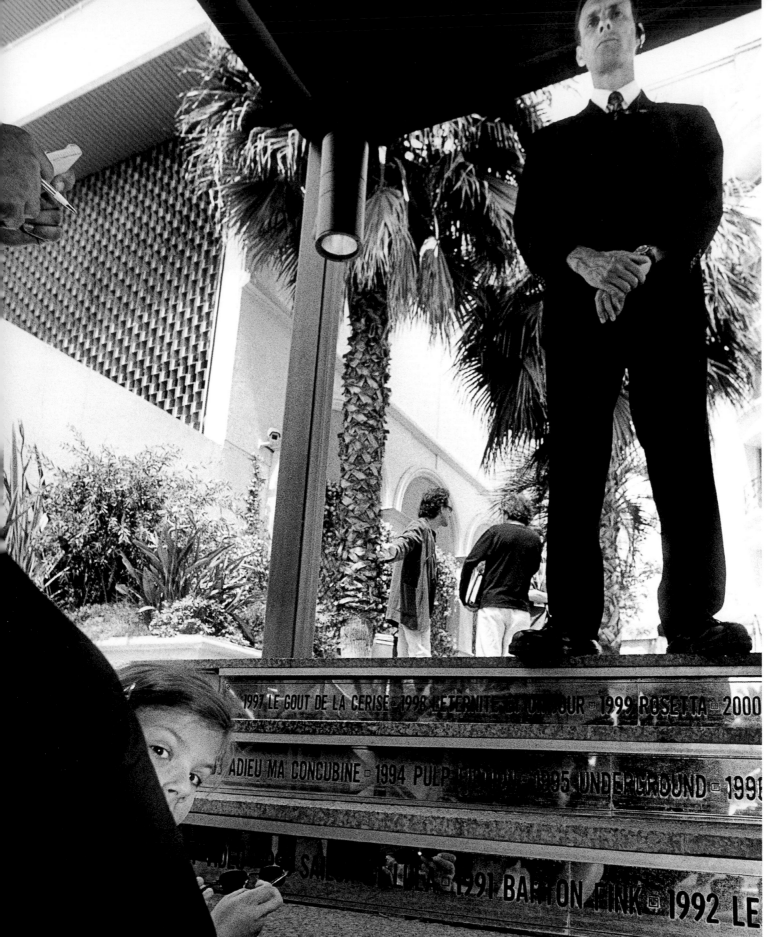

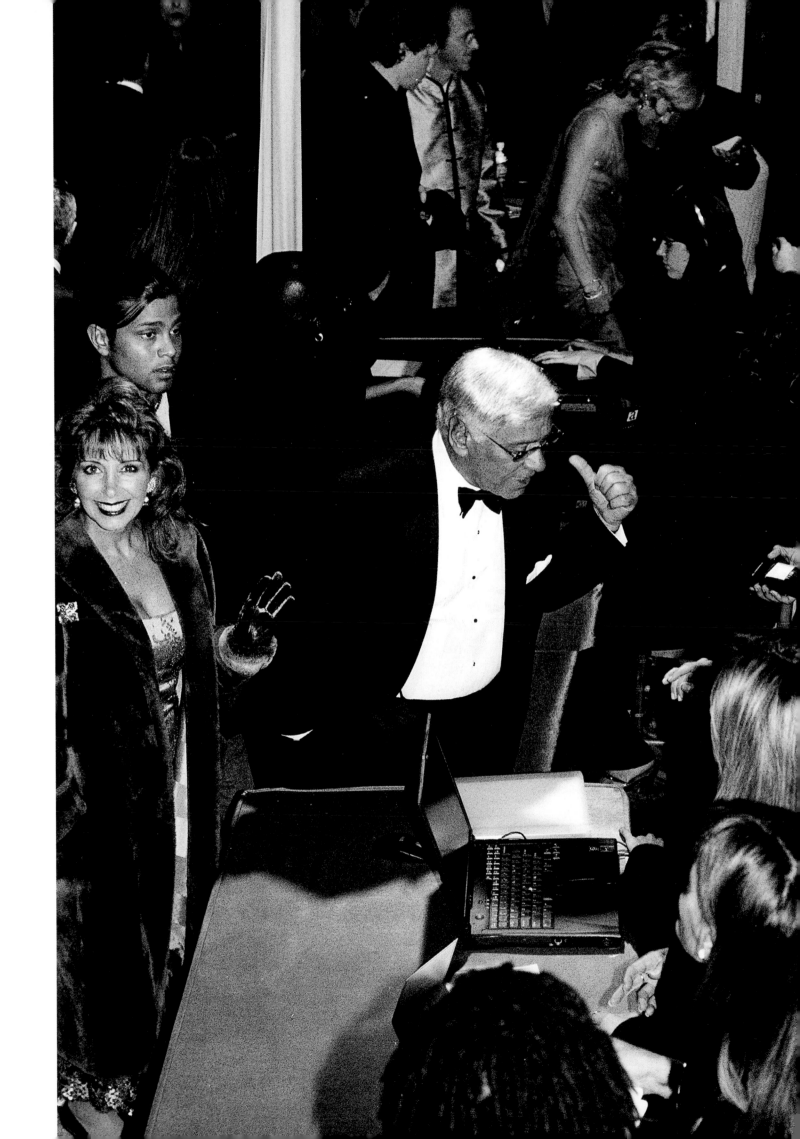

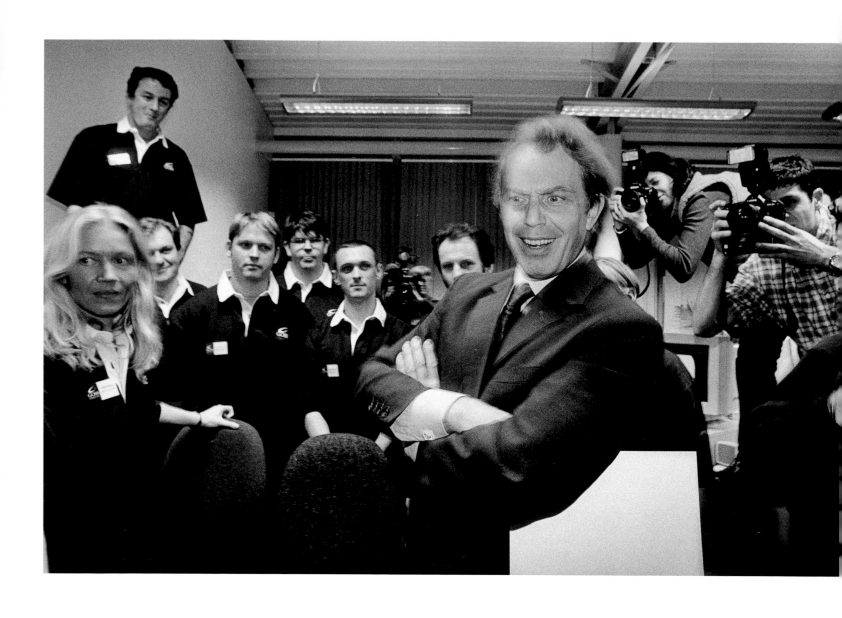

Tony Blair presents a public face, Truro

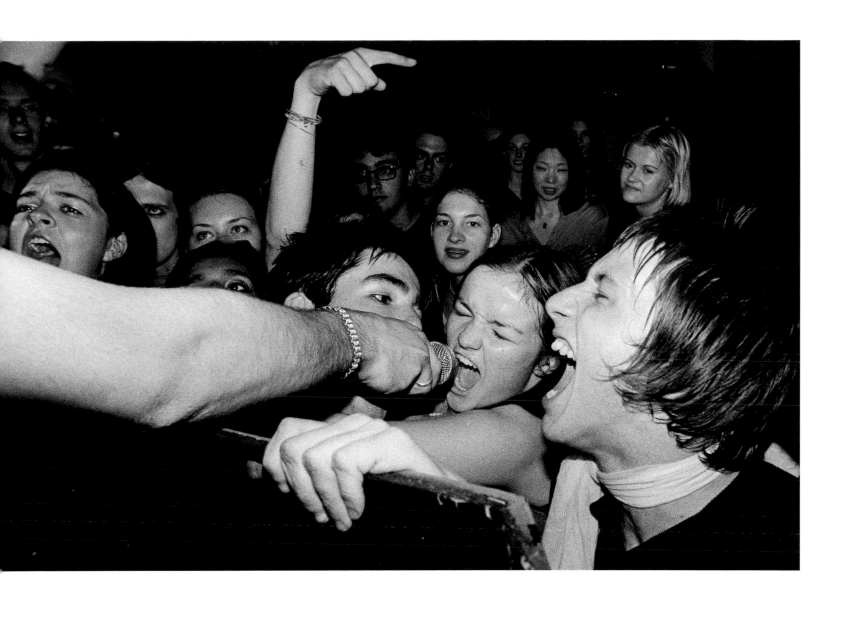

The audience joins the performance at a Blur gig, London

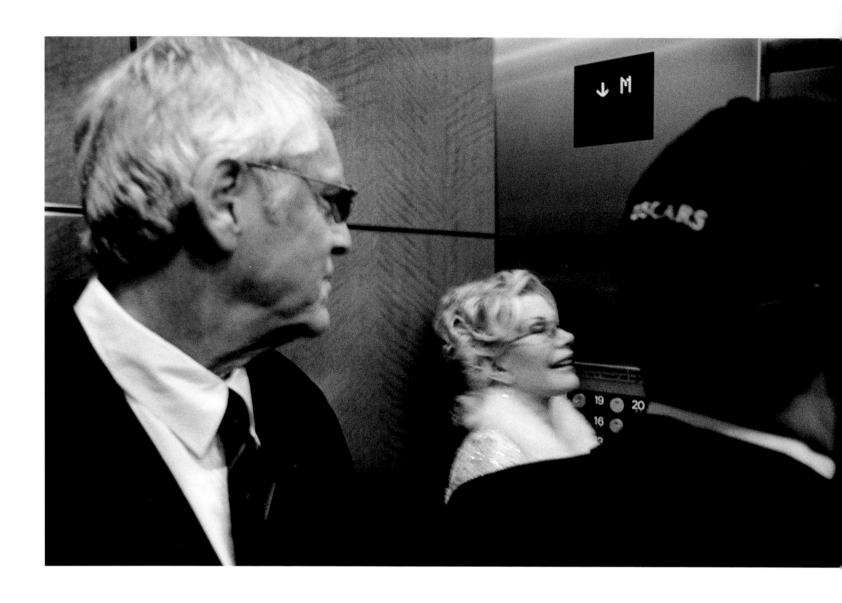

Joan Rivers descends from her hotel suite to the Oscars ceremony

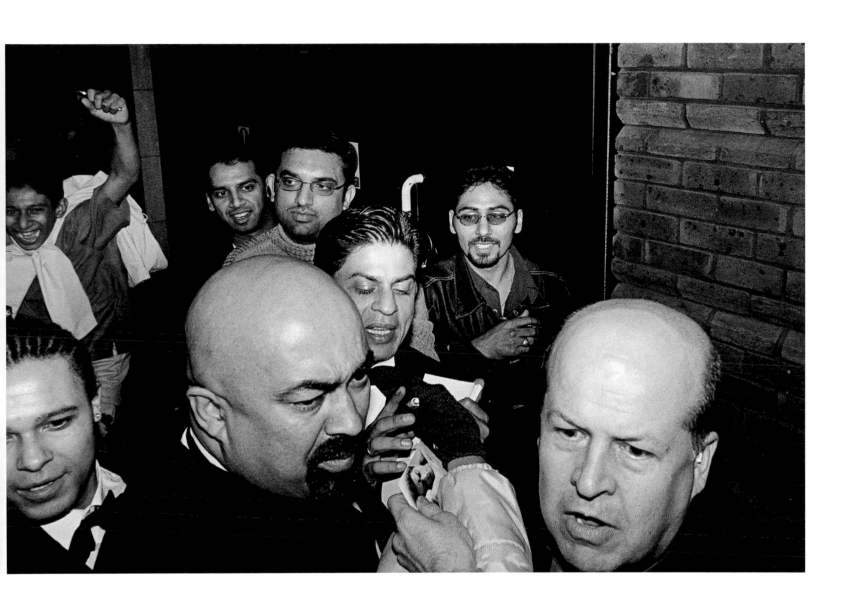

Shah Rukh Khan and entourage leave a film premiere, London

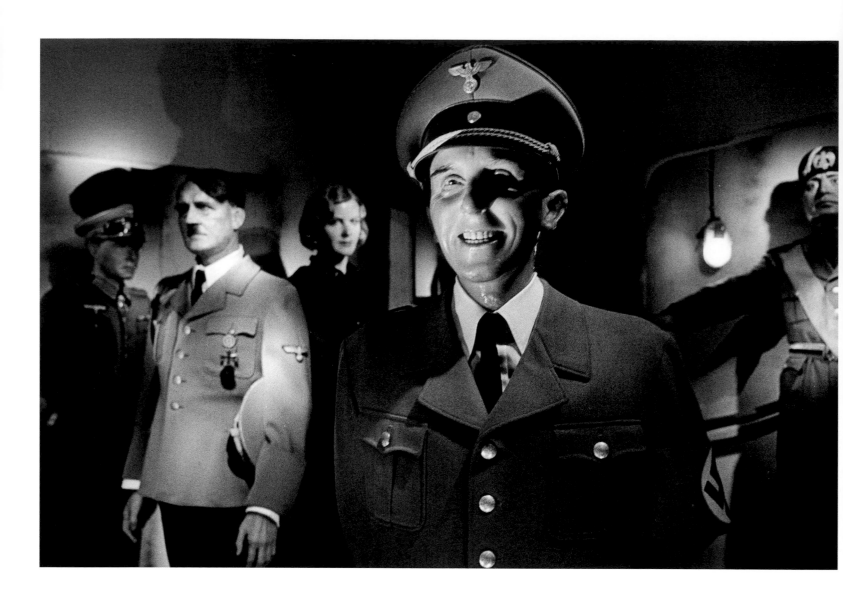

Goebbels dominates the Axis Leaders' tableau at the Panoptikum, Hamburg

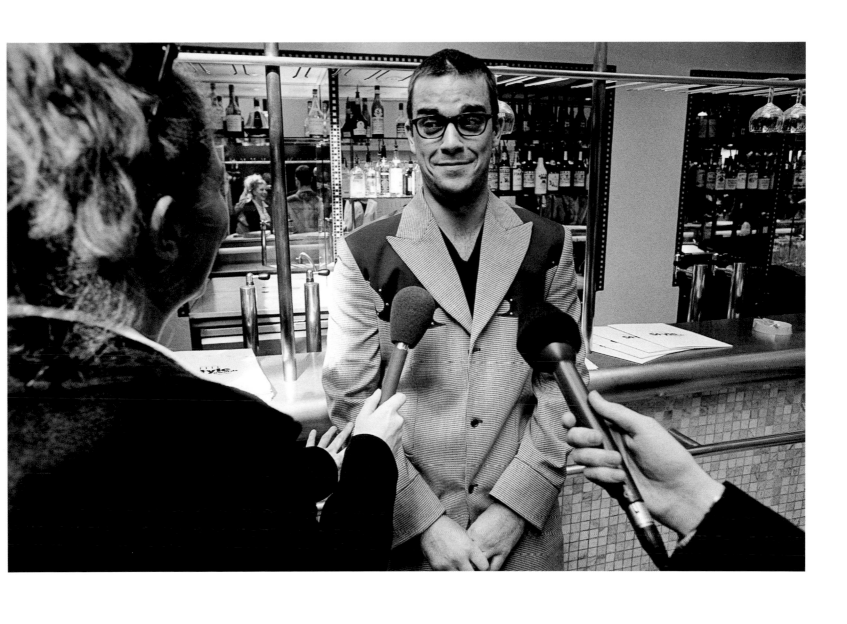

Robbie Williams, London
(Overleaf) Orlando Bloom at a friend's wedding, Henley-on-Thames

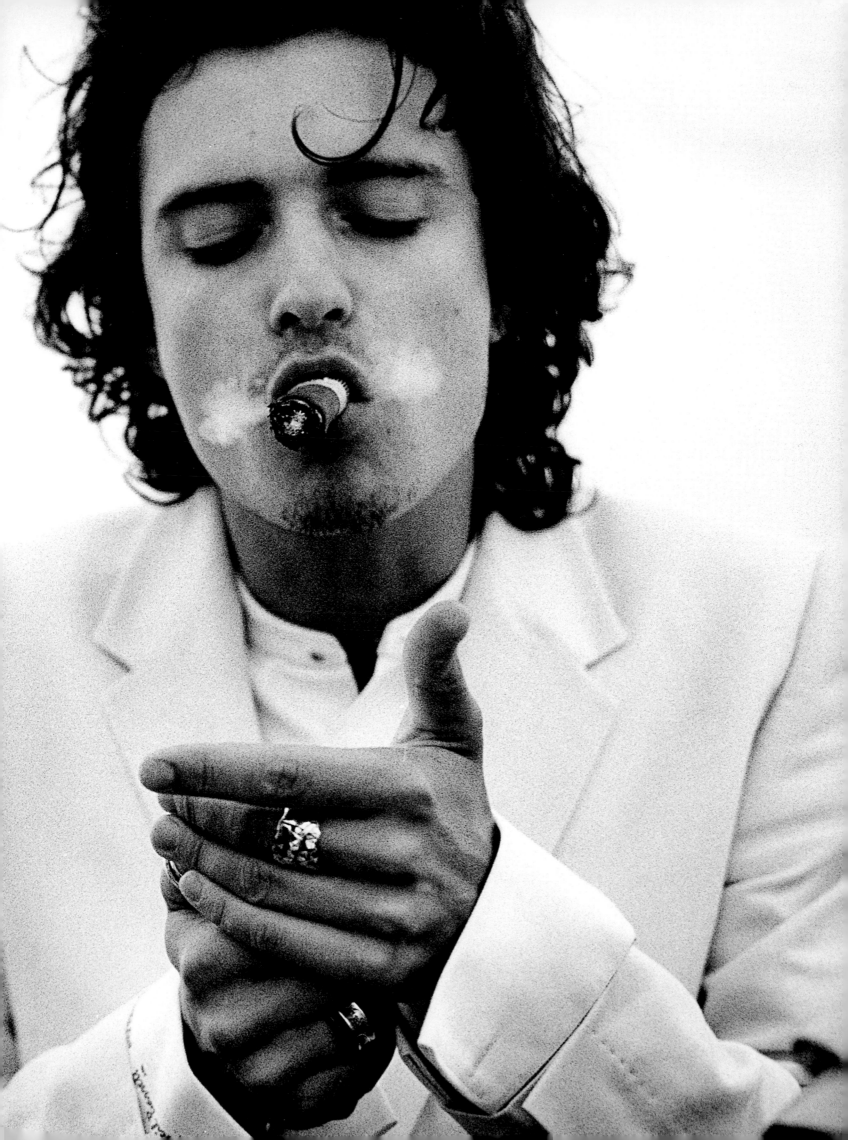

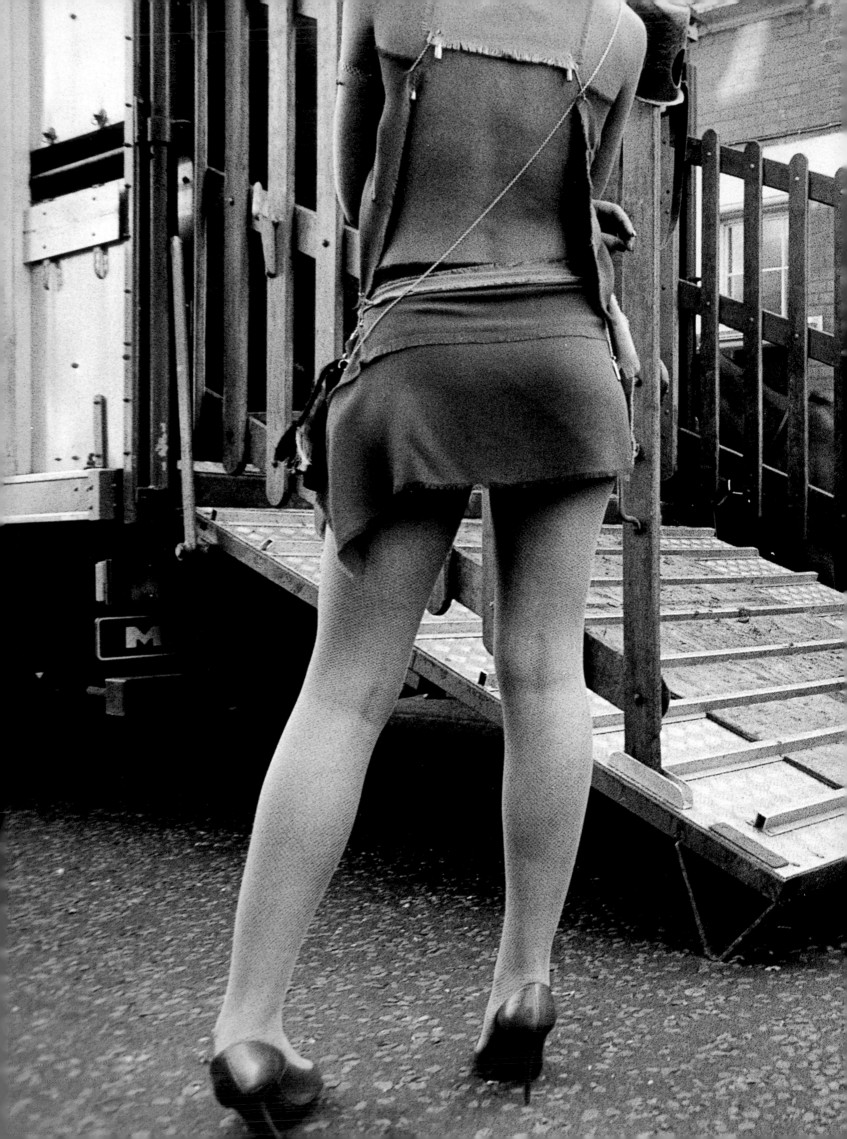

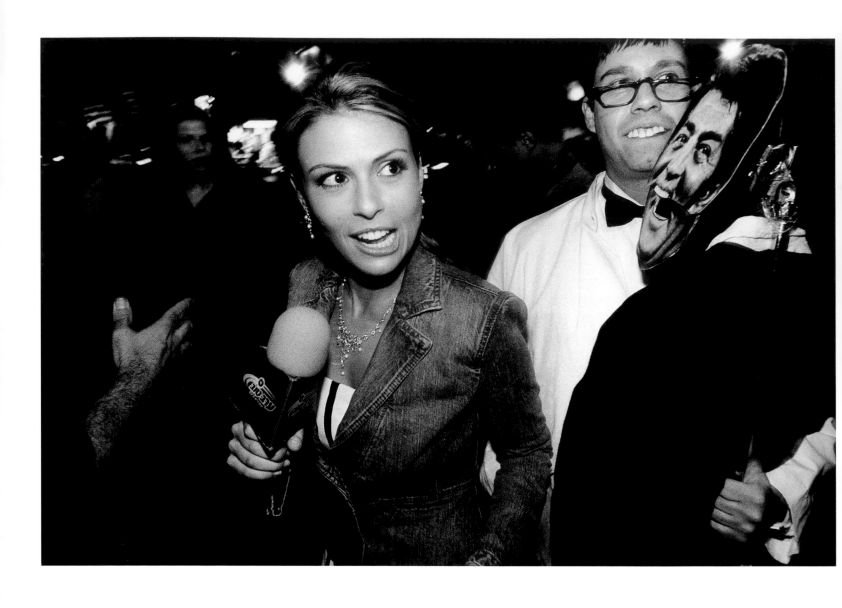

"Jerry Lewis and Dean Martin" interrupts an Israeli TV broadcast at the Reel lookalike awards, Hollywood

(Previous page) "It" girl Lady Victoria Hervey and horse, London

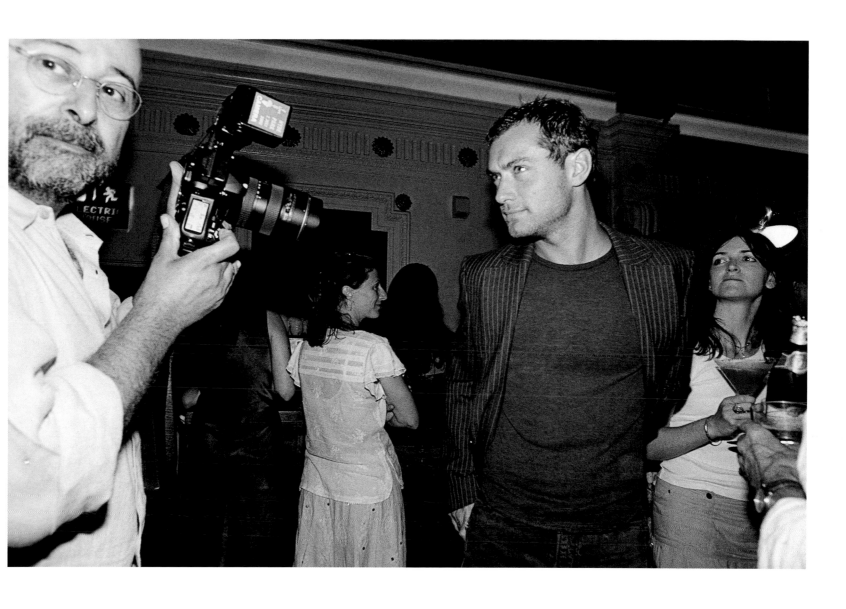

Richard Young and Jude Law, London

RICHARD YOUNG

SHOOTING STARS

In 1974, at the beginning of my career, one of my earliest "scoops" came when I gatecrashed a party Elizabeth Taylor was hosting for Richard Burton's 50th birthday at the Dorchester hotel in London. My pictures were a huge success, published all over the world, and it was the most exciting thing that had ever happened to me. I was thrilled to have captured forever on film the most famous and glamorous couple in the world.

Back in the seventies there was no doubt about who was or was not a star. From London to Los Angeles, Paris to Tokyo, the same celebrities made the press. Hollywood was the hub, and when a big movie star came to town there was always an enormous buzz. Nowadays we seem to have gone celebrity crazy. There's layer upon layer of celebrities from "A"- to "Z"-list. There is much I don't understand about what makes a star or what keeps someone in the limelight, but I know it's not necessarily about looks or even talent. It's very elusive. Occasionally someone new appears on the scene and you just know they are going to be around for a long time, but equally there are those who receive an enormous amount of media attention who you know will be gone in a flash. My job is to snap them for as long as they are in the news.

These days the stars themselves have so much control over what we do. The publicist, the managers, the teams of hair and make-up artists, all work together to create the perfect image for their client. Picture approval and computer technology mean the slightest imperfection is removed. I always try to capture the real person as far as I can. I don't want people to look ugly or compromised, but I want them to look truly like themselves, not like an airbrushed model. It can be quite deflating covering film premieres these days. Everyone looks the same: perfect teeth, toned bodies, and varying degrees of plastic surgery.

Although I can be nostalgic for the "good old days", there are still some real stars out there, with amazing presence. The great "A"-list stars stand head and shoulders above the rest. When someone like Robert de Niro, Tom Cruise or Madonna is in town there is always a very special atmosphere, and it is still as much of a thrill for me to photograph them as it was to photograph the King and Queen of Hollywood all those years ago.

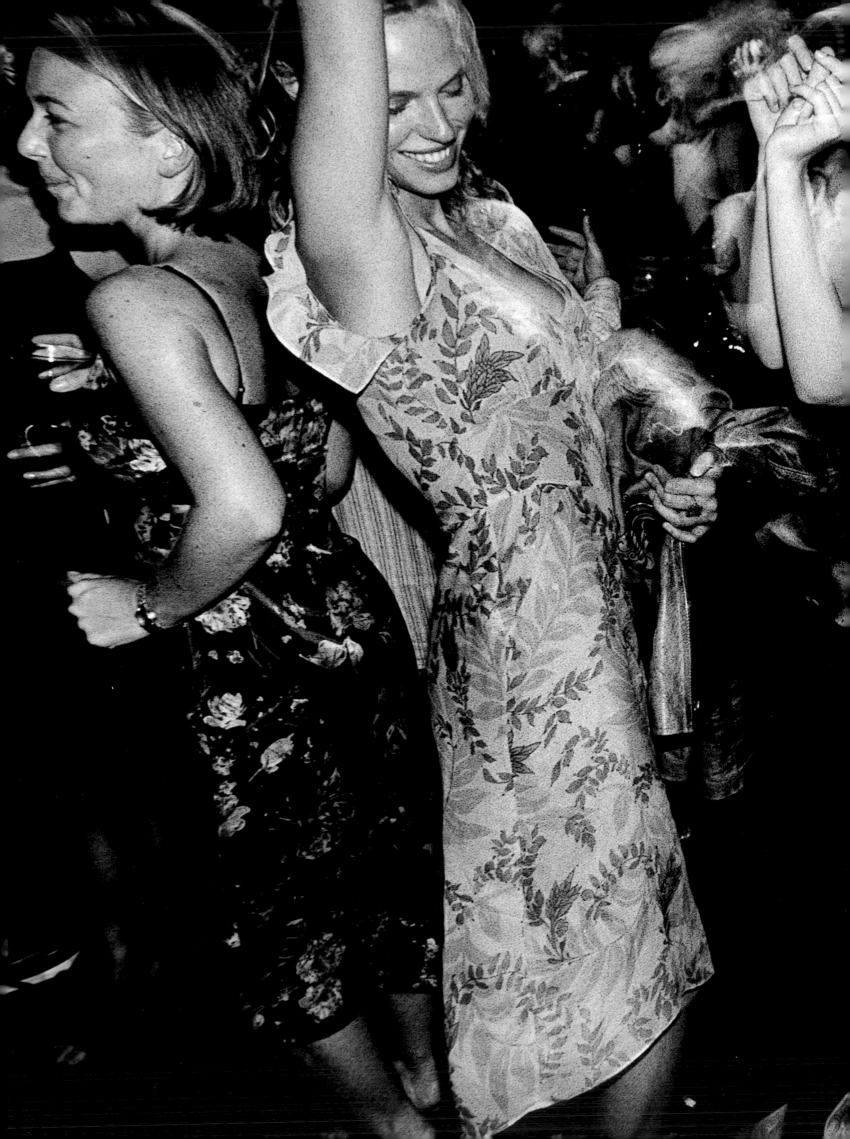

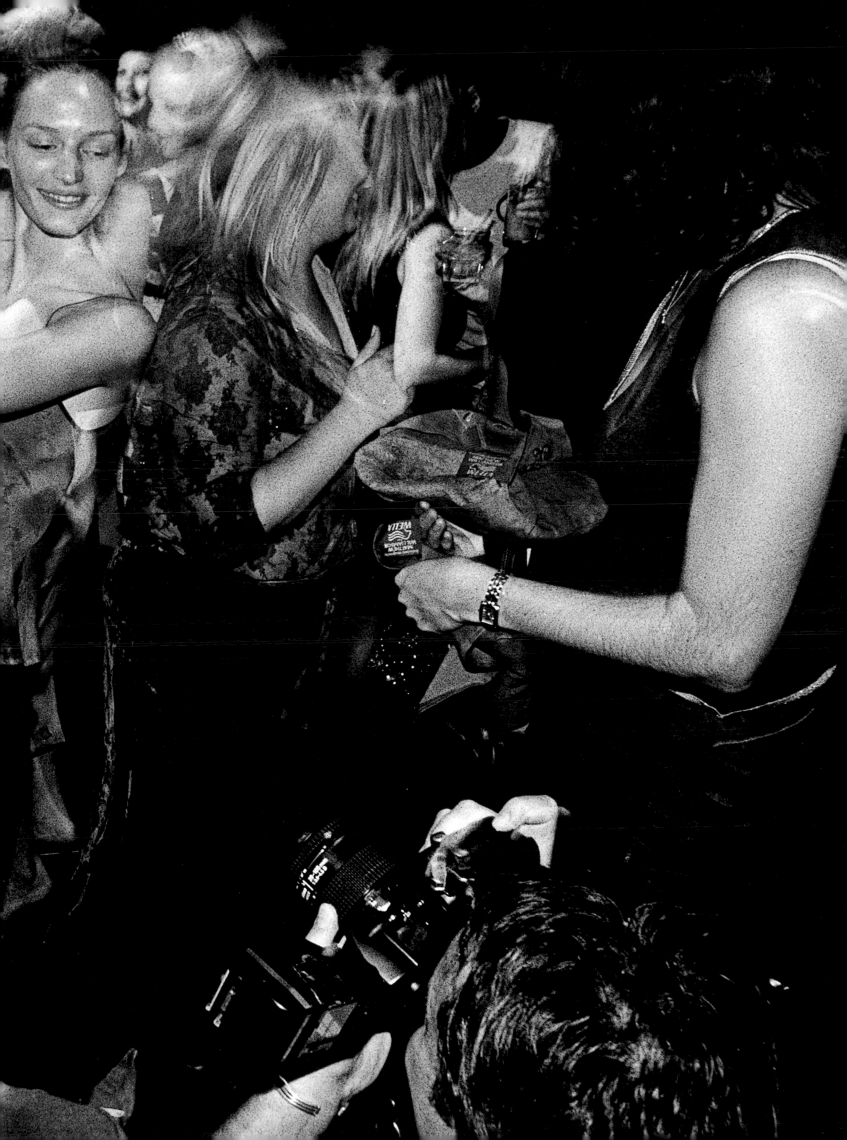

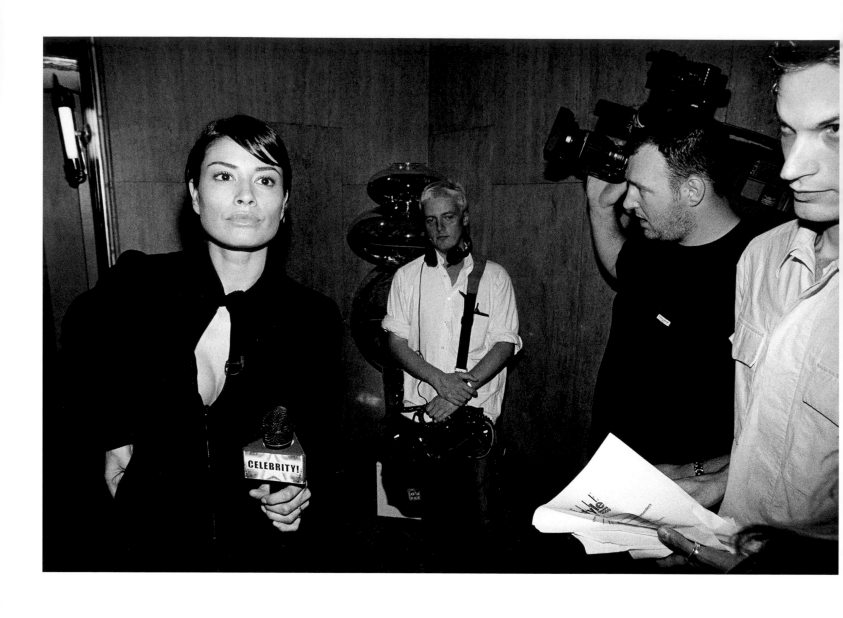

TV presenter Melanie Sykes looks for her next interviewee, London
(Previous page) "How do you want me?", London

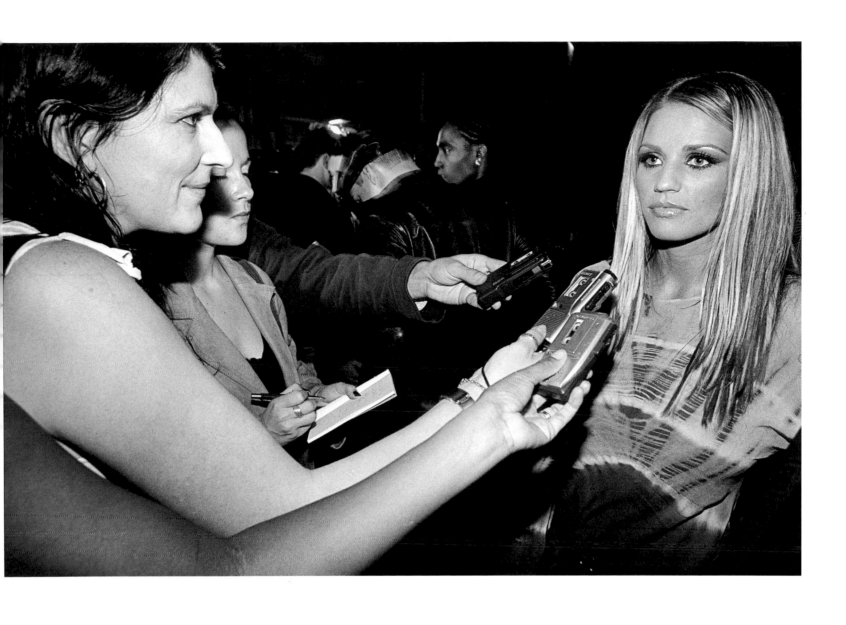

Glamour model Jordan speaks to the press, London

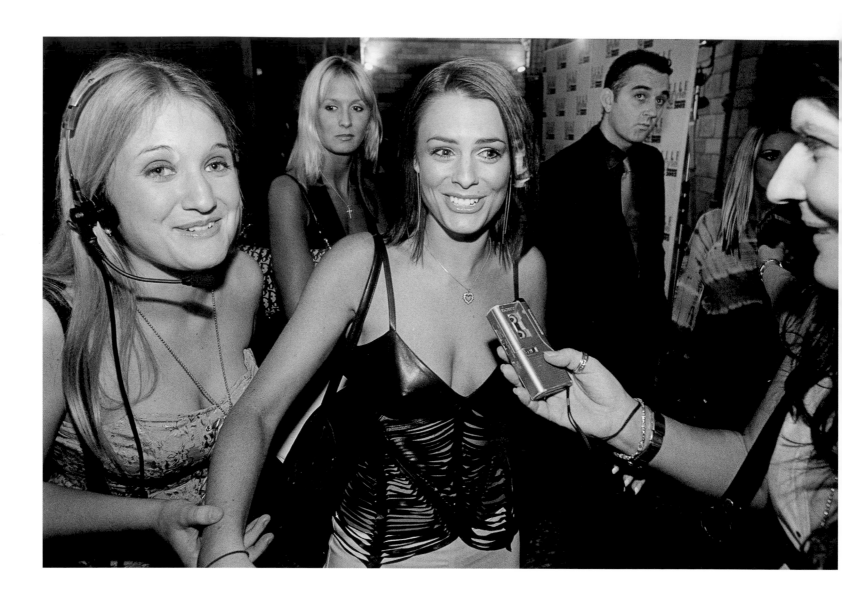

Starlet Susie Amy is paraded to the press by an awards party PR, London

Chloë Bailey, childhood friend Jodie Kidd and Jasmine Guinness at a fashion show, London

CHLOË BAILEY

LOOK BEFORE YOU LEAP

It's a funny thing, you don't even know it's happening until it's almost over. It goes as quickly as it comes. Sometimes you can put your all in and get fuck-all out. Not my time or turn, that's how I view it when the negative stuff happens. No time to dwell. Pick yourself up and crack on. Even if it is all an act, which of course it is.

Fame doesn't make a difference to who you are as an individual, but people's perceptions do. And that's the way it goes. Some thrive on it, some detach themselves from it and others simply revel in it. You get what you're given in life, it's how you use this tool that makes or breaks you.

My aim is to be successful, not famous. To do a good job of anything I turn my hand to. The nature of the work brings fame, but that's not the point. I spend my life doing a job I love. Fame is not an issue or important in any way, it's just part of the package.

When I did my first acting job I really didn't know what to expect. I was flown to Spain to film a show called *Is Harry On The Boat?* I arrived to meet the producer and pick up my script, and it was only then that I had any inkling of what I had got myself into. My opening scene was a raunchy encounter with a beautiful young man called Ben. I'd seen him on a popular show in the UK for years and just couldn't believe my eyes when I saw it was him. The scene really didn't require that much acting.

The rest of my scenes were all talking scenes. When we rehearsed, the producer asked me to deliver my lines with a cockney accent. I agreed, and then asked about the title of the show. "So, *'Is Harry on the Boat?'*, what's that all about?" He laughed and replied, "It's rhyming slang. Harry Monk: spunk. Boat race: face. 'Is there spunk on my face?'" I felt sick for about five minutes, then decided to walk off the set and change my agent. That's how quickly things happen in this industry.

Fashion designer Jasper Conran with Naomi Campbell and her mother Valerie, London

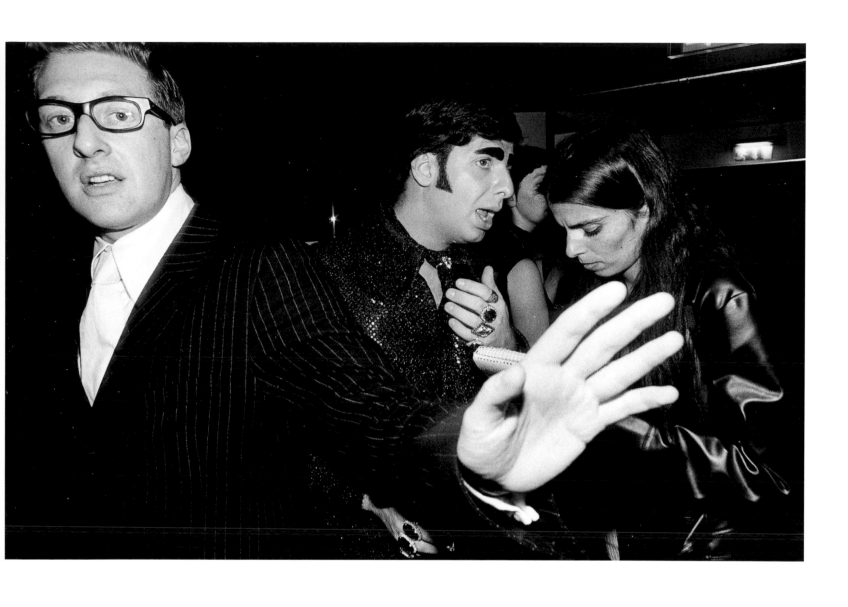

A publicist tries to prevent "king of cabaret" Lenny Beige (Steve Furst) from being photographed, London

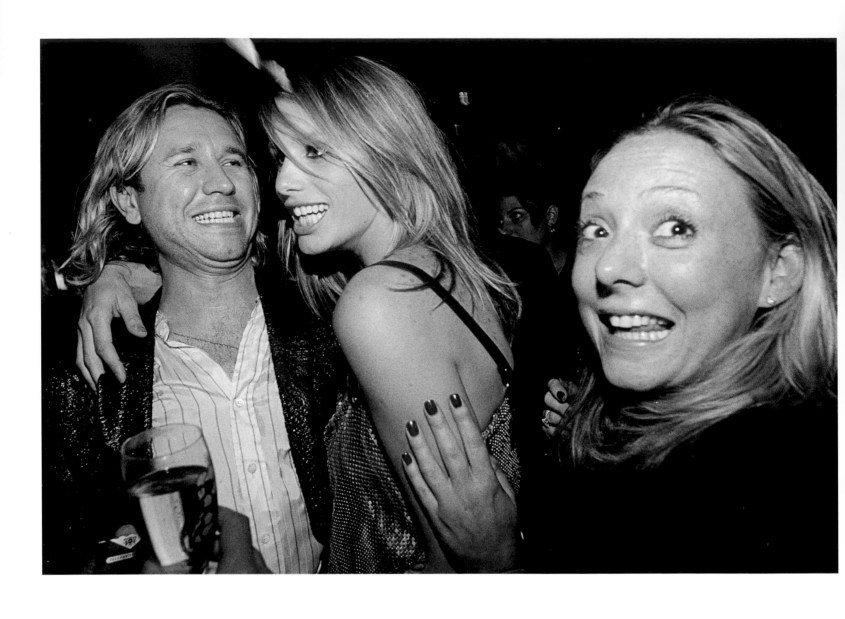

Supermodel Georgina Cooper and company, London

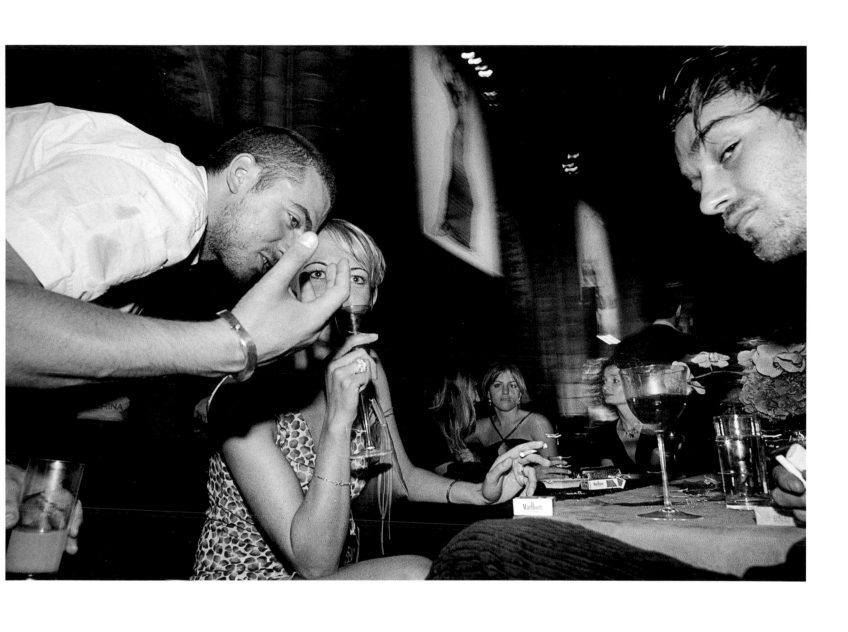

"Celebrity guests" at a London awards ceremony

(Overleaf) Sophie Dahl, Jean-Paul Gaultier, Naomi Campbell and Duane Ashurst at the first *Elle* Style Awards, London

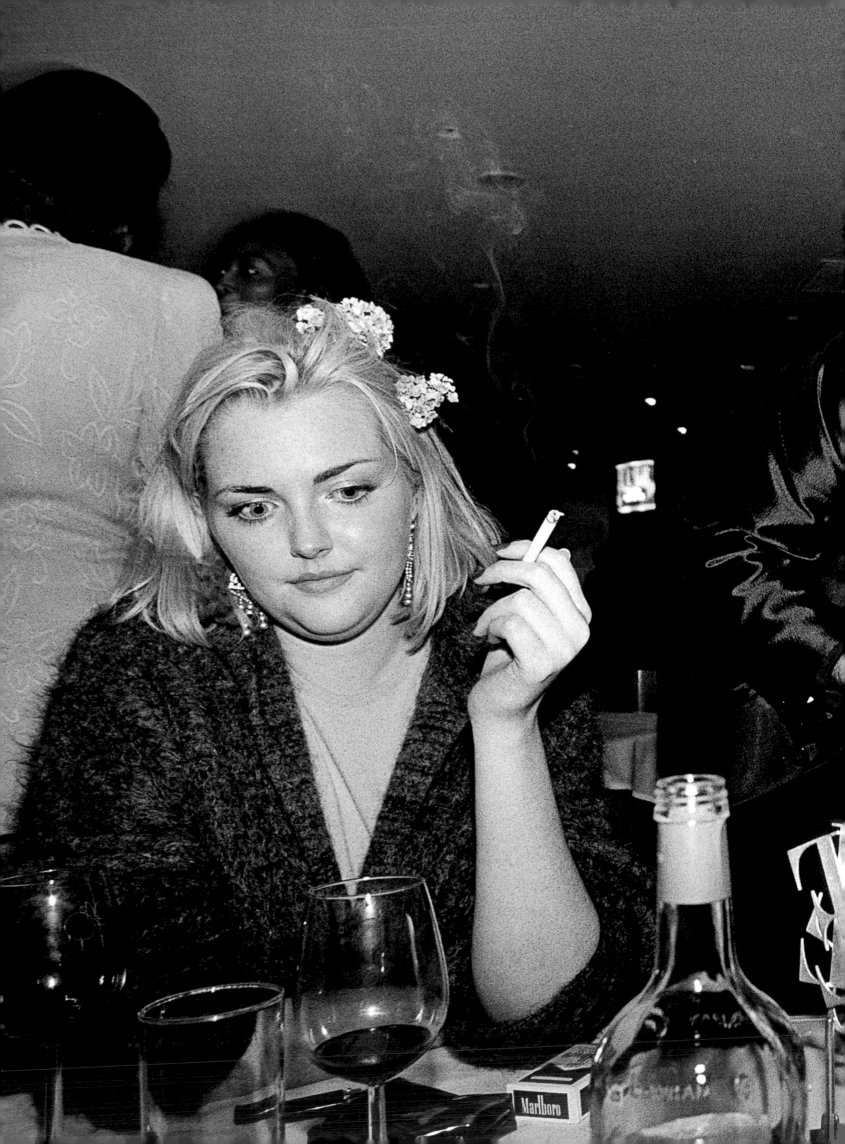

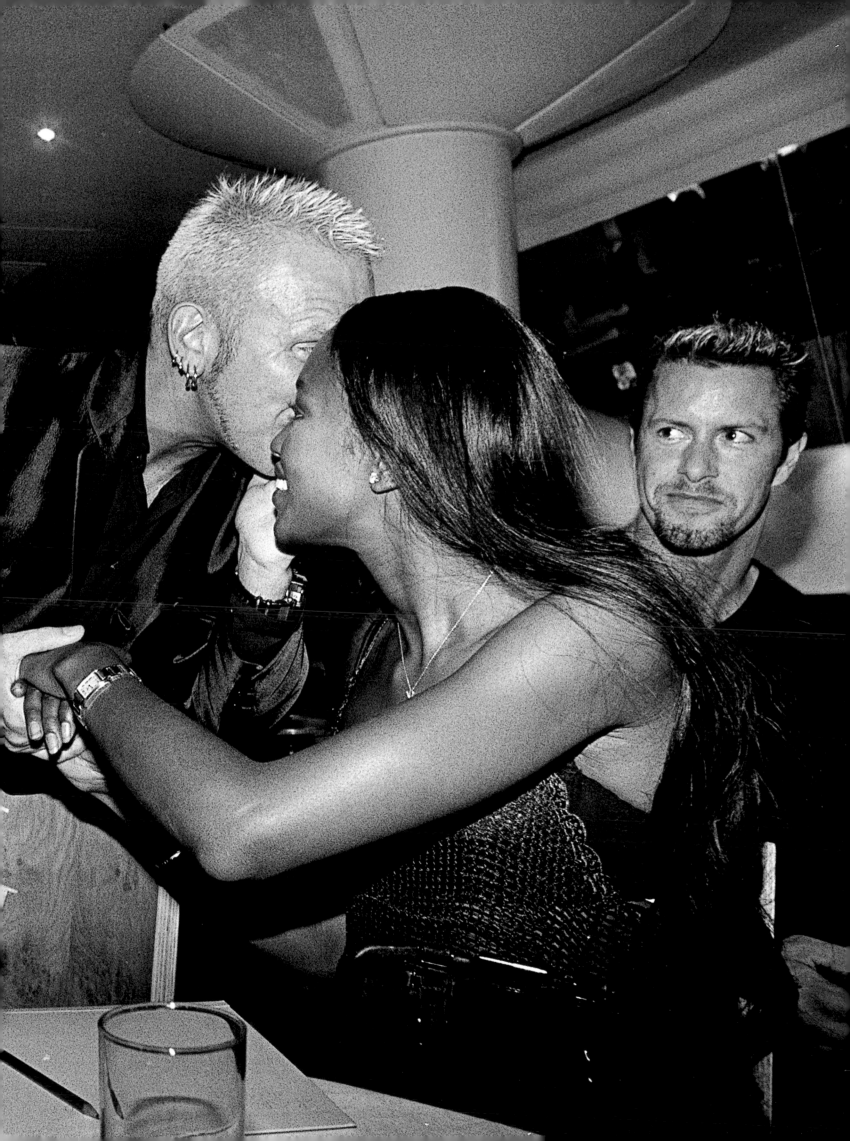

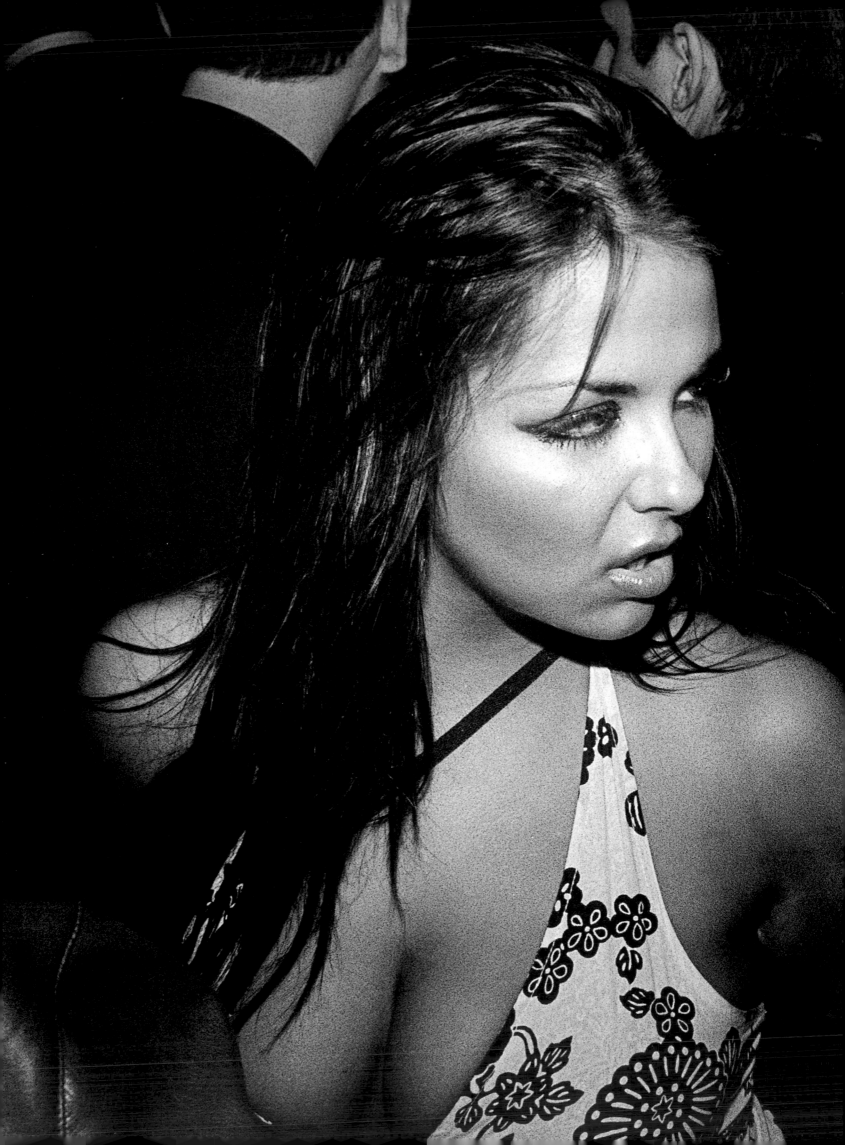

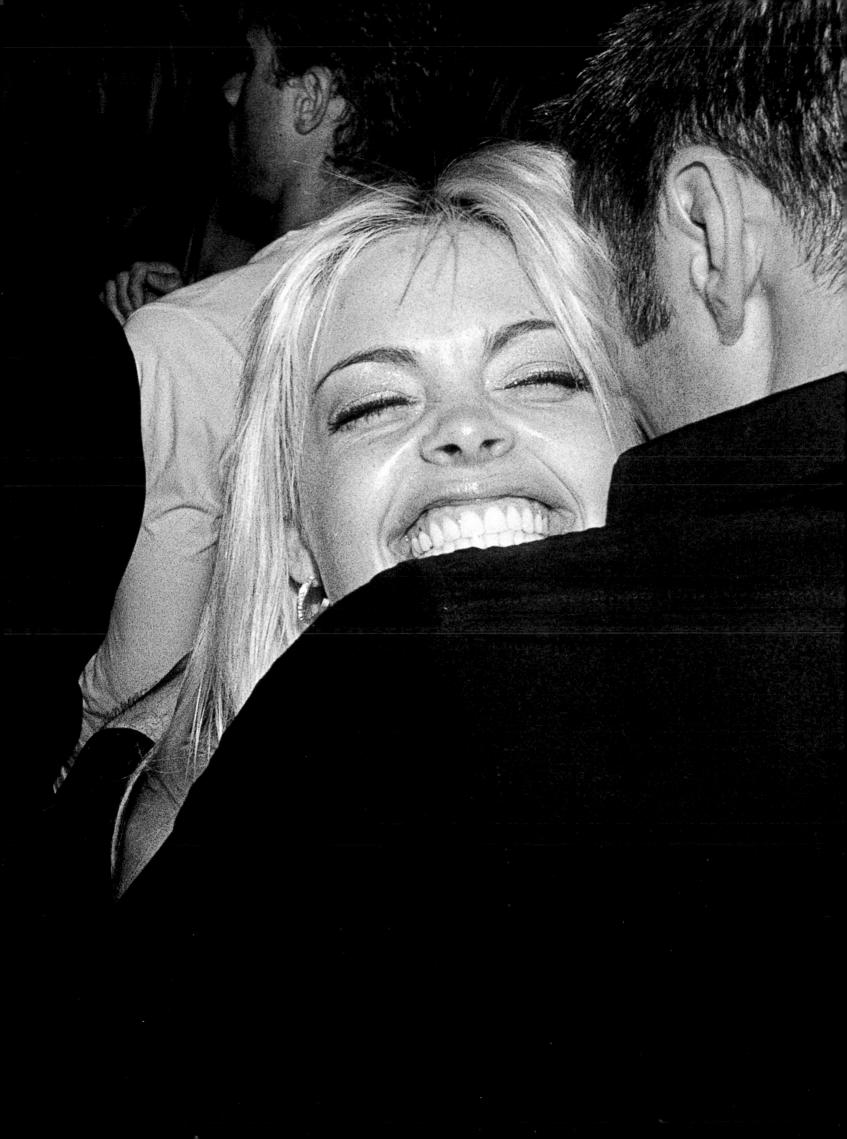

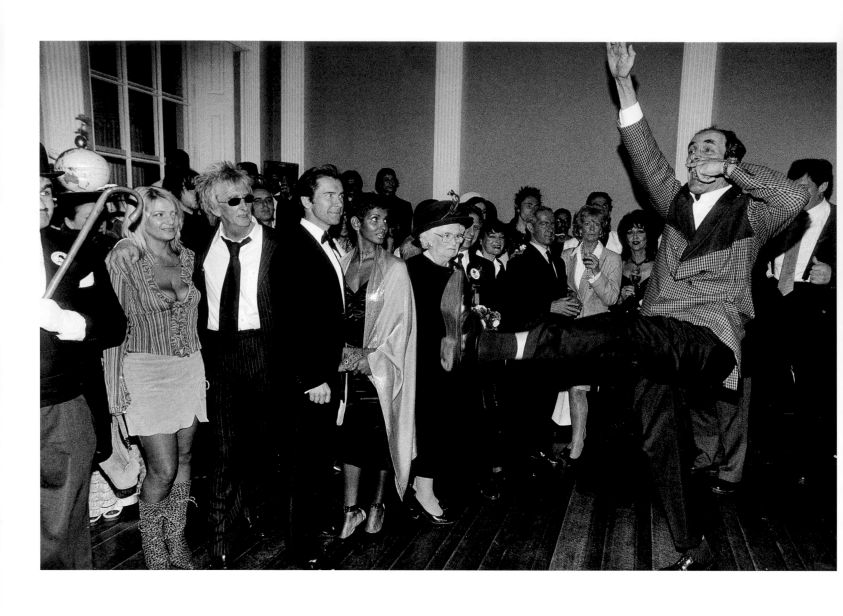

Lookalike convention, Institute of Contemporary Arts, London

(Previous page) US porn star Jesse Jane is embraced by an admirer at Prince Albert's *Rouge et Blanc* ball, Cannes

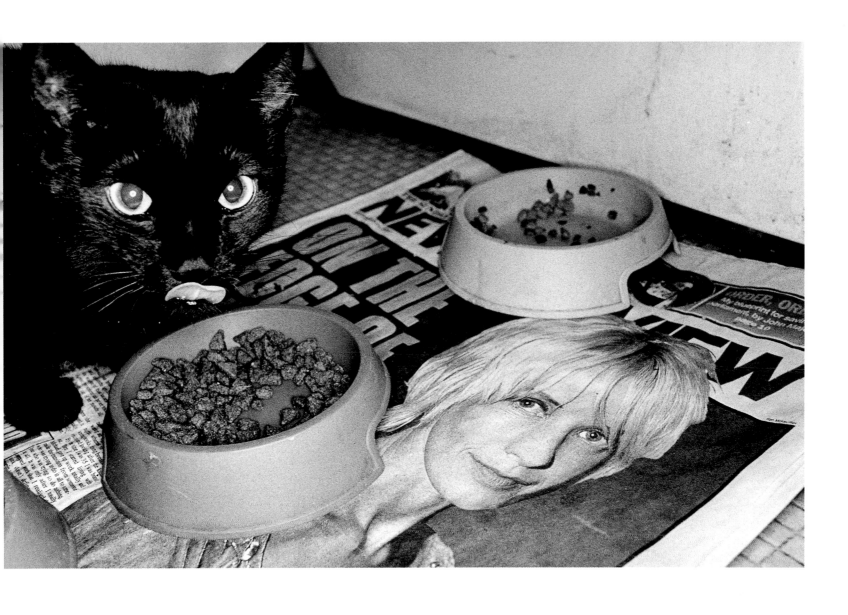

Yesterday's newspapers under the cat food, London

(Overleaf) Heather Stewart-Whyte, Paris

HEATHER STEWART-WHYTE

LOST INNOCENCE

She had it all. Good health, loving family, and a dream home she'd worked so hard for. Smothered with camera flashes, working with the best, from Yves Saint Laurent, Gucci, Victoria's Secret, to Ralph Lauren. Constantly in the public eye, she saw only good in people. Little did she know that her fame and fortune would attract the most dangerous of parasites.

Sucked into darkness, a mother torn from her children. Left to suffer her worst nightmares. Not just a cry of pain, but a deep and eerie howl of suffering came from within her. Not knowing if she would hear her children's voices, look into their beautiful eyes or ever hold them again.

Not able to reach out for help, knowing that he would be happy to carry out his murderous threats.

No longer free, a hostage to his cruel games, she watched her life so lovingly built raped of its very existence. Forced to play a role to stay alive, with an eternal faith that one day she could give her children their mother back.

Her faith was the only thing he could not steal. Her prayers were her lifeline, God's help was on its way. The wounds are healing.

Redemption came.

The years that the locusts have taken shall be restored.

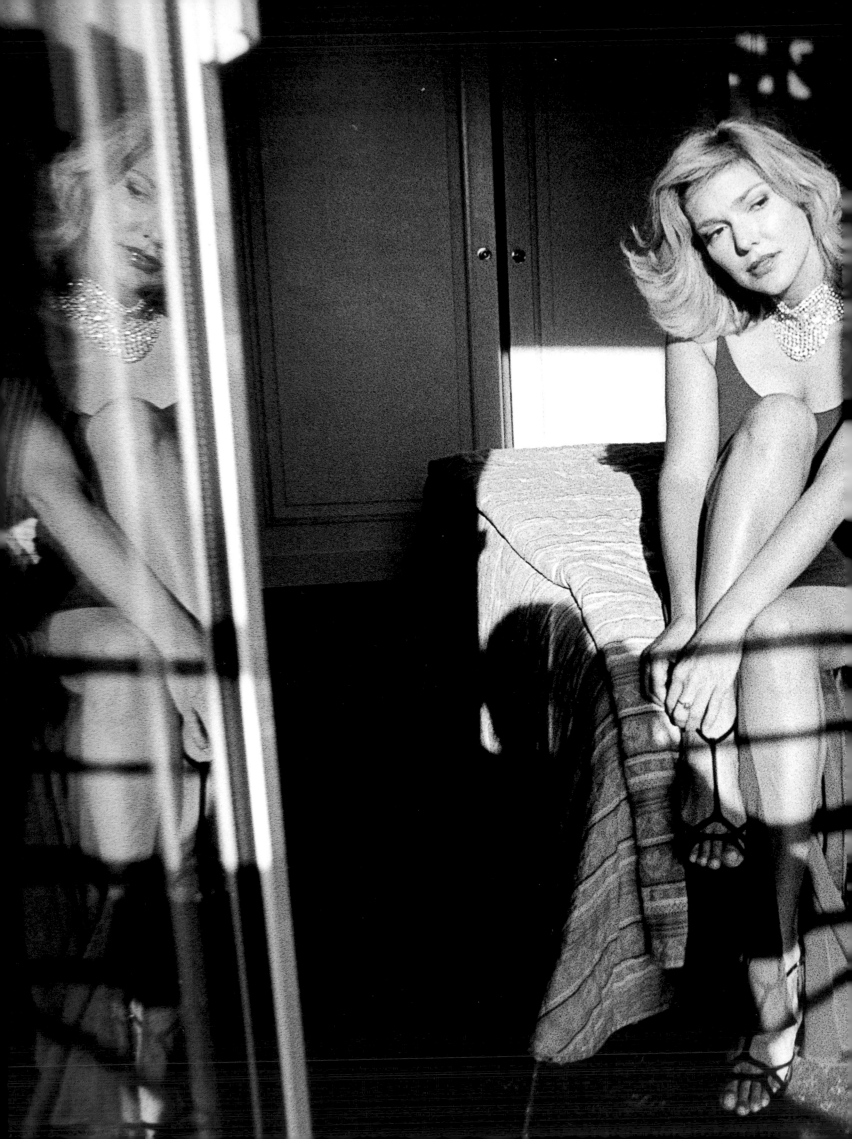

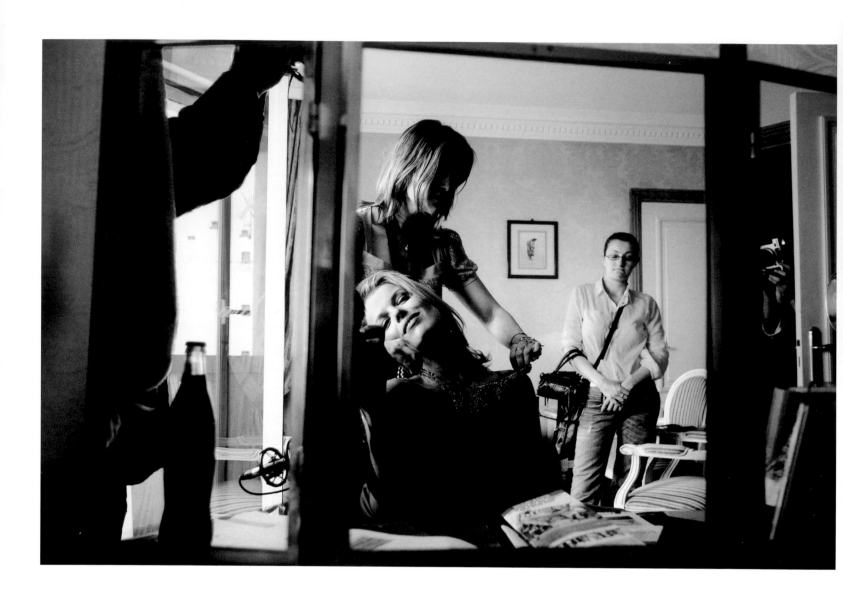

Supermodel Eva Herzigova chooses jewellery in the Chopard suite at the Hotel Martinez, Cannes
(Previous page) Actress Laura Harring prepares for her film premiere in a suite at the Hotel Majestic, Cannes

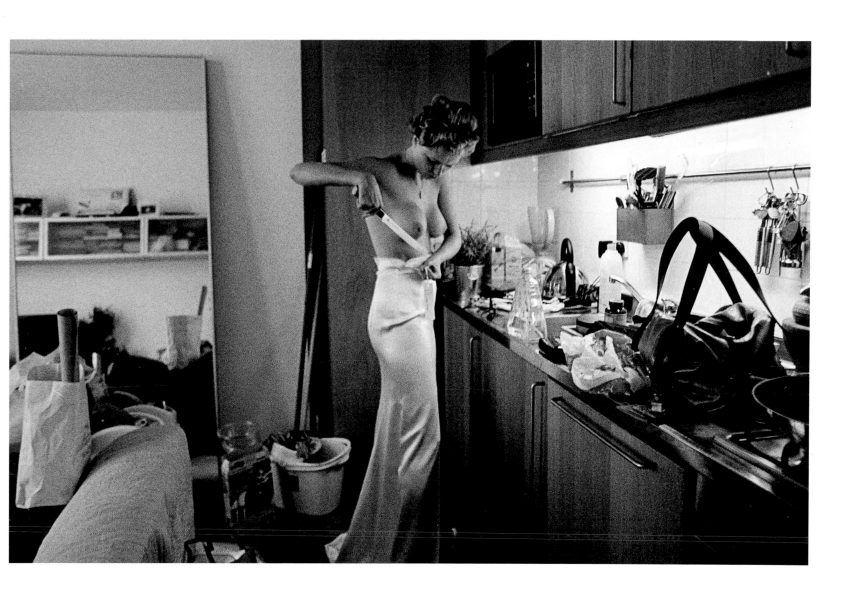

Anouska de Georgiou customises her party dress before Sir Elton John's summer party, London
(Overleaf) Lisa Voice and companions, Grand Hôtel du Cap, Cap d'Antibes

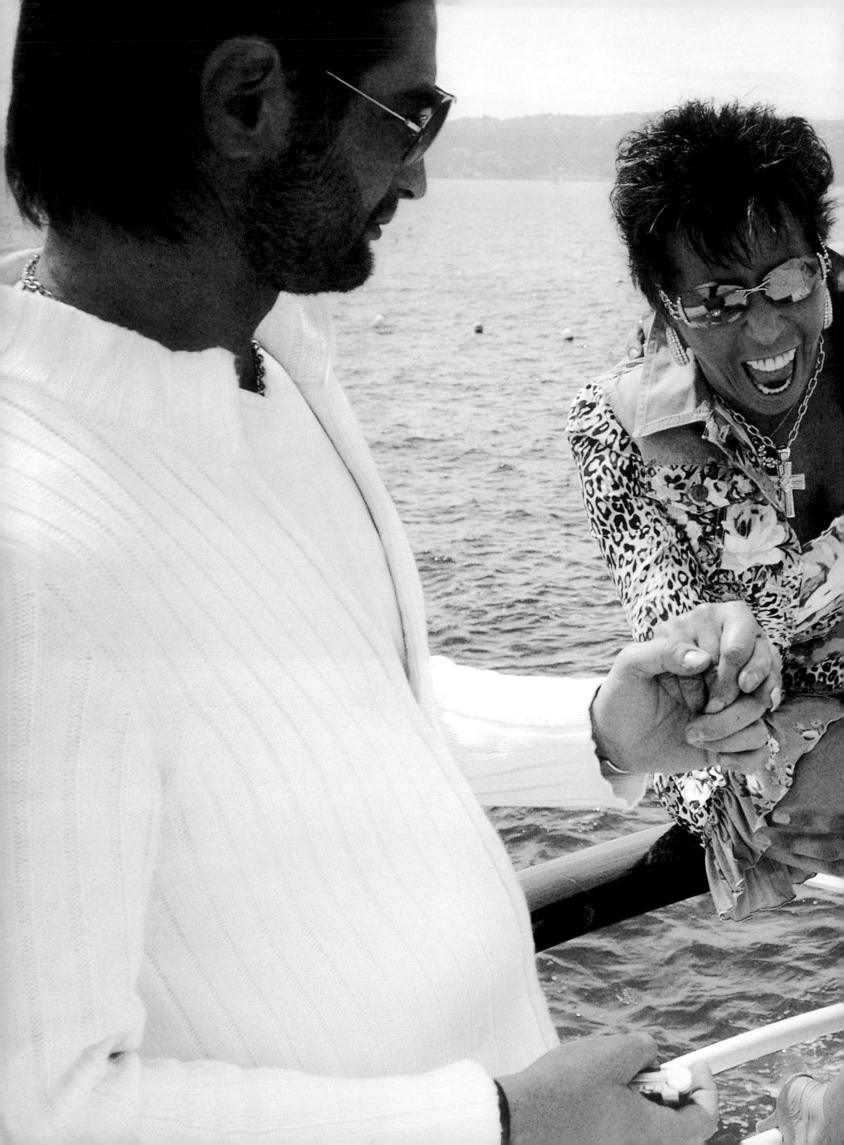

LISA VOICE

ROCK 'N' ROLL SURVIVOR

I first met Billy Fury in 1972 and we were together until the day he died in January 1983 at the age of 42 – same as Presley – from a heart condition. He'd already had two open heart surgeries and was due for a third. He'd had rheumatic fever as a child from standing in doorways to dry off from the rain, because he knew his father would beat him if he went home wet. He was often unable to work because of the illness; he'd only started working again towards the end. In Bill Kenwright's show, *The Billy Fury Story*, I was portrayed as an archetypal Jew with a black wig who never opened her mouth. There was an article in the *Jewish Chronicle*: "Where Is She Now?" Well, I've never been lost, I'm still here! So I called the journalist and he told me that when he went to the opening night he couldn't understand why an icon like Billy would be living with a woman like that. He'd spoken to Kenwright at the interval, who'd said, "Don't worry, the second half gets better. He dies and she cops the lot!" The truth was, Billy was bankrupt and I looked after him. I paid all the bills and everything.

There's a lot of bitterness, a lot of envy in this business, there always has been. Always with the men I've been with. My ex-husband tried to kill me many times. I've had a bullet through the back window of a taxi after I left a lunch at the Ivy, I've had a gun to my head. And just recently I was violently attacked. The police had never seen such a violent attack with bare hands. The charge is attempted murder. My jaw was broken, he cracked my skull, and broke my nose – I've got to have two bone grafts in my nose. There's two titanium plates holding my face together, I'm like the Bionic Woman! So I survived that and I don't know how.

Just before he died, the last time I ever saw him, my ex-husband was begging for me to come back with him, but I wasn't going to make that mistake again. He'd had me wired up, I had eight cameras in my bedroom, my car had been wired up with microphones. I never went anywhere, I just lay on my bed every night looking at the ceiling, thinking, "Will I ever get out of this hell?" People ask why did I stay so long, and the reason is the children. When he agreed to leave, I wrote the cheque with a big smile on my face – I was free. My children are and will always be priceless to me. I was always the breadwinner, paying the bills. But he wouldn't let me go out. That's why it's just great walking out now. Because I've been through a life of hell, living hell. Billy was an alcoholic, Steve was a cocaine addict, so I've had both. It just happens. They never fought me in the beginning, but it never ends up that way, they all change, become obsessional, and the hate and everything. It's horrible. I'm just happy that I've got my kids and I can have my friends, and I've got my own life. For the first time in my life I have a life.

I've had more lives than a cat, really. After this last attack I was in intensive care for five days, and everyone was amazed that I lived. But I'm here. I'm still here. Of course I'm not a giver-upper, no way. I've had nothing. I've lived on bare floorboards, no heating, on thirty quid a week, when people thought I had millions, you know? I worked all my life. I left school at fifteen and my Dad said, "You're in work tomorrow. You're not laying in bed all day." I enjoy my work. I don't care. I work day and night. My sense of humour has helped me through the bad times. I'll look at something and I find it so funny I can just laugh and laugh. People think I'm eccentric, but actually I'm not. I just love music and I love people, and if I find something funny, my laugh seems to be contagious. People laugh around me, and others wonder what's going on that's so funny on the other side of the room. Whatever happens, you've got to love life. Take what life throws at you and never give up. At the end of the day, it's only rock 'n' roll.

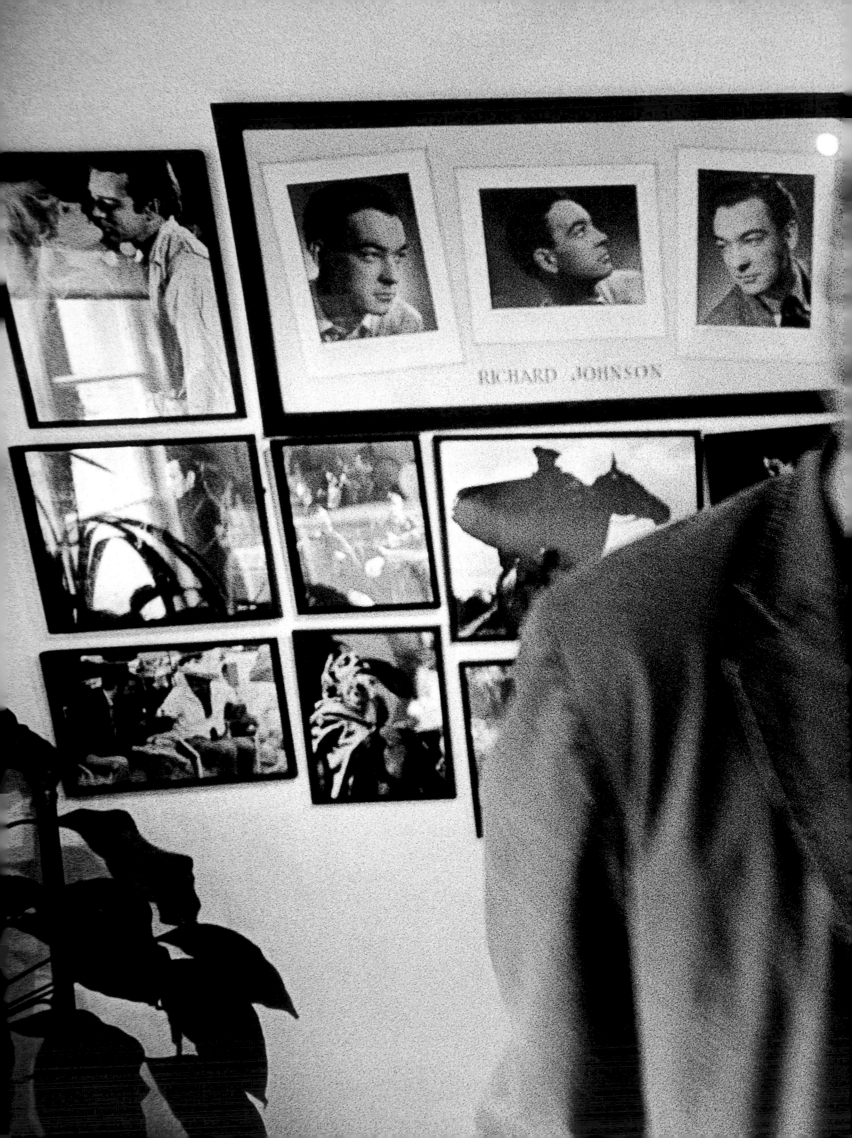

RICHARD JOHNSON

RICHARD JOHNSON

WHO IS RICHARD JOHNSON?

The ticketer at the BA desk looked up at me after he'd studied the Movement Order issued by Scottish Television. "Didn't you used to be the young Richard Johnson?" he enquired. The white-haired gent before him with the bald spot and the lines that nearly eighty winters had etched into his face was categorically the old Richard Johnson. A shred of celebrity still clinging like a peeling snakeskin, long after the tabloids had left the pitches where they once waited outside the Ivy. Or, rather, they no longer waited for me there. Curiously, I missed them for a while – they were a reassuring part of my life for so long. That great doyen of the paparazzi, Richard Young, has been standing outside restaurants or on doorsteps in all kinds of weather for so long that many of his subjects (victims?) have come to like and trust him, some of them (the ones who thought they needed the publicity, perhaps) even inviting him to their weddings or their parties. By now his archives are so valuable, one suspects he's considerably richer than most of the people he's photographed. Ironically, he's become famous by photographing celebrities.

I always used to be rather pleased, when coming out of the stage door after playing a leading role, that the autograph hunters didn't recognise me. It seemed to prove that I must have inhabited my role so well that I could still retain my anonymity. Perhaps there's the difference between fame and celebrity: the famous person does something well enough for his name to become known to the public, whilst the celebrity gets his photo published in the tabloids frequently enough to be recognised. It always seemed to me that one of the few real advantages of fame (apart from the money) was that well-informed head waiters made sure that you got a table in their restaurants (and if you were Graham Greene nobody knew your face, so they didn't gawp).

When I was married to Kim Novak, she was so easily recognisable that people, I used to think, could identify her from the back. She'd probably have been recognisable in Shanghai or Timbuktu; such is the power of the movies (American ones, anyway). She took to wearing a wig and sunglasses when out and about. Now in her seventies she doesn't care that people have stopped staring, she never enjoyed the hoo-hah anyway. She's still famous, but no longer a celebrity.

Celebrity doesn't last.

I have a cautionary tale for celebrity readers. It's a Hollywood story called "The 5 Ages of an Actor's Life" and it goes like this (the speaker is a Producer):

1. "Who is Richard Johnson?"
2. "Get me Richard Johnson!"
3. "Get me a Richard Johnson lookalike."
4. "Get me a young Richard Johnson."
5. "Who is Richard Johnson?"

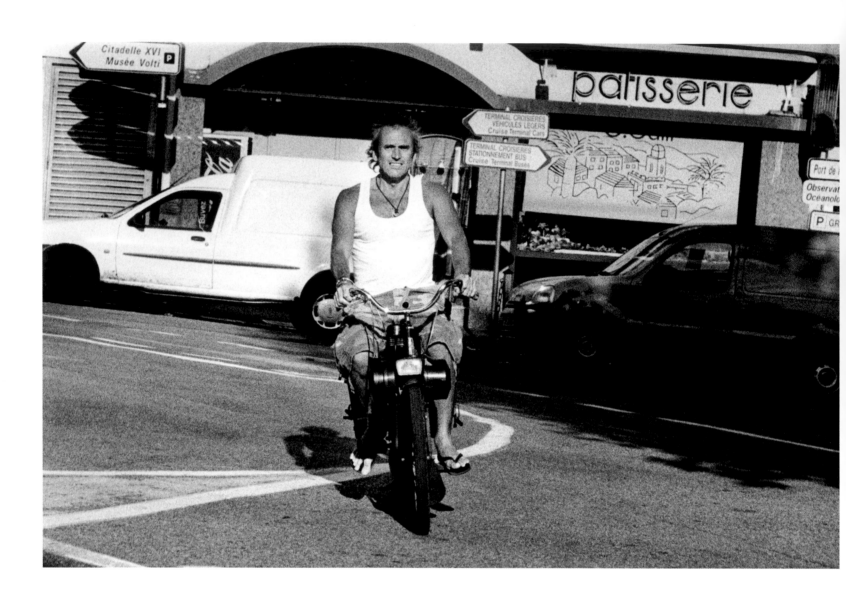

Tim Fountain evades the traffic in Villefranche

(Page 142) Richard Johnson among his old film stills, Kensington

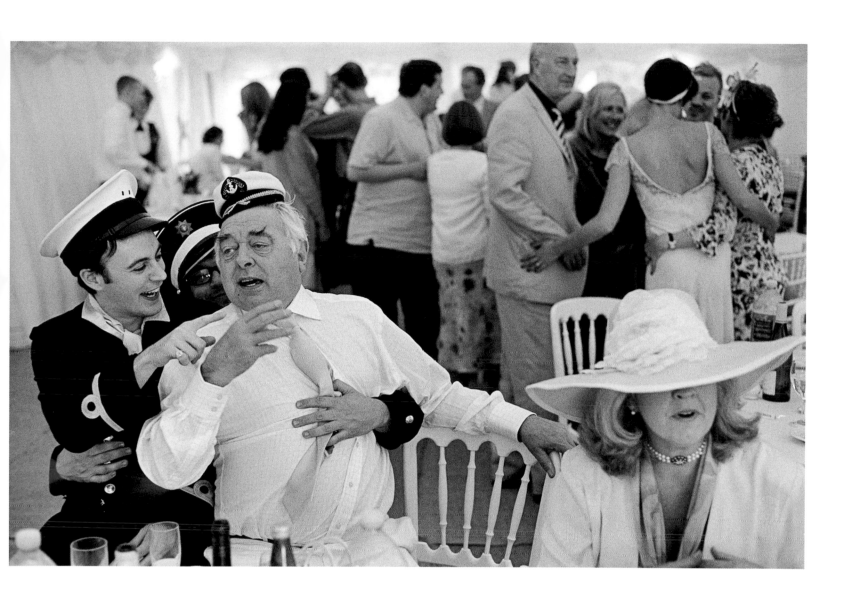

The late David Hemmings performs for guests at his son's wedding, Henley-on-Thames

TIM FOUNTAIN

LOOK AT ME!

As a child fame was all I wanted. The images of Burton and Taylor, Starsky and Hutch, Elvis and Priscilla were burned indelibly on my psyche. The stories of the errant Yorkshire pools winner Vivien Nicholson captivated me. The fast cars, the smashed tellies, the drunken fights. Theirs was the life more lived. An existence in the fast lane, with none of the long black-and-white movie-infected Sunday afternoons that characterised my childhood. I wanted a piece of the action too.

I'd rehearse for when my time came. Conducting interviews with myself on ficticious TV channels, walking round my village commenting on the weather or the decorations on people's Christmas trees as if people were listening. I'd arrange *It's A Knockout*-type events with my Matchbox cars in which I was always the winner. I taught my pet goat to breakfast with the family in order to make the front page of the local paper. I commentated on the local radio-control car club races held behind my parents' pub. I played the lead in the musical *Grease!* at sixth form college even though I was tone deaf. Anything to be at the centre of the action. To have the spotlight turned on me. At university a fellow student shouted across the refectory, "Why don't you get a fucking private life?" I didn't want one. If a thing was worth doing, it was worth doing in public.

When I left university I went into showbusiness. I became a playwright. I wrote plays about famous people. The composer Tchaikovsky, the eccentric Quentin Crisp, the columnist Julie Burchill. I escaped my background. I toured the world with my shows. I bought a flat in Notting Hill. But still I wanted more. As Quentin Crisp said, "If I showed you a great lump of stone with a hole in everyone would say 'Oh it's a Henry Moore' but if I showed you Henry Moore himself no-one would know who he was". I decided I would go on stage. I created a one-man show for myself. A show in which I talked about my sex life and the thousands of men I'd had sex with, a show that exploited my lack of a private life. During the performance I sought sexual partners on the internet and the audience decided who I should sleep with. The following night I reported back on my encounter. The show became "the *succès de scandale* of the Edinburgh Fringe", it transferred to The Royal Court Theatre in Sloane Square. There on the same hoardings where Sir Laurence Olivier and Sir John Gielgud's names had been in lights was mine. A listener to Radio Five Live demanded I be "burned at the stake". The *Guardian* said my show made *Big Brother* look like Wittgenstein's *Tractacus*. The *Daily Mail* ran a full page: "Curtain Up on Depravity". Scotland Yard threatened me with prosecution after I led the audience into Sloane Square and stripped naked with a man who described himself as a "shy exhibitionist". Taki described me as "a freak-cum-pervert poofter" in the *Spectator*. My Aunty rang my Mother and said, "I didn't realise your Tim was gay". I was recognised on tube trains. In gay bars the boys whispered about me. I was ushered to the front of queues in nightclubs. But still I wanted more. Fame I realised was not a station you arrived at but a means of travelling. But this was the life I always saw for myself, the life I always wanted. As Julie Burchill remarked in my play, "fame is a mask that eats the face and that's how it's been for me, but in a good way".

I'm currently living in Villefranche in the south of France, in a tiny gatehouse overlooking the harbour. I ride around on my 1946 Solex cycle, and the closest I get to being recognised is when the baker calls me "Monsieur Solex" and the kids shout "Grandpère!" and make gestures which look dangerously close to wanking. It's a very different life to London (although I do have a pair of high-powered binoculars to check when the US Navy come into the harbour, which seems to happen quite often). But here there's no parties, no opening nights, just sunny days, fresh air, work – and I love it. I sometimes wonder if I'm going to end up becoming "a shit in a shuttered château", as the poet Philip Larkin described English authors who ran off to France, but I suspect it won't be long before the bright lights draw me back. After all, as somebody French once said, "a man may change the sky above his head but he cannot change what is in his soul".

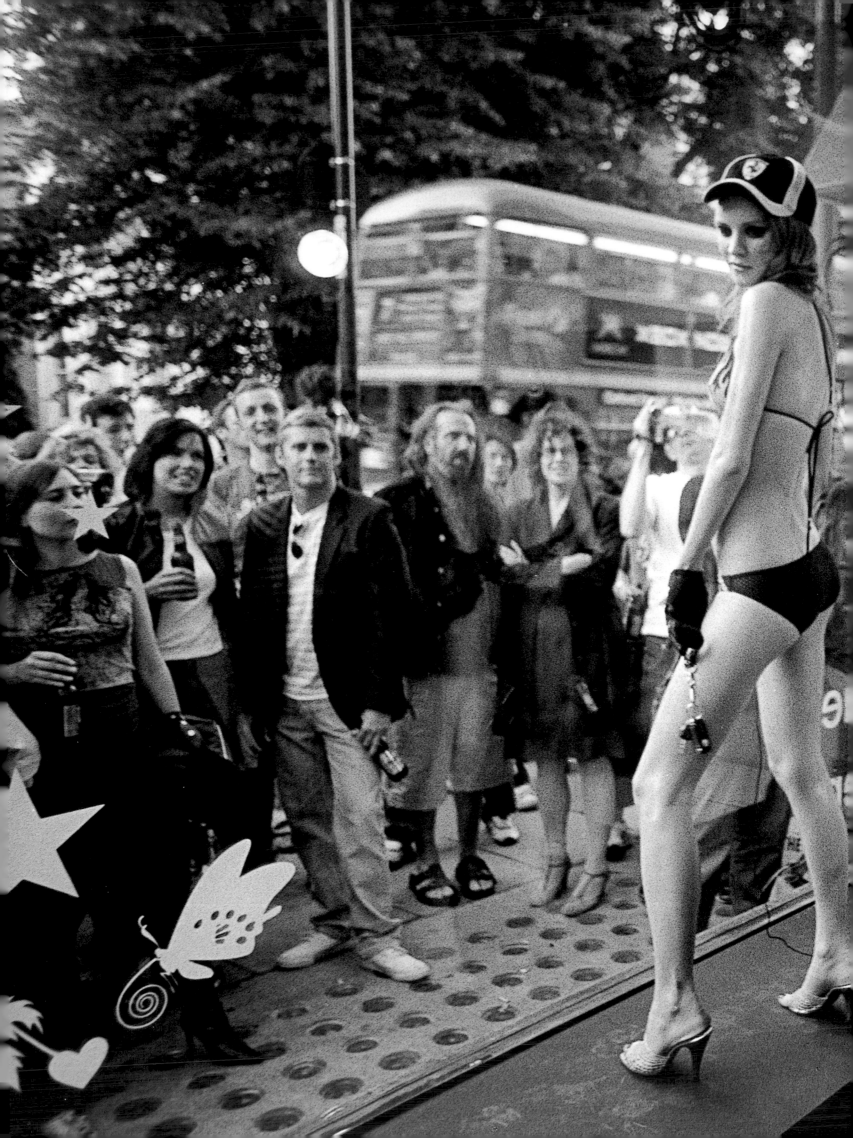

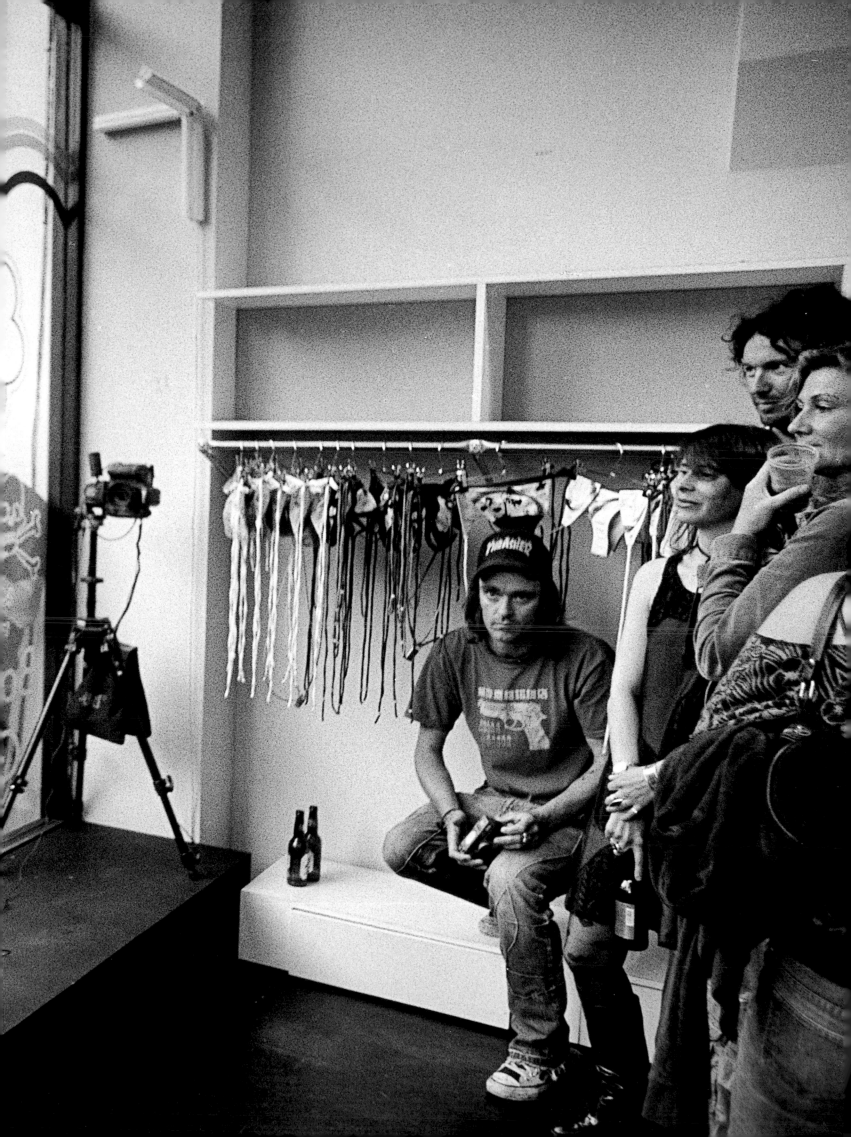

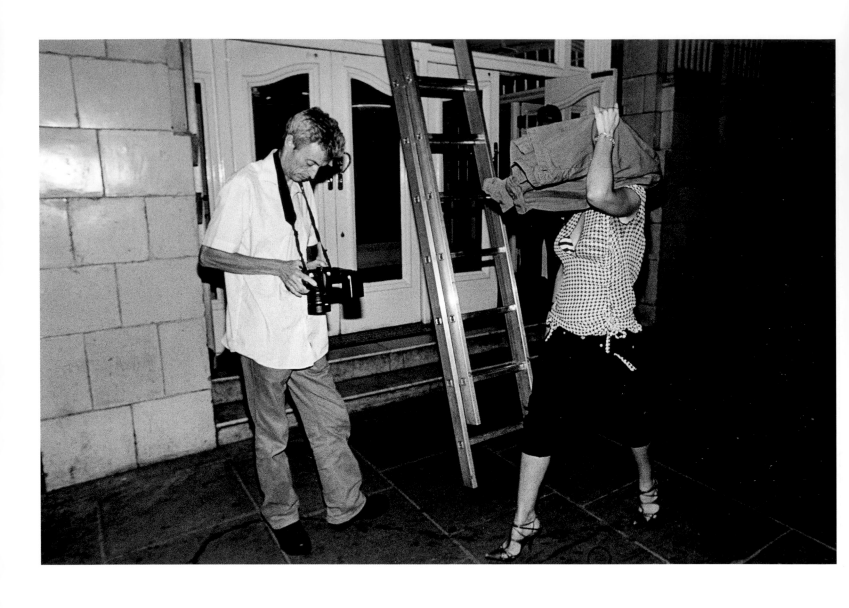

A paparazzo checks his images while a potential victim escapes his lens, London

(Previous page) Swimwear launch, London

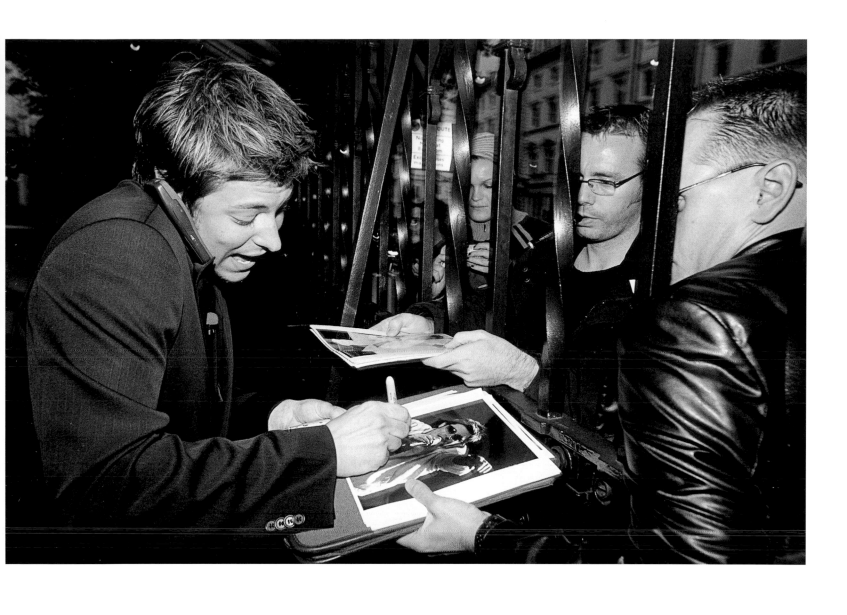

Pop star Duncan James dutifully signs publicity snaps, London

(Overleaf) Paparazzi leap on Jude Law's car to steal a picture, London

Victoria Beckham arrives at a party, London

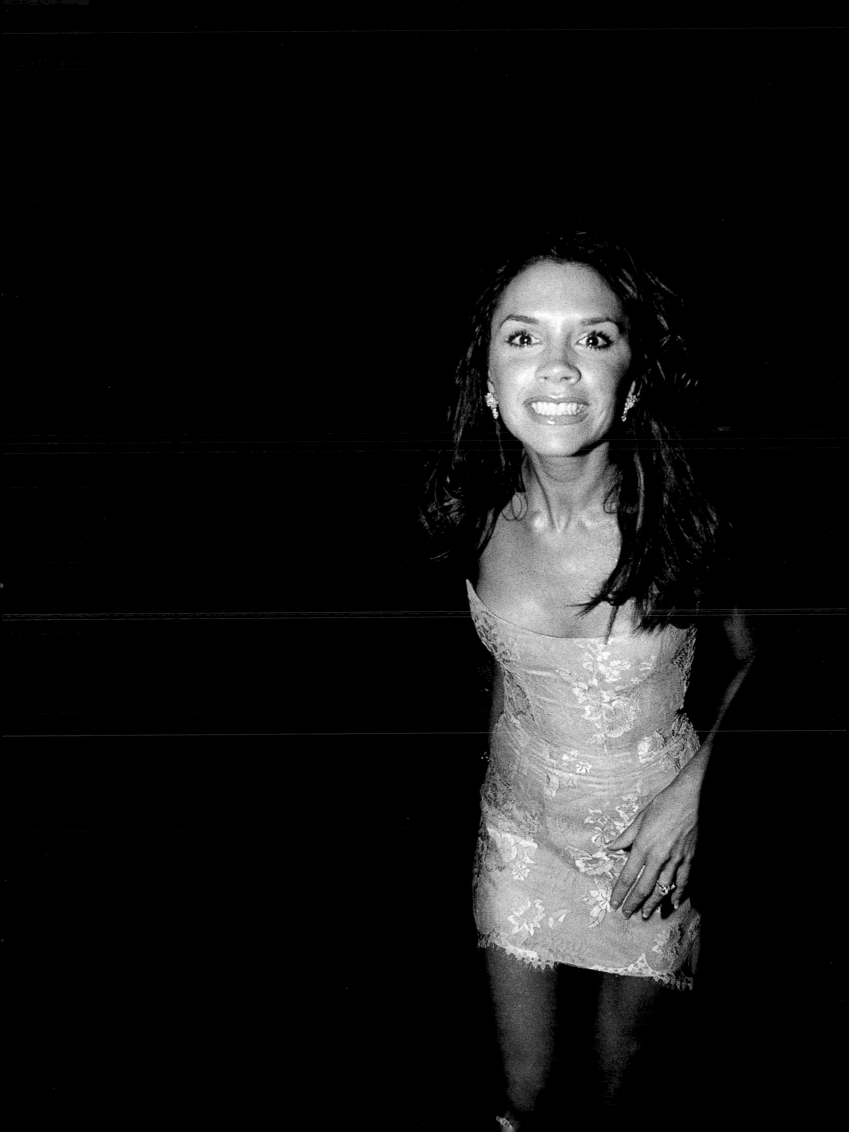

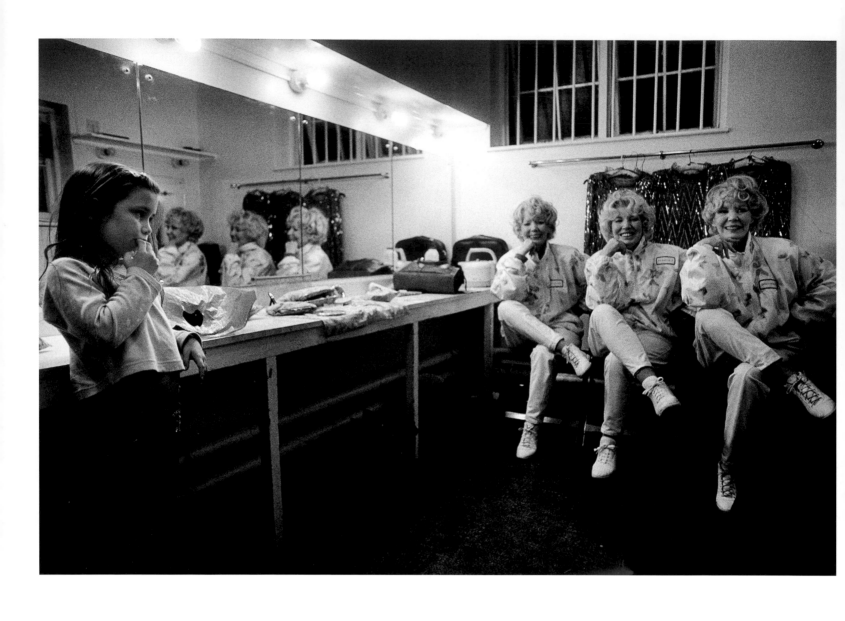

Britain's longest-performing group, the Beverley Sisters, and a bemused granddaughter, Worthing

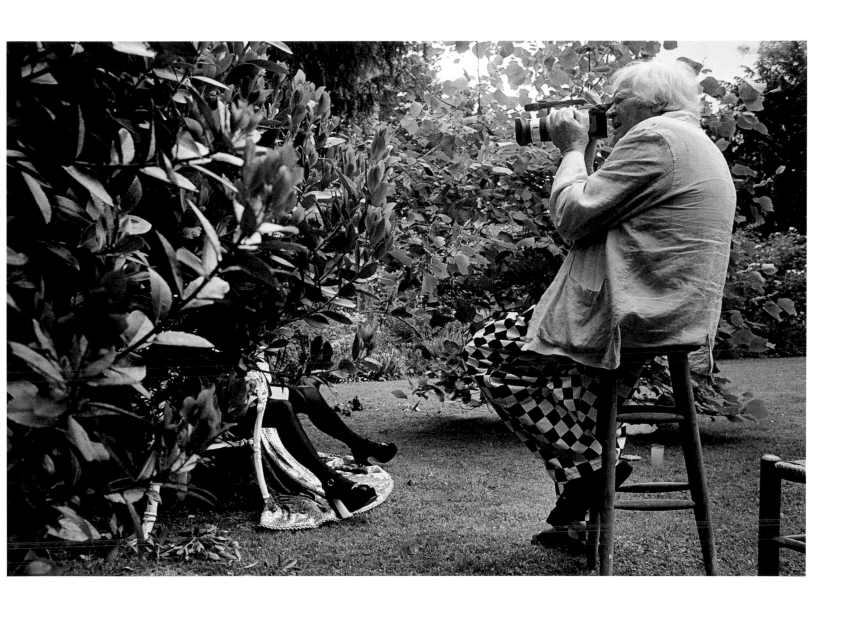

Veteran director Ken Russell films his straight-to-internet movie, *The Fall of the Louse of Usher*, in his back garden in Southampton

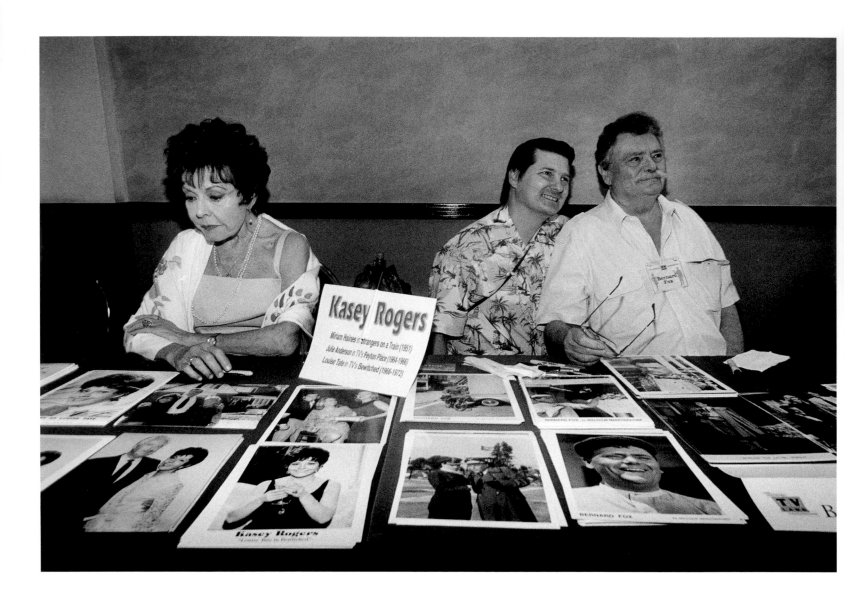

Kasey Rogers and Bernard Fox await their public at the TV Land Convention, Burbank

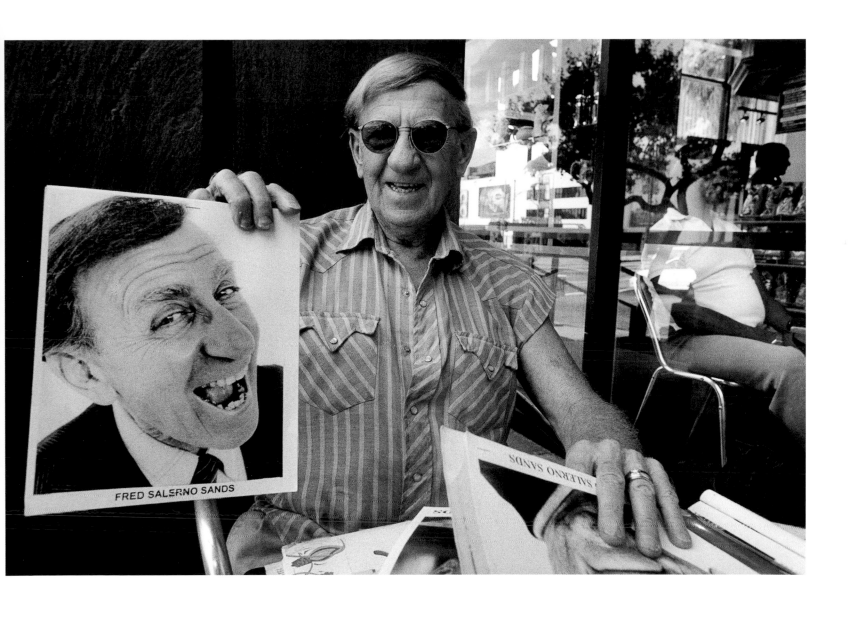

Actor, poet, playwright and teacher Fred Salerno Sands promotes his long-planned Jimmy Durante show at the Coffee Bean, Hollywood

(Overleaf) Christopher Dennis at home

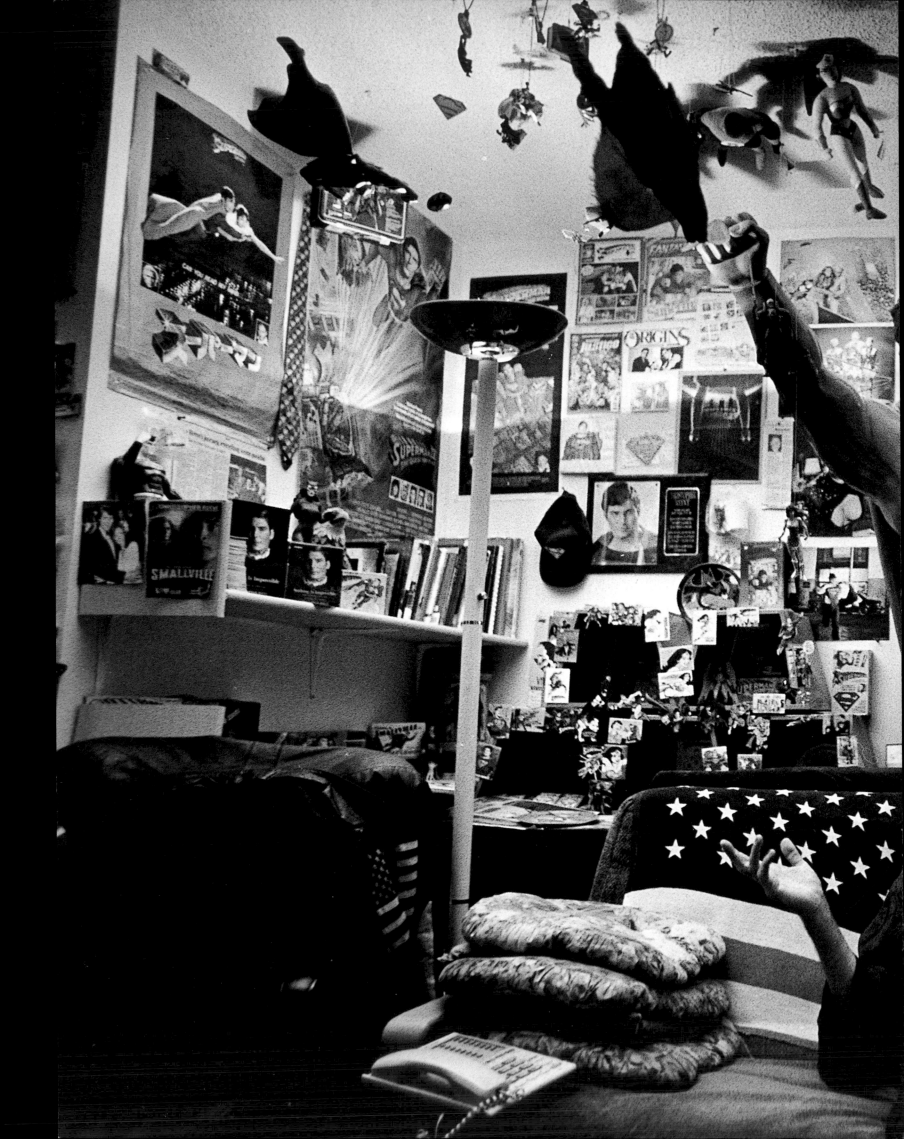

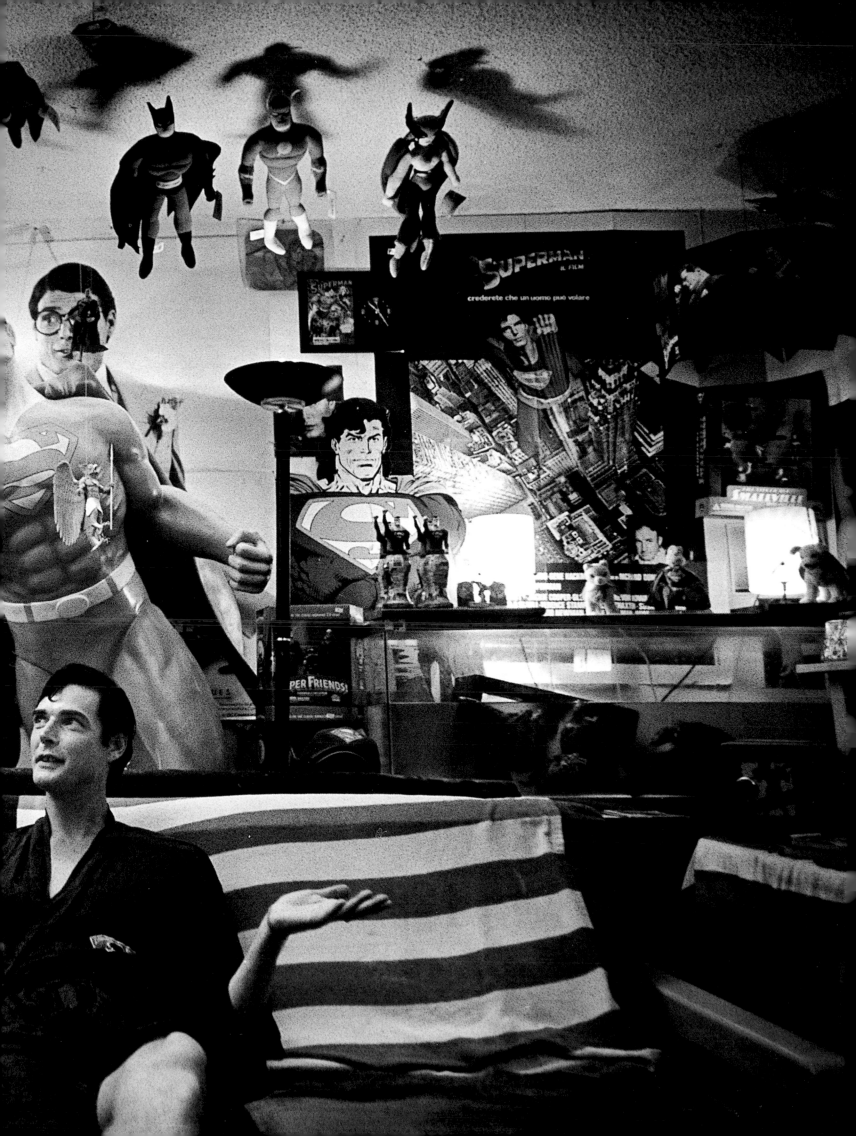

CHRISTOPHER DENNIS

SUPERFAN

My name is Christopher Lloyd Dennis. I have been in such films as *Coyote Ugly*, *Bedazzled*, *Red Dragon*, *The Italian Job* and *Hollywood Homicide*. Although people often told me I looked like an actor and that I should be in the movies, I was not always certain that I wanted to be an actor myself. I worked in a variety of fields, such as carpentry, landscaping and even shark fishing. Eventually I started doing small parts in movies and on television, and found out how much I enjoyed acting.

People commented every now and then that I looked like a blond version of Christopher Reeve or Superman, but I never really took it seriously. One day, while working on a movie set, a hairdresser gave me a photo of Reeve and told me to dye my hair black and then hold the photo up to the mirror. I was shocked at the result: I looked almost exactly the same as Christopher Reeve. My agent suggested I could make a living as a lookalike and I had a Superman outfit custom-made. I began working in Hollywood in front of Grauman's Chinese Theatre, greeting the tourists and posing for pictures as a Superman/Christopher Reeve lookalike, and I have been doing it for over ten years. I have posed for photos with thousands of tourists from all over the world. When I play Superman, the smiles that I see on people's faces bring joy to my heart.

I feel very fortunate, as portraying Superman has given me many great opportunities. I have met and posed for photos with many celebrities, such as Sophia Loren, Paris Hilton, John Schneider (Jonathan Kent), Margot Kidder (Lois Lane), Sarah Douglas (Ursa), Jack O'Halloran (Non), Marc McClure (Jimmy Olsen) and Jeff East (young Clark Kent), as well as with many of the Bond girls, such as Jane Seymour, Lana Wood and Trina Parks. I have appeared as Superman the *Los Angeles Times*, the *New York Times*, and was recently featured in a cover story in *USA Today*. I have appeared on many television shows as Superman, such as *The Tonight Show with Jay Leno* and *Jimmy Kimmel Live*. I have also appeared in *People* magazine, *Entertainment Weekly* and *Dazed and Confused*.

Inspired by Jim Hambrick, the curator of the SuperMuseum in Metropolis, Illinois, and the number one Superman collector in the world, I have also become an avid collector of Superman memorabilia, and my house is a Superman/Christopher Reeve shrine. In June of 2005 I attended the annual Superman Celebration in Metropolis, Illinois, and proposed to Bonnie, the love of my life. We plan to marry next year, and we hope to have our own Superman museum in Hollywood someday. Over the years, I have learned everything about the Superman legend, and I am considered by many to be a Superman historian. The character of Superman is very dear to me and I portray the role in tribute to everyone who has played Superman in the past, such as Kirk Alyn, George Reeves, and especially Christopher Reeve.

I had the rare privilege of meeting Christopher Reeve in October of 2000 at a *Somewhere in Time* premiere in New York celebrating the movie's 20th anniversary and re-release into theatres. I was dressed in 1912 attire as Richard Collier, Reeve's character in the movie. He graciously agreed to meet me, and when I approached him, he looked at me and said, "Astonishing!" To which I replied, "No, you're the one who is amazing." Christopher Reeve was a great Superman on screen, but even more inspiring is that he was a real-life Superman and a true hero. He showed incredible courage in battling his spinal cord injury and the contribution that he has made in the fight to cure paralysis will live on forever.

I have continued on with my acting career and hope to be established as a leading actor someday. I am still waiting for my big break. I dream of one day playing Superman on the big screen. It would be an extension of my admiration and respect for this legacy to have the opportunity to become part of the Superman legend. As Christopher Reeve once said, "the torch has been passed from previous generations of actors and readers who loved Superman. I felt that during the seventies and eighties I was the temporary custodian of a part that is an essential piece of American mythology."

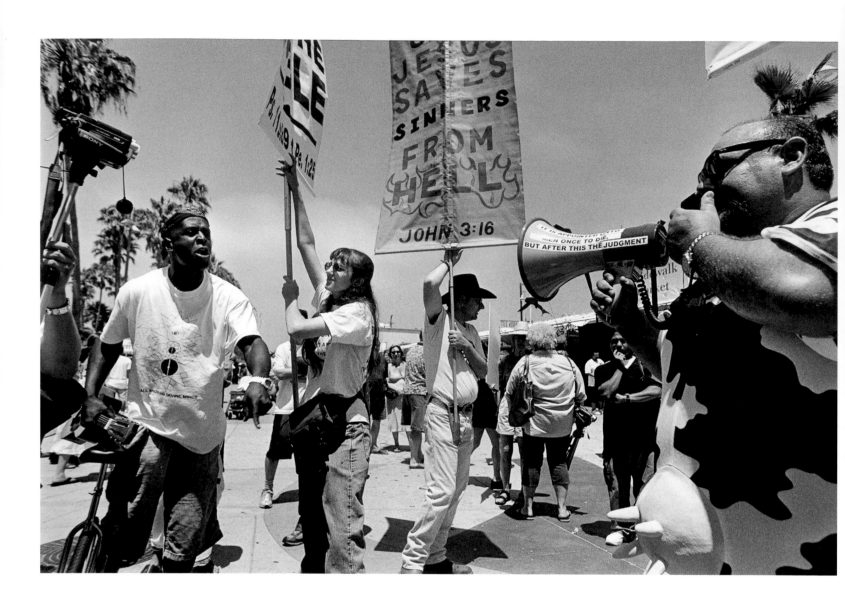

A TV evangelist preaches against vegetarianism and Hare Krishna, Venice Beach

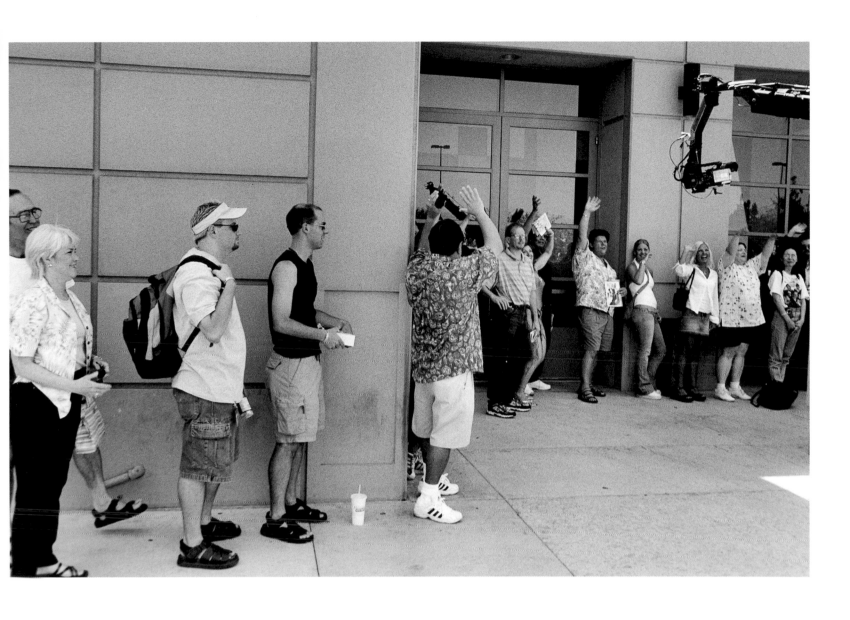

Crowds wave to the folks back home as they are filmed for the TV show of the TV Land Convention, Burbank

Dana Lee Klug offers a personal insight into the pitfalls of Hollywood life

(Overleaf) A Starline tourist bus stops outside Grauman's Chinese Theatre

The women and men of Hollywood need to approach and speak to Dana Lee Klug about hell.

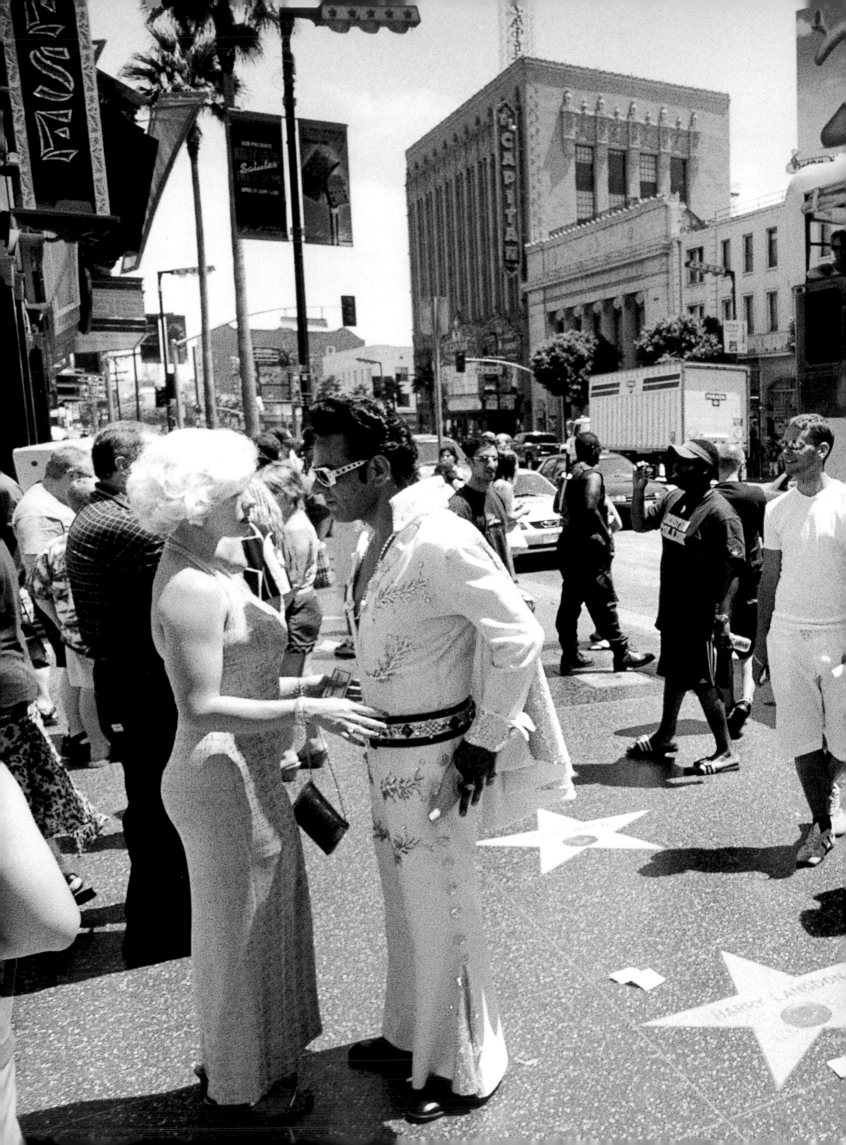

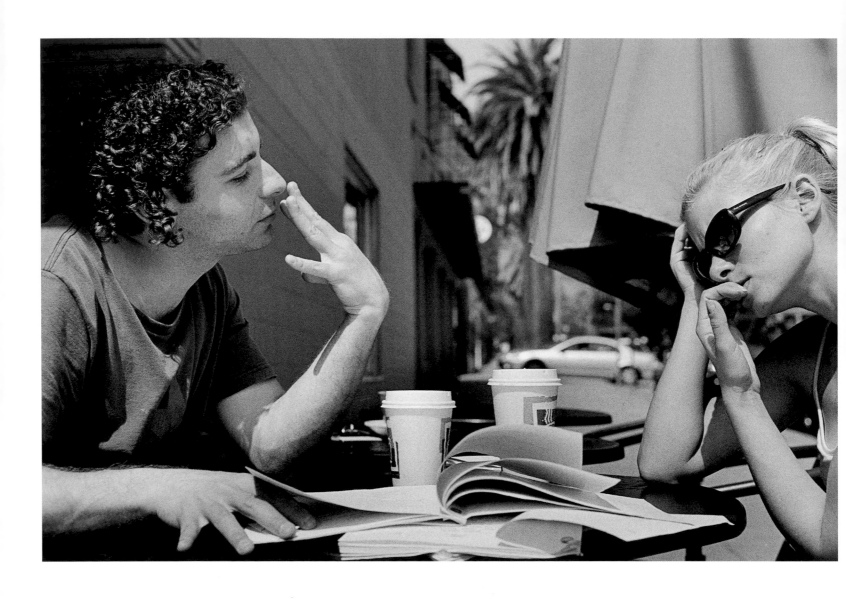

Hopeful actors Moe El Emam and Shelley Cox rehearse an audition piece in Espresso mi Cultura coffee bar, Hollywood

Latvian emigrée "Angelina", Hollywood Boulevard

London casting

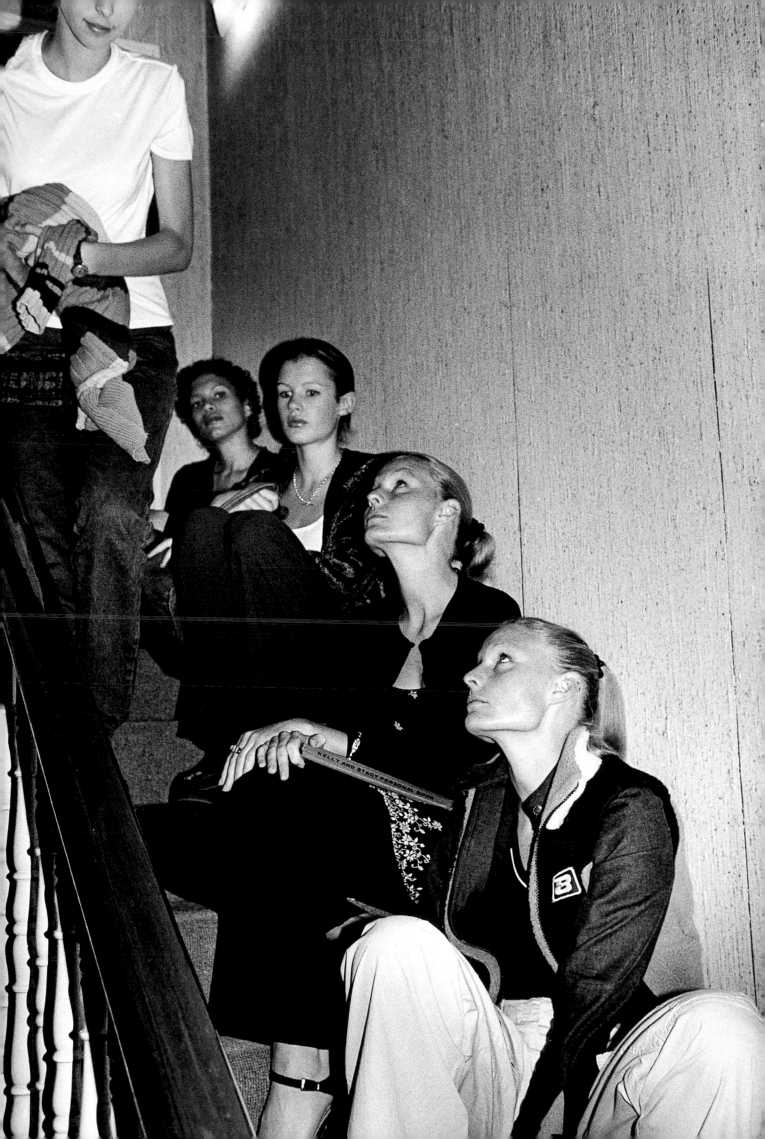

ANOUSKA DE GEORGIOU

FAME

Like sex with a stranger
The fantasy is always better than the reality.
It never lasts as long as you think it will
And leaves you feeling empty, used and alone.

With bright smiles and luminous glow
Like a metronome swings to and fro
To fill a void that has no end,
To make the millions you can't spend.

Just to hear them scream my name
Just so I won't feel this way.
With friends like these, who needs a foe?
"Is that the time? I have to go."

Tease them with my Marilyn
Photoshop me – make me thin
Tell them what they wanna hear
Live forever… show no fear.

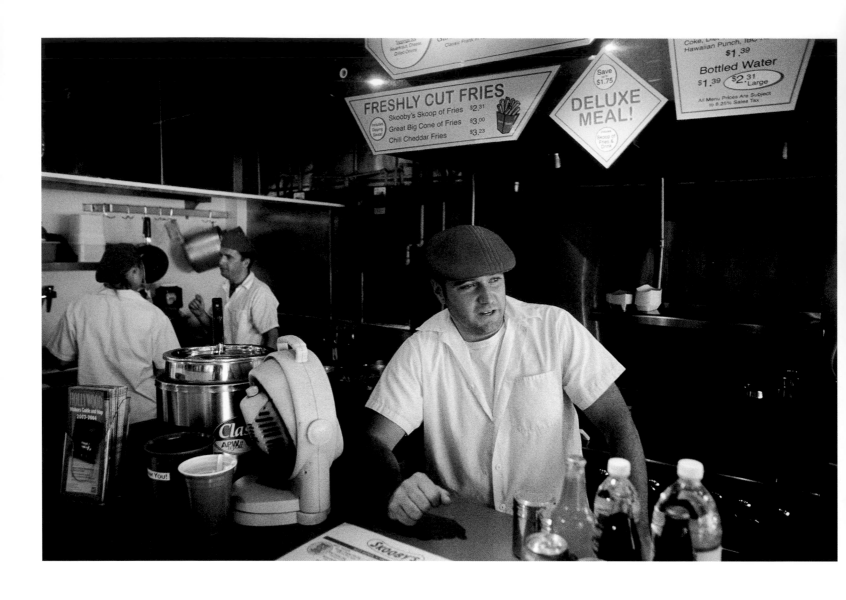

Mike Williams, former star of *The Blair Witch Project*, serves hotdogs at Scooby's on Hollywood Boulevard

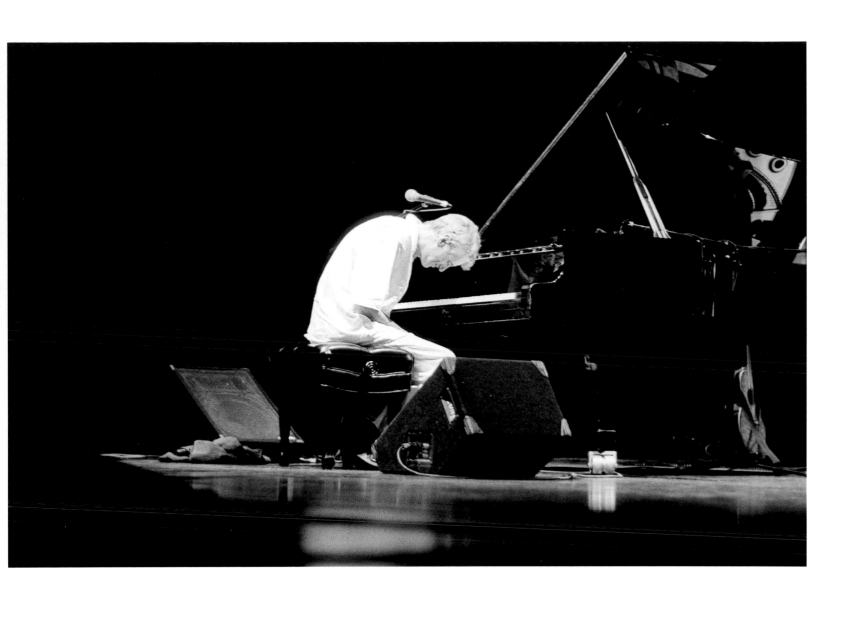

Peter Hammill, Queen Elizabeth Hall, London

(Overleaf) Delilah Sampson, third runner-up in the Erotic Awards, London

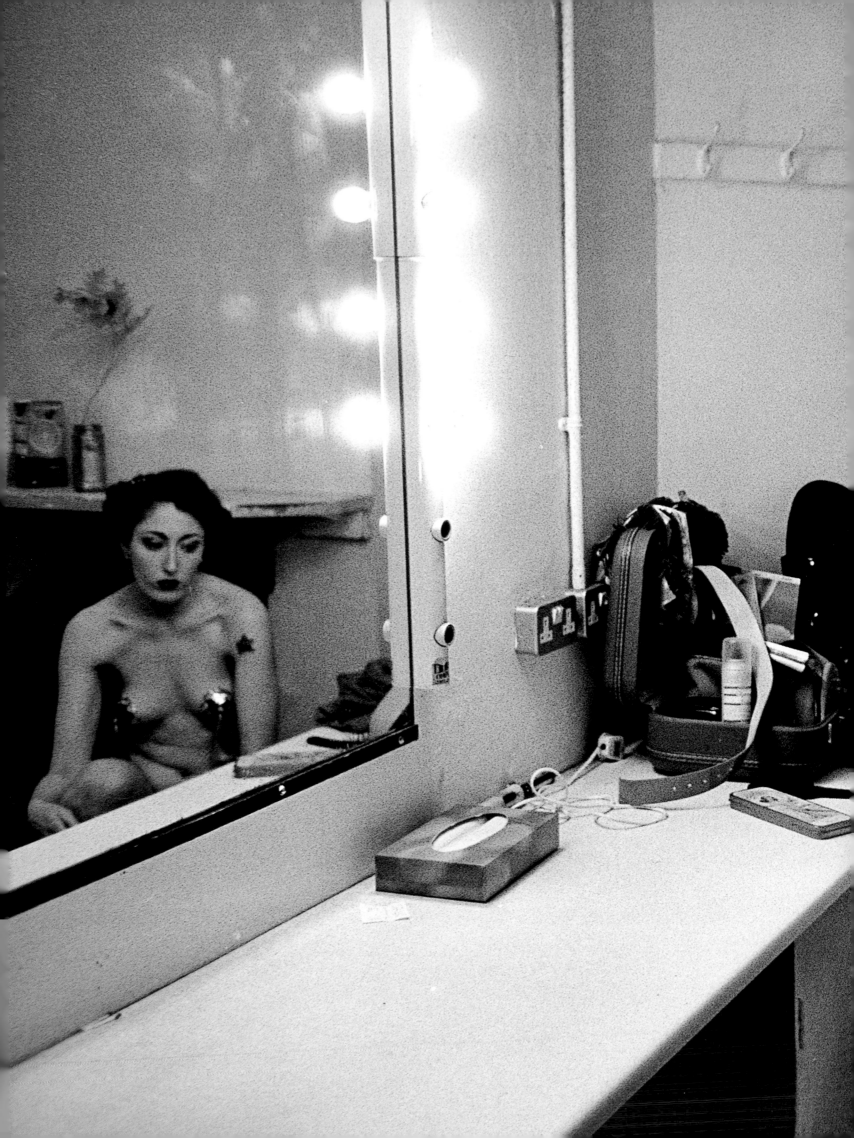

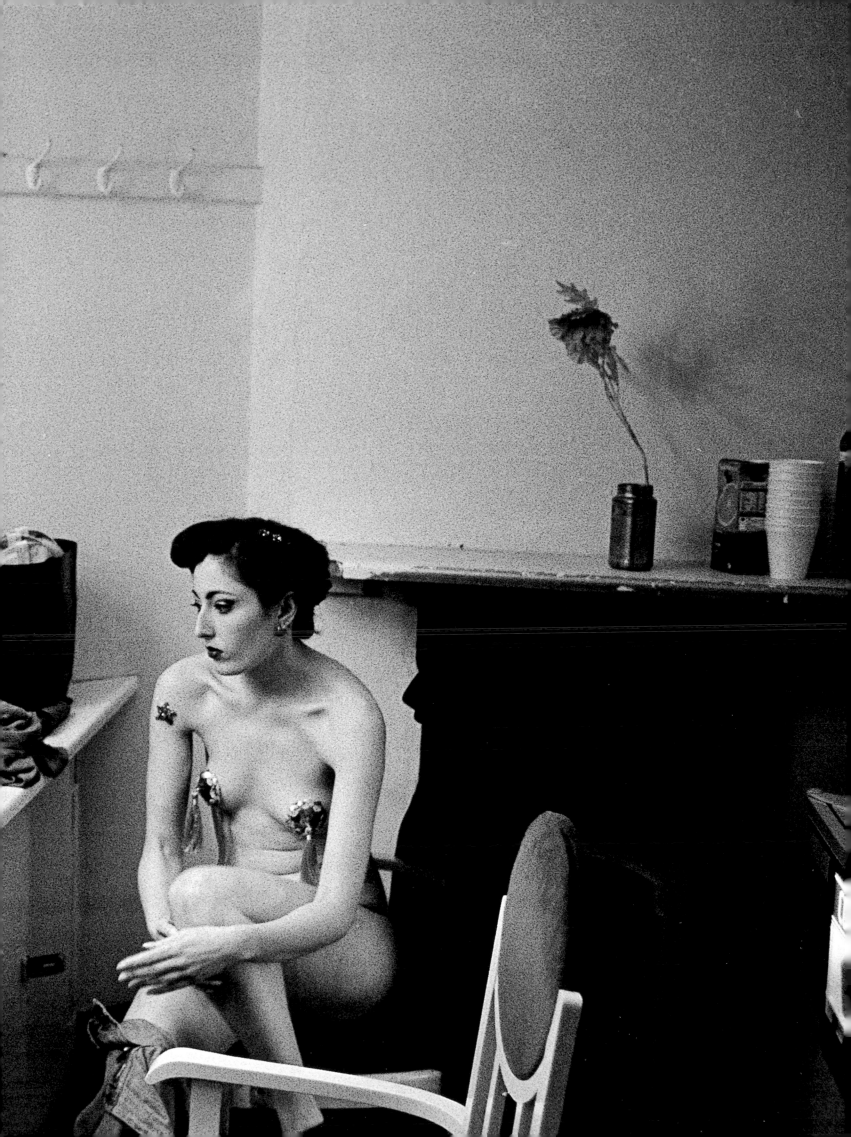

Noel Neil, "the original Lois Lane", TV Land Convention, Burbank

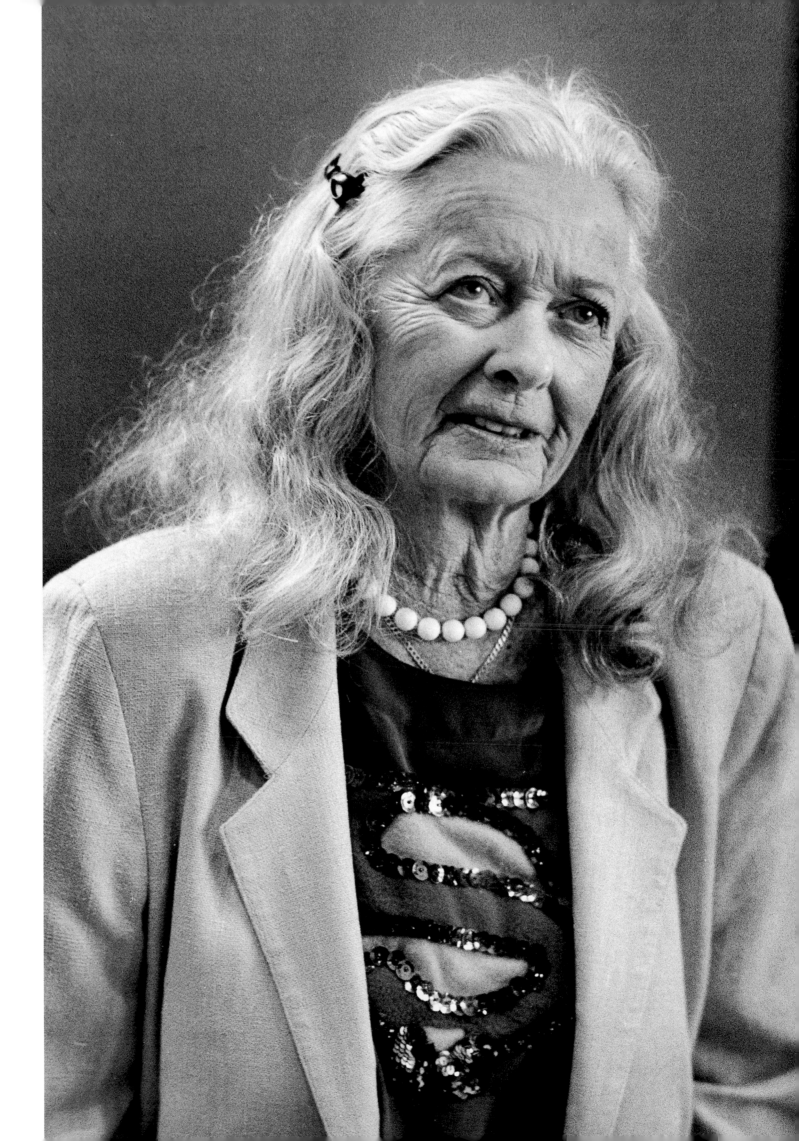

BETRAYED!

Why men cheat on the world's most gorgeous women

Julia
Canceled her wedding after a former fiance cheated

J.Lo
Ex-love P. Diddy broke her trust
BUT THE WEDDING'S

Vanessa
Husband Kobe's begging her to stay

89 Canada

34>

127 0

DO NOT OPEN...

PIMPLE
PANIC!

BRONSON'S

Jennifer Aniston's
PIMPLE PANIC!
You won't believe what she did!

THE NATIONAL

CHARLES BRONSON's DYING WISH
— His final hours

America's Newspaper

ONLY $2.19

Jennifer Aniston's
PIMPLE PANIC!
You won't believe what she did!

THE NATIONAL ENQUIRER

CHARLES BRONSON's DYING WISH
— His final hours

America's Newspaper

ONLY $2.19

AUGUST 26, 2003

BEN's LIES!

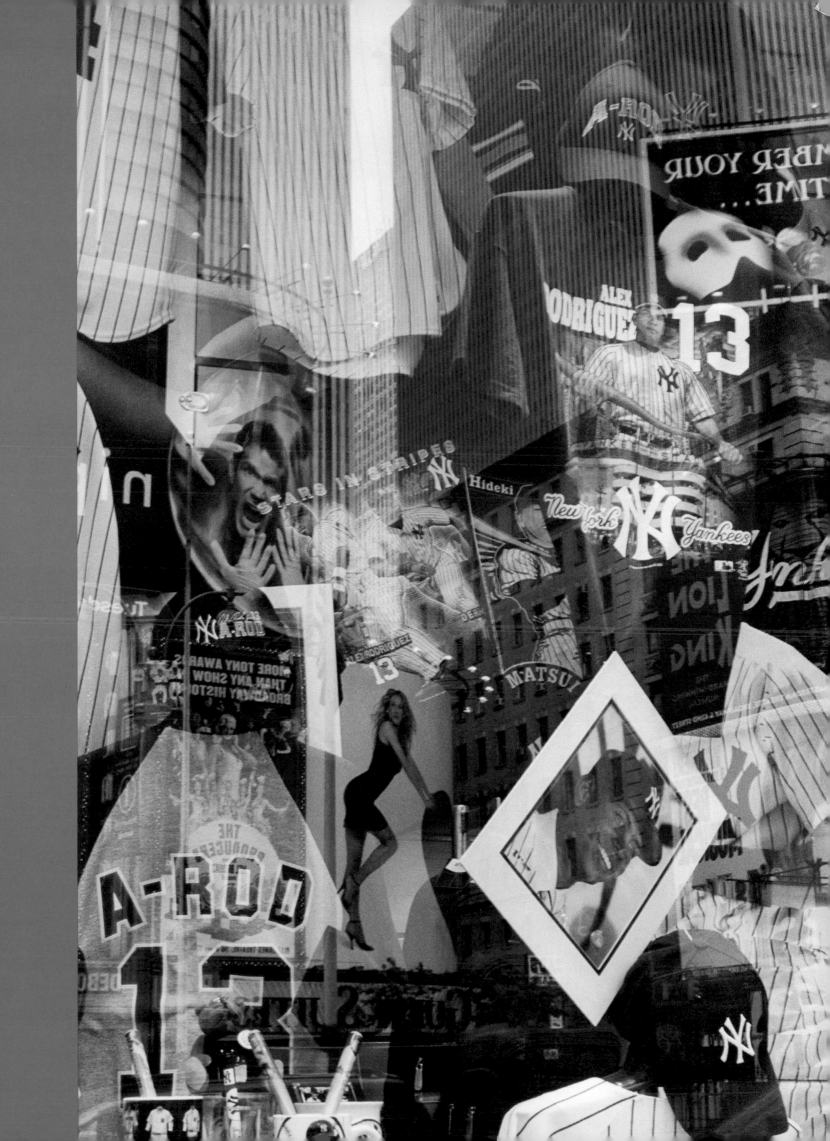

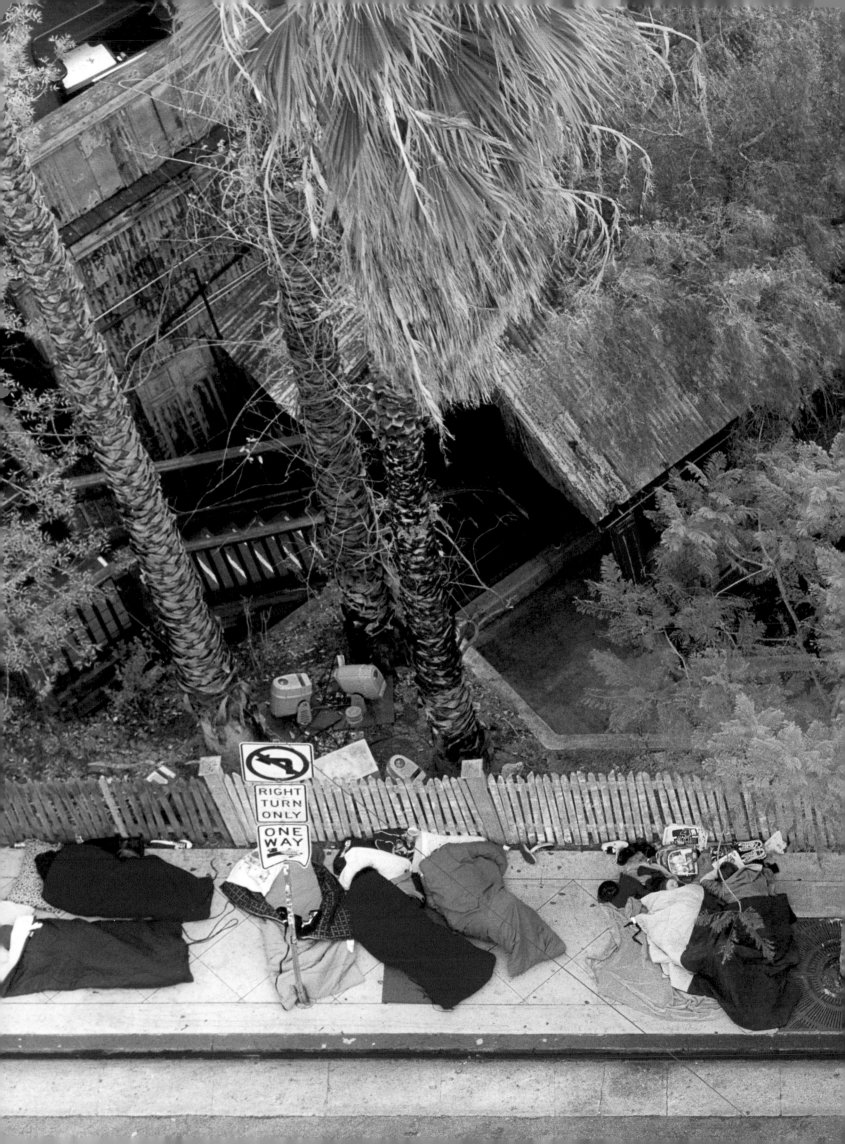

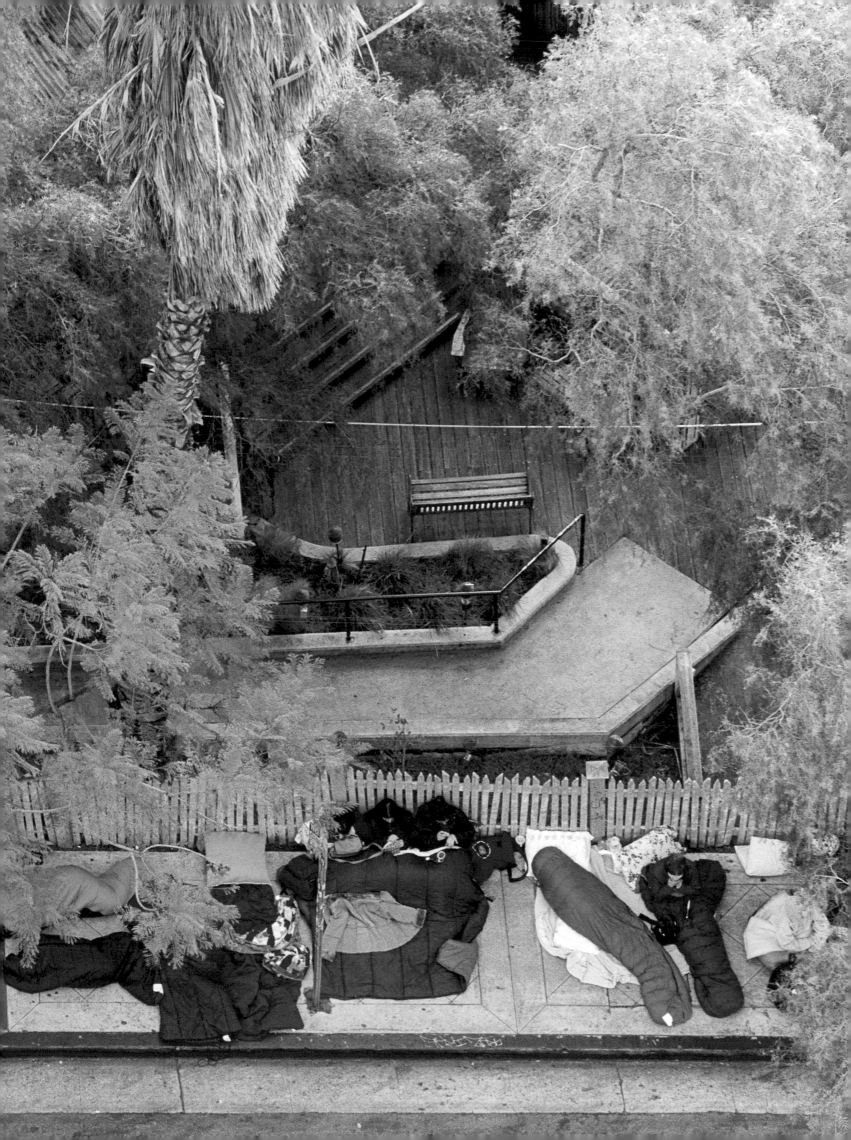

"IT'S LIKE HAVING ALZHEIMER'S. YOU DON'T KNOW ANYBODY, BUT THEY ALL KNOW YOU." TONY CURTIS

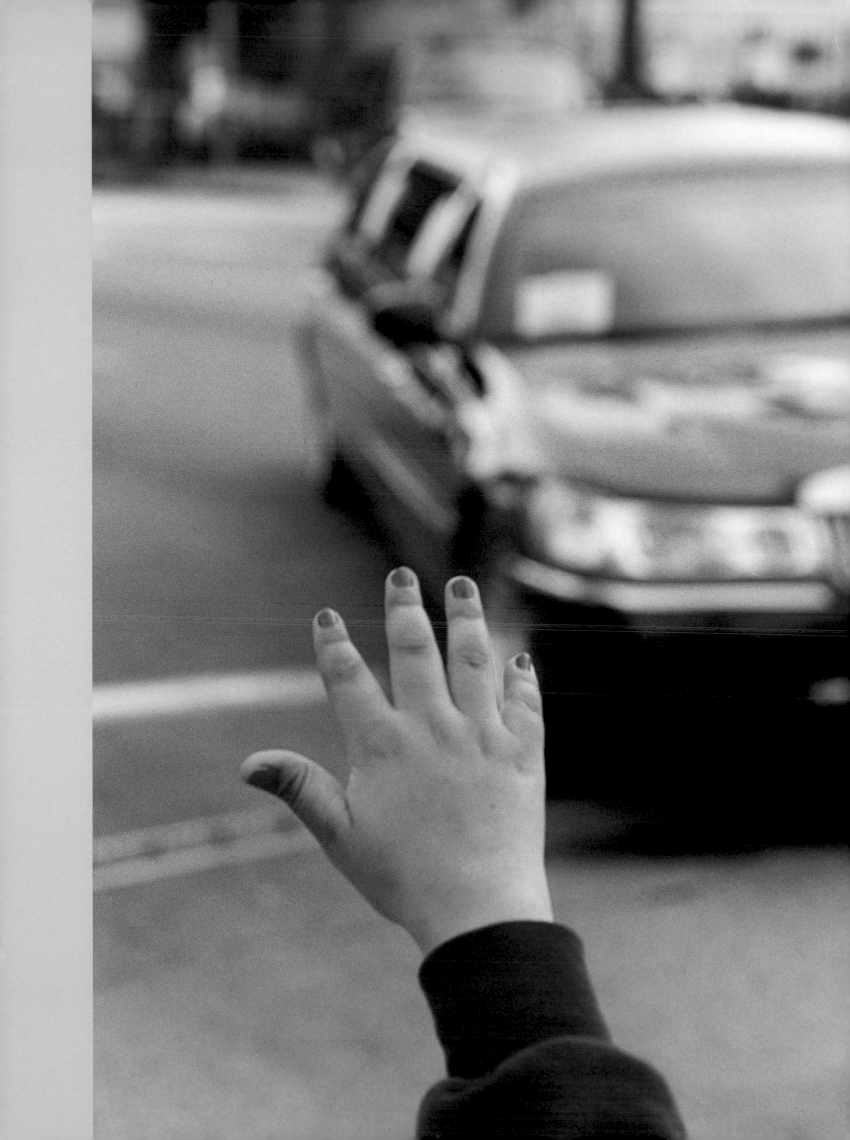

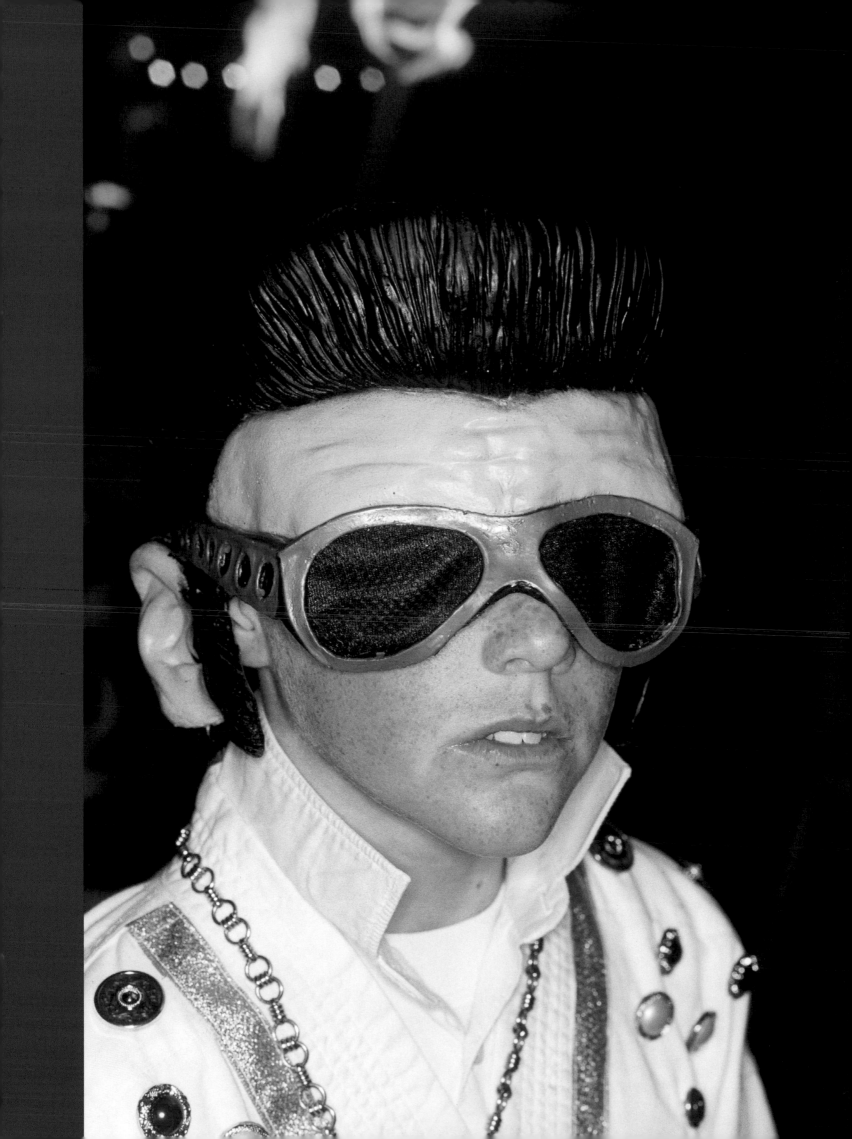

"A GOOD ACTOR MUST NEVER BE IN LOVE WITH ANYONE BUT HIMSELF."

JEAN ANOUILH

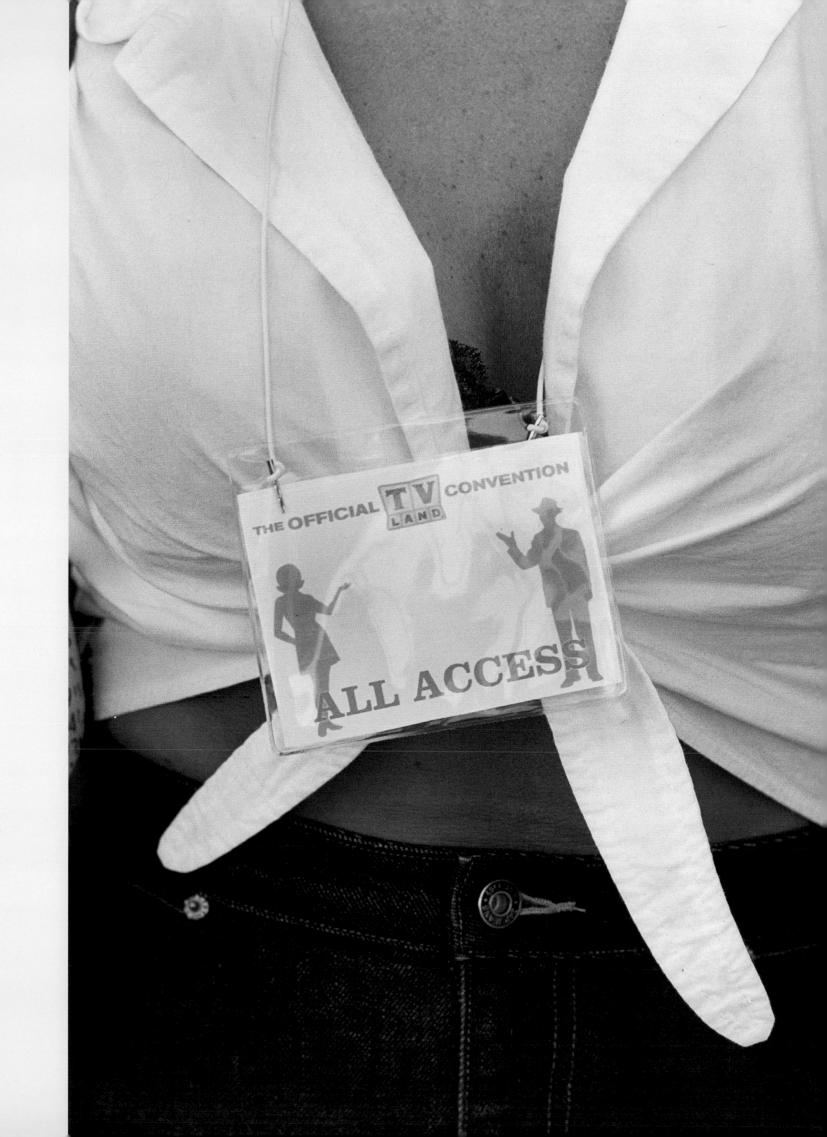

"YOU KNOW, A LONG TIME AGO BEING CRAZY MEANT SOMETHING. NOWADAYS EVERYBODY'S CRAZY".

CHARLES MANSON

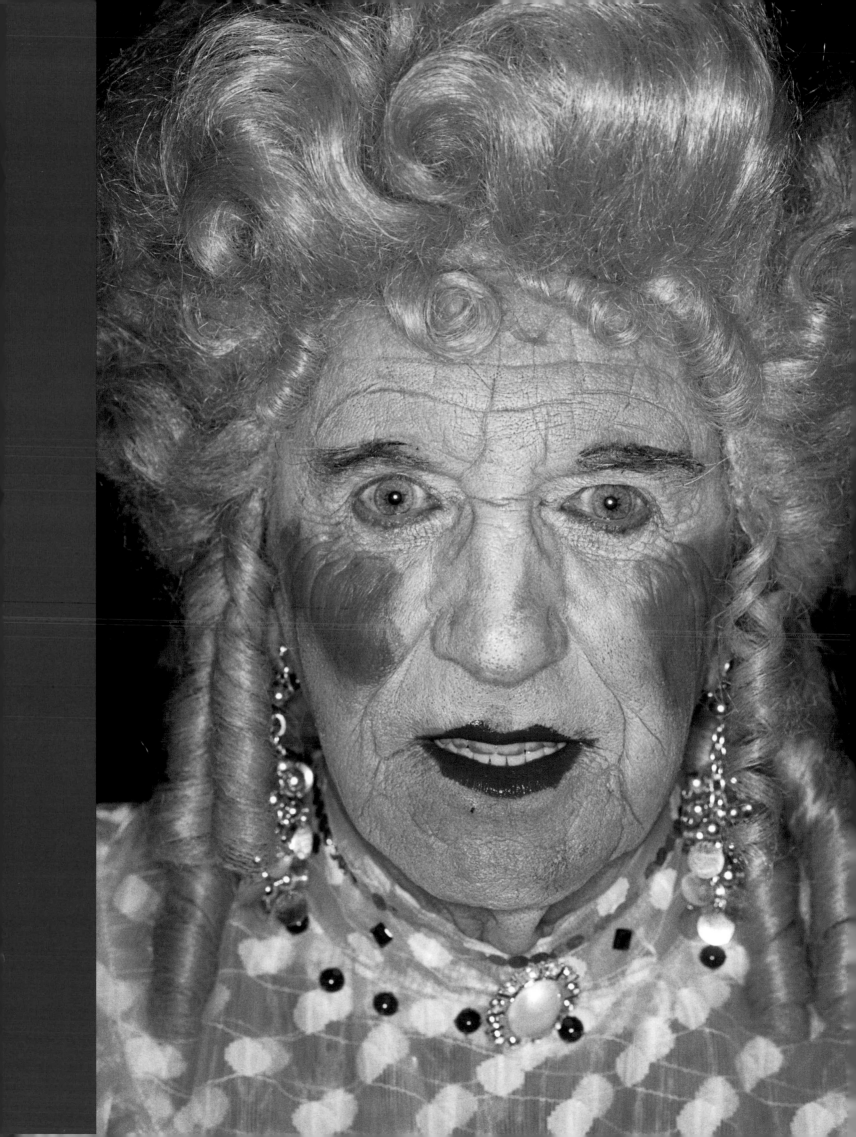

"IN THE SILENCE OF NIGHT I HAVE OFTEN WISHED FOR JUST A FEW WORDS OF LOVE FROM ONE MAN, RATHER THAN THE APPLAUSE OF THOUSANDS OF PEOPLE." JUDY GARLAND

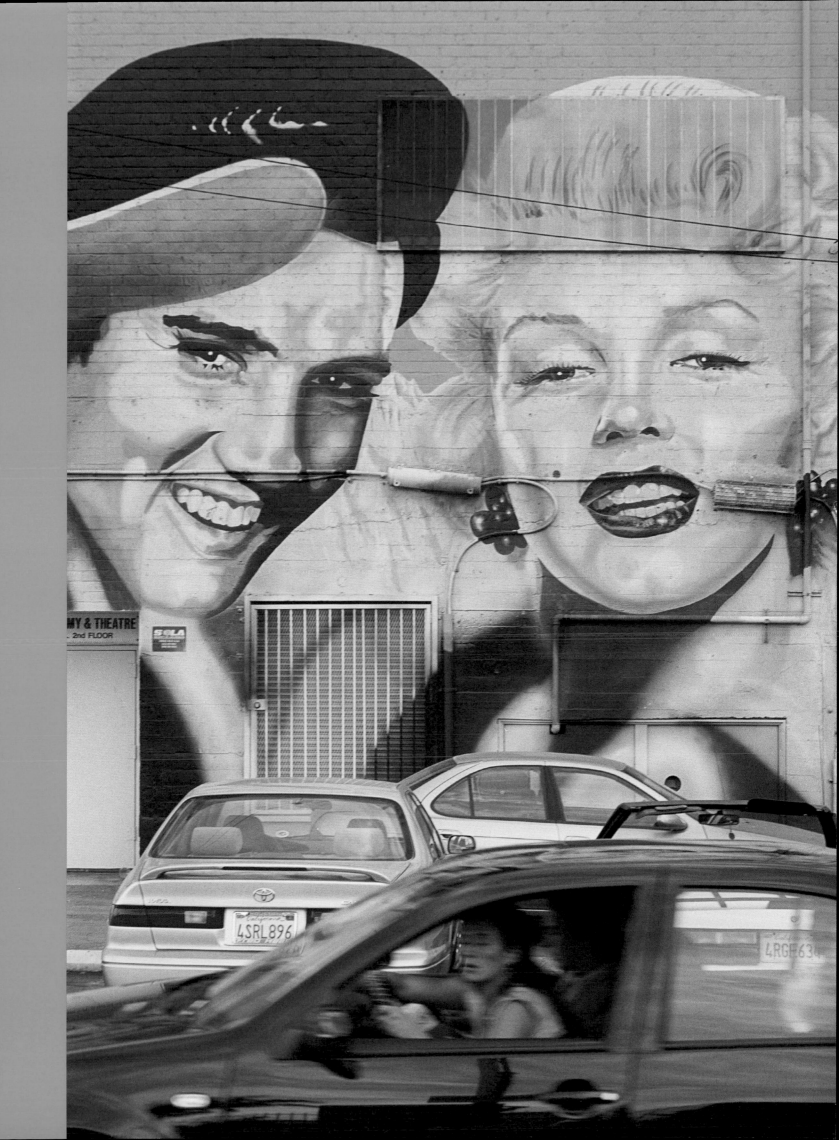

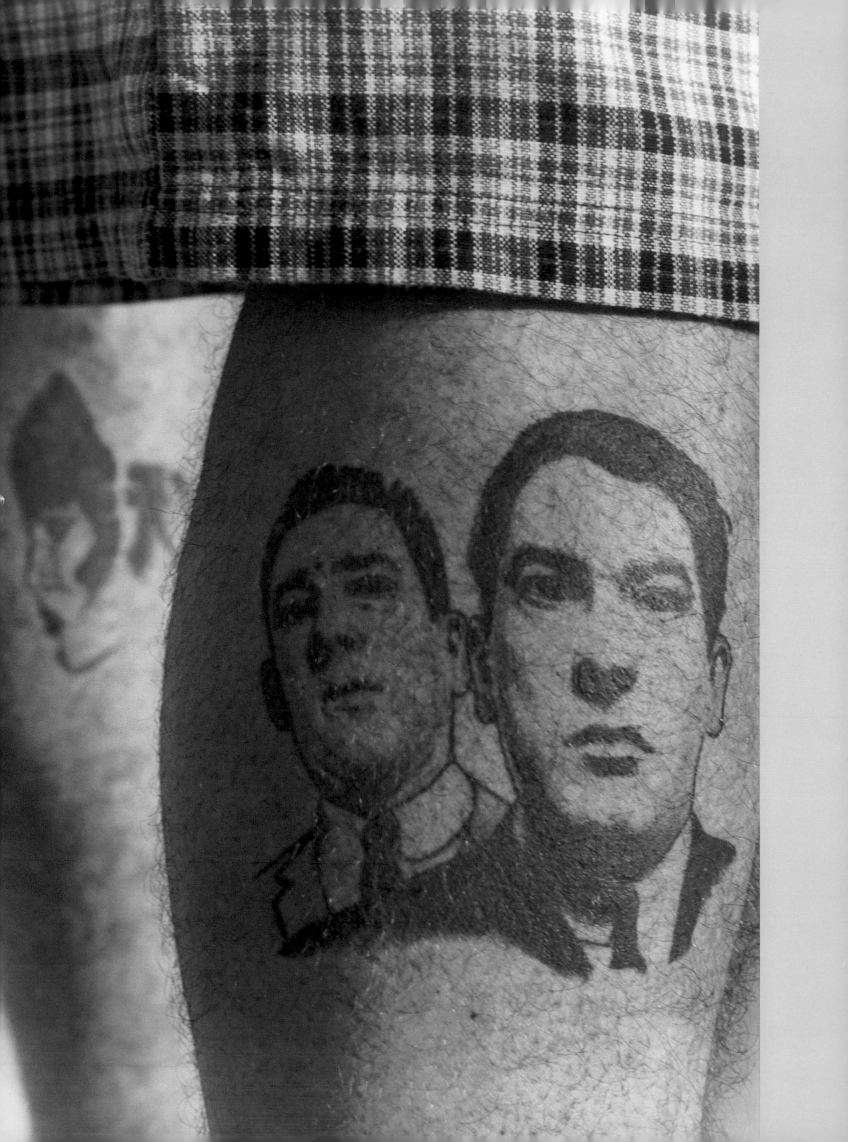

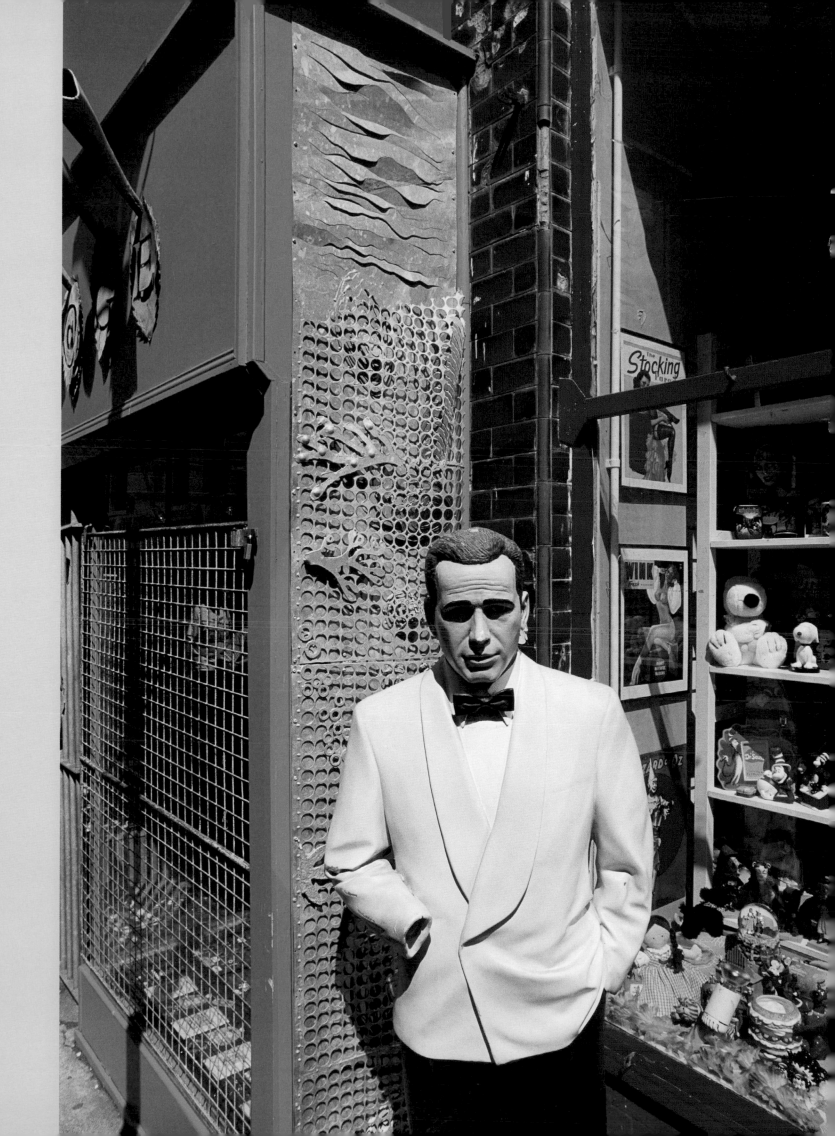

"I STOPPED BELIEVING IN SANTA CLAUS WHEN I WAS SIX. MOTHER TOOK ME TO SEE HIM IN A DEPARTMENT STORE AND HE ASKED ME FOR MY AUTOGRAPH."

SHIRLEY TEMPLE

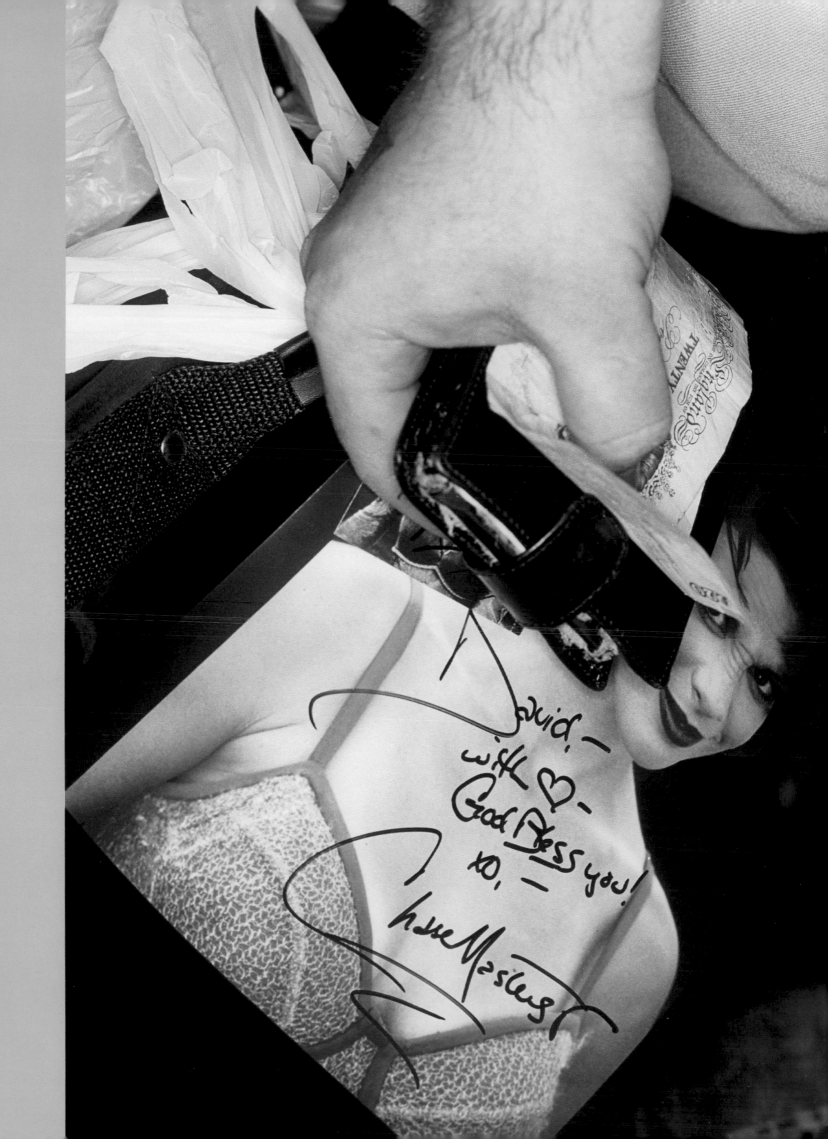

"IF YOU HAVE TO TELL THEM WHO YOU ARE, YOU AREN'T ANYBODY"

GREGORY PECK.

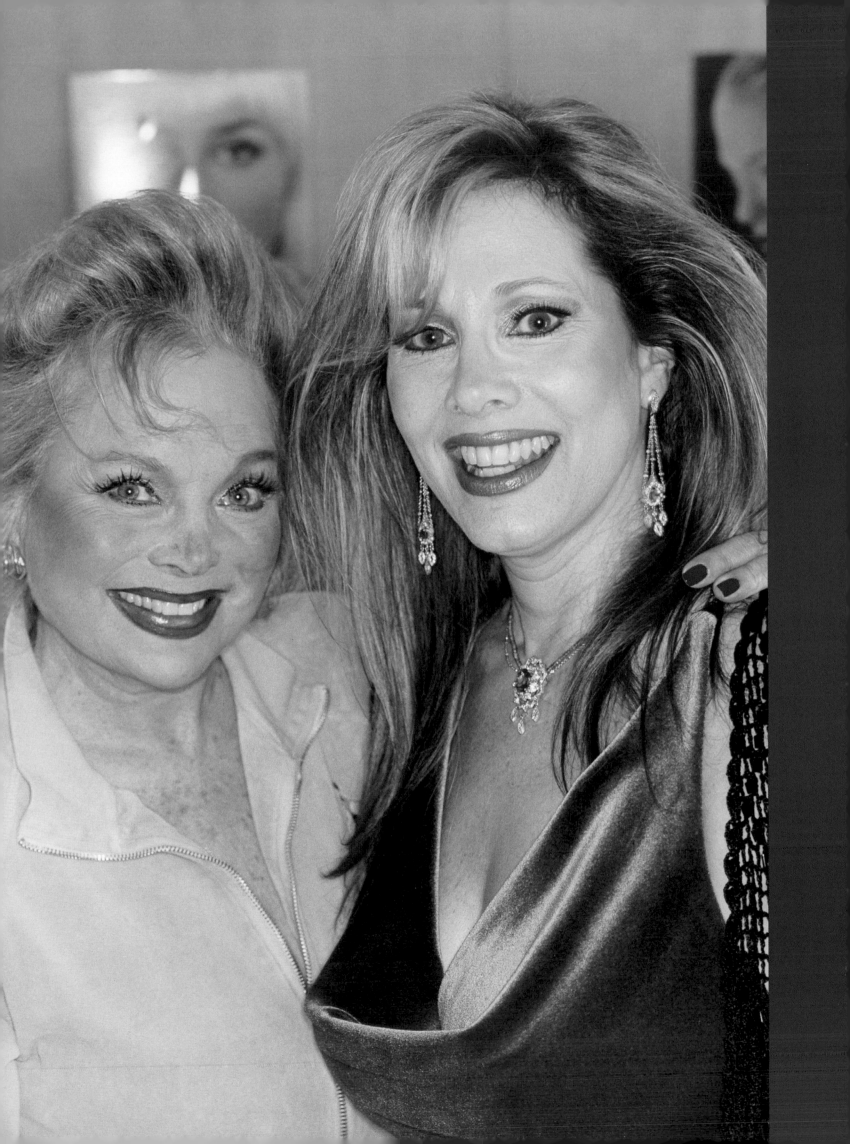

SHADOW PEOPLE

Modern society the world over is increasingly obsessed with fame. The huge amount of literature in magazines, newspapers and books devoted entirely and unashamedly to celebrity is shocking. People of every age, creed and class yearn for a daily diet of celebrity gossip. Why? What can explain this all-pervading obsession?

It is a culture that begins at an early age. Even pre-school children show external idolisations (boy- and girl-bands' marketing is routinely aimed at an alarmingly young audience). Once the appetite has taken root, hunger for the ethereal and elusive quality that is stardom can continue throughout life – becoming more and more addictive. Some fans become so obsessed with their idols that they want to merge with them, eventually losing touch with their own identity.

So how does this phenomenon get so out of control? We want to look like the stars, eat like them, buy what they buy, do what they do, follow their life choices mindlessly. In extreme examples, there is no end to the weirdness people will fantasise about and act out. Stalkers are common now, it has become the norm for celebrities to employ security guards. There have been many famous cases where obsessional fans have become so consumed by their idols that their only release appears to lie in destroying the object of their fantasies. John Lennon's killer Mark Chapman told his parole board in 2004 that he killed the ex-Beatle because he wanted to "steal" his fame: "It was just a tremendous compulsion of just feeling this big hole. Of being what I thought was a big nobody, a big nothing, and I couldn't let it go."

There are also fans who desperately want their adored celebrity to recognise them no matter what. John Hinckley attempted to kill President Reagan because he believed it would impress Jodie Foster. A recent study of mail sent to Hollywood's royalty and US Congress members threw up a bizarre range of "gift" enclosures including syringes of blood, semen, a bedpan and a coyote's head. It seems natural to follow leaders and be interested in "bigger" people than us, but plain daft to just hang onto anyone's tail because they are famous. Where is the distinction between cherishing our great leaders or inspiring pioneers and obsessing over what Madonna might wear to Wal-Mart? Where does it all go wrong?

There are different reasons for different ages. The child needs heroes and heroines to look up to and try and imitate, to use developmentally as alternatives to its mother and father. The love-struck adolescent needs a celebrity to project their first love onto. This will provide them with a safe, anonymous infatuation to yearn for. It also enables them to expose vulnerable feelings without the possibility of being rejected. The adult's need for celebrity is more varied and complex. Some may need to negotiate their sense of worth against a celebrity's, measuring their own merits and achievements against those of figures in the public eye – as if by following the same diet, wearing a certain label, or watching the right movie, they can achieve a more fulfilled existence.

Dr Raj Persaud, consultant psychiatrist at the Maudsley Hospital, says that we all suffer from multiple delusions, of which two are predominant. The first is the delusion that we are extraordinarily wonderful in some way and it is peculiar and puzzling to us that the rest of the world hasn't realised this yet and accorded us due respect. Such individuals are referred to in psychotherapy as suffering from a Narcissistic Personality Disorder. They are unconscious of being in denial of their vulnerability and their equality to others. They get very cross and upset if you dare to criticise them in any way because they "are not like everyone else". They feel themselves to be gifted and superior. Many celebrities fall prey to this syndrome because they are

talented in one area but, rather than recognising that as just one area of their self, they globalise that specialness over the whole personality. They over-identify in it. In fact, they need this part of them to hold their personality together. Many narcissists need the affirmation of celebrity and success, or to surround themselves with the trappings, in order to validate themselves. There is a huge investment in the outer self at the cost of an underdeveloped inner-core strength. By mixing in the same circles as the rich and famous they hope some glitter may rub off on them. Generally narcissists experience more difficulty than most in knowing how another feels, and so become increasingly self-centred and cut off from reality.

The second delusion, known as "impostor syndrome", is the feeling that we are much more depraved than anyone realises, and sooner or later will be found out. Those who pay too much attention to the fears connected to impostor syndrome can run into severe social paranoias, which tear at the flimsy veneer of their public persona. This syndrome is also common among celebrities; they do not really understand the processes that made them famous, and so live in fear of falling out of fame at any point, destroying their idea of self. Equally, fans will mimic their idol in an attempt to compensate for their own perceived failings.

Carl Gustav Jung, the well-respected pioneer of Analytical Psychology, believed that celebrities are like pegs onto which we project our loftier characteristics. For example, we might project a mother figure onto the Queen, or a saint figure onto Mother Theresa, we might imagine our sexy selves in the screen presence of Angelina Jolie or George Clooney. We can project internal parts of the self onto people outside of us. The danger is that we mistakenly perceive them as special attributes we do not possess. We aspire to own the good in others, whilst denying the good in ourselves.

As well as personal projections, huge collective projections can take hold. Take, for example, Princess Diana. How did so many ordinary people from all over the world come to feel so much grief over the death of someone they only knew from glossy photos in magazines? What did she come to mean or symbolise for them? Many people went into deep depression when she died, suffering severe anxiety disorders, overdosing on medications and generally giving up. Perhaps part of the reason people were so personally affected is because her public persona was easy to love and take into one's affections. She also suffered publicly in ways with which we readily identify, with her marriage breakdown, depression and eating disorders. Her suffering and her charitable deeds took her from the realm of popular public figure to near-sainthood. Once she was lodged in people's hearts, her loss could trigger or open up old wounds relating to loss of loved ones, loss of youth, loss of wife or mother, loss of good in the world, loss of hope, justice, friend, leader and so on. The sudden way she died connected us to our individual experiences of life's brutality and injustice. It confronted us with reality: that she wasn't a religious icon or a saint; she was a mortal like the rest of us, who can equally suffer meaningless bad fortune and be killed in a road accident. Her death forced us to take back that saintly projection, which can be an uncomfortable shift in perception. It is with reluctance that we had to rescind our idealisation of her. Or did we? She represented the virgin girl, our sister, a perfect lover or an ideal mother. She also died young, rich and beautiful, immortalised from the ugly decrepitude of old age. She was the real-life Cinderella or Snow White that all girls want to be; the innocent simple girl, chosen by the Prince, rebuffed by the stepmother and condemned to flee the wicked press. She was the martyr who pursued good but was brought down in suspicious circumstances open to interpretation of evil assassination. The "princess of our hearts" was a transitional symbol of dreams, fantasies and fairytales which became reality, elevating our hopes and our place in the world. Some have cruelly suggested that it was her lack of personality that gave *carte blanche* or *tabula rasa* to so many diverse representations. But her vulnerability and weakness gave her massive strength and power over our imagination.

Projection then plays a huge part in why we become obsessed with celebrity. External figures have always been used by humankind to carry our inner idea of father, mother, good and evil, and the eternal mysteries of life, because they can reassure against the unknown and help us to define our inner sense of morality and conscience. Historically, when man encountered the divine on earth he created primary mythologems – mythological figures, which Jung understands as archetypal. Archetypes are eternal and collective primordial images built up of ancestral experiences, which manifest themselves everywhere: in religion, mysticism, dreams, visions, fantasies and projections onto well-known figures. Today, living mythology expands in infinite yet shapely multiplicity in celebrities and what they come to mean for us on the individual level and the collective. They are our modern-day Greek mythological tales. The Greek gods were essentially symbolic; they had a simple essence or nature. Celebrities on the other hand are more complex, and usually take us through their stages of development.

Yet celebrities try and mimic the timeless and eternal quality of the gods. Divine youth promised by plastic surgery will inevitably fade with age. Celebrity psychology of identifying too much with their archetype is as interesting as it is tragic. Elvis Presley was a king on earth, seen as a divine individual, but he became depressed with the rigidity of the expectations of the role he was granted by his fans. Marilyn Monroe was typecast as the eternal feminine and also felt the imprisoning shackles of her symbolism. People did not want her to be anything else than a sex symbol. Kurt Cobain instinctively recoiled from his unwanted superstardom, but then sank into heroin addiction and eventually took his own life.

Classical Greece was determined to view gods such as Apollo or Hermes under an eternally youthful aspect, conceived and loved as figures of purity and perfection. It is clear that humankind will always have the fantasies of eternal youth, pure beauty, classical wisdom. Celebrities today are the closest real things we have to those gods.

Sometimes projection is used unconsciously to ward off the more sinister parts of self. For example, Freud believed that the Devil is a construct to carry the negative father who does wrong or abuses his children. This idea is extended from the individual to the cultural when psychoanalysts suggest that Christianity attempts to resolve Oedipal conflicts with the concepts of a good God-father and an evil or sexual Devil-father.

Equally, a person who experiences unacceptable impulses or wishes may enter a state of possession, where the demons that take over their body are bad and reprehensible wishes: derivatives of instinctual impulses that have been repudiated and repressed. Witchcraft is a perfect example of a cultural projection of the unacceptable onto a scapegoat, denying responsibility for internal "witchiness" through externalisation. Women, because they have been treated as insubordinate to men, are more likely to be the victims of men's dark projections, or simply the scapegoats of their fears of how to manage life's huge uncertainties and unknowns. As our fate is at the mercy of a random and often capricious universe, we are driven to try and regain control of our environment, judge people or events and attempt to ward off potential disaster. Because we live in a world governed by no clear rules, we can use constructed myths, roles or archetypes to help focus our lives.

We have traditionally constructed demons, spirits, gods, and witches to represent different parts of the psyche. More recently we have focused on celebrities. If we project parts of our self onto others and worship them or denigrate them, then aren't we running the risk of losing that part of ourselves? Not knowing who we really are? The self sees all, but does not see itself…

Group behaviour plays an interesting part in the culture of fame. If we look at the psychology of what happens in groups of any size, we see several features which are distinctive to all group performance. Members of a group (including society at large) will act and react towards one another so that their behaviour becomes mutually influencing or interdependent. So if all your school-friends are bringing in copies of celebrity magazines

and talking about the people in their pages, the likelihood is that you will do the same, and adapt in order to fit into the group. Teenagers are more likely to need group recognition and status than adults, as they seek to feel a part of a group and gain a sense of belonging, whilst also obtaining a deeper, stronger sense of self. They are more than their selves; they have merged to become part of a collective. Groups will develop shared collective interests and goals. Over time, standards internal to the group will arise. Members will act and expect each other to act in a certain way. Members who do not obey these standards lay themselves open to disapproval and rejection. So there may be a global group phenomenon going on. If a collective is interested in fame and its glittery stars, we are likely to be influenced and find ourselves adapting, out of an unconscious desire to fit in.

The first group we identify with is family. This is where we put our primary allegiance to our leaders for the first decade or two of our lives. In this group the roles of parent and child are clearly articulated. There is a power structure, the vertical dynamic of which will remain imprinted on the child's psyche forever more. Later on in the child's life, the celebrity icon or the famous idol may come to imitate or replace the parental spot. What the family does is set a hierarchical structure, which acts as a precedent for all group structures. Groups need leaders and peers, and have clear role structures to reinforce them. Indeed most work groups operate on this basis. The custom is to have a leader or a boss and then a scaling down, in which all members of the group must conform to their place within the set structure and principles of behaviour. Peers or siblings, those of ostensibly equal status, act as horizontal dynamics, where co-operation and competition abound. Thus the very nature of the duality of parent-child may play some part in setting up an idol space in our relationship dynamics.

All people, famous, powerful and normal will feel lost at times. Who are we? Where are we going? What is the point of all of this? These philosophical questions resurface from time to time, haunting our existence, our sense of self and our place in the world. Being, or feeling, alone and lost is a normal part of human experience. We cope in a myriad of ways. Some look at people they admire and attempt to mimic them, in order to try and emulate their achievements. Unfortunately, the values of our society at the moment seem not about self-actualisation and growth and integration of self, but rather are preoccupied with greed and obsession. We live in a "greed is good" culture, where consumerism is king. Our obsession with consumerism revolves around the visual, the aesthetics, the appearance of things, people, food, houses, environments, etc. Some would say our over-arching value today is the pleasing appearance of an object or a person. That is a far cry from what it ought to be. Are we really that shallow, only taken in by appearances? Is there an evolutionary reason for this? Early Homo sapiens' communication was non-verbal. Once symbols could be read or deciphered we started language. Our predominant sense is vision – which perhaps explains our endless quest or endeavour to embellish or emulate the seen world. Will we move on to celebrate deeper traits in people? Valuing ability, skill, talent, intelligence, knowledge and wisdom, verbal facility, sociability, motivation, initiators, inventors, thinkers…? There are inspirational people who can dazzle us and teach us and bring us guidance and hope and joy, without the fripperies of a ludicrously unaffordable designer dress, a million-dollar makeover, or a big-budget movie to promote.

Is there still a more perverse side to celebrity? It seems we are obsessed with celebrity and fame because it covers our literature and we buy it *en masse*. But what if it is all a machinated conspiracy to make money at our expense? How foolish are we? The media use persuasive powers and propaganda tools to tell us what to like and dislike. How far do they dictate our compulsion towards celebrity and its icons? How manipulated

are we when we are force-fed voyeuristic images of famous people in our papers every day? How responsible are the media in raising untenable heights in standards of looks and how to achieve them? Editors and advertisers know that by making the people more neurotic and self-obsessed about who they are, what they look like and what colour their highlights should be, are breeding more and more voracious and insecure people. It's the old adage of the bullying husband: make her feel irrelevant and useless by being more powerful than her and you'll keep your power over her, and her devotion to you, because she hasn't the self-confidence or self-esteem to leave you.

Media-fuelled consumerism is doing the same to us. They say we should follow this fad or trend or we won't belong, we will be rejected by the group. They harness our fears and insecurities. The more we consume, the more we want (everything is a five-minute wonder). And then they sell us the answers: buy this and you will overcome your weak sense of self and your perishable looks. Except the cycle just gets worse and worse. We have to do and buy *x, y* and *z* to be better people or to be loved or more beautiful or not die! So off we go again to shop until we're fit to drop – or until the next magazine rolls off the press with a new set of strictures. We are in thrall to the view the media holds of us and throws back at us in a dazzling glare. We have learnt that we are insecure, tiny, insignificant people who should try and emulate the bigger and better people in the magazines. We are marshalled into a psychologically regressive state of infancy, feeding on the manipulative views of others, and on our own skewed view of our idols.

The more the power the media have over us, the more manipulable we are. We surrender to TV's cunning tricks to keep our attention. It introduces us to characters to whom we may form strong affective attachments. Close-ups give us access to these characters' emotional lives. Soap-opera worlds provide a surrogate community life for viewers. The effect is real, but it is a one-way relationship, and is therefore a delusion. We stay in, watch TV, fall out of social practice so stay in more (an introvert's trap). We admire TV characters' social skills at the same time as we become increasingly passive and voyeuristic. Psychiatrists theorise that voyeurs lack the social skills or opportunities to develop proper intimate relationships, and so have to resort to merely observing, perhaps protecting an immature personality from the emotional risks of intimacy. We watch and gossip and feed the insatiable hunger.

Our obsession with celebrity is clearly complex and multifaceted. It even hides itself: so much on TV and in magazines is from hidden cameras and hidden lenses, adding a more sinister element to the need for fame. Is there no shame anymore about how we obtain our gossip? Doesn't it feel wrong to invade famous people's lives at the cost of their right to privacy?

We are beginning to understand that everything carries its opposite within it; all things, paradoxically, can seem to be their own reverse. We psychologically need to love but we also need to destroy the objects of our love. Both drives are very well exemplified by a tabloid press that reliably follows the model of building up heroes, only to tear them down. We are Ancient Romans in the Colosseum watching our favourite gladiator finally devoured by the tiger. We have always needed external puppets to reproduce what life and its conflicts do to us, how it raises our spirits and wears us down. Freud would say that the need to keep mimicking life in art or the media is an attempt to reconcile life's traumas through the repetition compulsion. We re-enact trauma again and again until we can digest it better. Until we can come to terms with life's paradoxical brilliance and its utter monstrosities we will continue to reproduce it and mimic it. Maybe it is by understanding our complex selves that we can understand why we pick the people we do to love (whether they be tangible or not), how we gain and lose control, and how we are lost and meaningless yet driven and meaningful. We tend to hold onto all sorts of delusions, but avoid

confronting them. This may help us maintain our grip on sanity, but it dangerously highlights our lack of perceptive accuracy. Are we any better than Plato's cave dwellers who believed the shadows were real people?

Celebrities are a delusion – or at least they represent ideas or symbols that are not true *per se*. Such delusions, as we have seen, can be surprisingly useful and can have positive benefits too; though if taken too far can have disastrous consequences for both sides of the fan-celebrity relationship.

Our sustained obsession with celebrity should be more deeply understood by individuals and by society at large. By looking more closely into our personal psychology and also through philosophical eyes, we may have a richer understanding of all the fascinatingly different aspects of the self in its myriad forms and expressions. Failing that, we will continue to need celebrities onto whom to project our unconscious material. When individuals do reclaim their projections by understanding them better (i.e. making them conscious) it will invariably benefit both the fan and the celebrity. If we are too busy being interested in the lives of others, not only are we grimly unaware of why we are doing it, but more worryingly we may fail to live our own.

SARAH HIRIGOYEN

ABOUT THE CONTRIBUTORS

Chloë Bailey is an actress, model and TV presenter.

Sarah Bailey is deputy editor-in-chief of *Harper's Bazaar* in New York.

Alice Braga is a Brazilian actress whose credits include *Cidade de Deus* (*City of God*) and *Cidade Baixa* (*Lower City*).

Christopher Dennis is an actor and Superman/Christopher Reeve impersonator.

Tim Fountain is a playwright and performer. His plays include *Resident Alien, Julie Burchill Is Away* and *How to Lose Friends and Alienate People*.

Anouska de Georgiou is a singer-songwriter and actress.

Peter Hammill is a singer-songwriter and lead protagonist of seminal "progressive rock" band Van Der Graaf Generator, whose first album release in almost 30 years, *Present*, was accompanied by a triumphant reunion tour in 2005.

Sarah Hirigoyen is a psychotherapist who works at the Priory Hospital in London, for the NHS and her own practice.

Richard Johnson is a stage and screen actor and an authority on Shakespeare. His screen appearances range from 1960s classics *The Haunting, Operation Crossbow* and *The Amorous Adventures of Moll Flanders*, to playing a "distinguished gentleman" in 2002's *Lara Croft: Tomb Raider*.

Dame Vera Lynn was Britain's "Forces' Sweetheart" during World War Two. Her songs "We'll Meet Again" and "White Cliffs of Dover" confirmed her position as the nation's most popular female entertainer.

Heather Stewart-Whyte is an author and former supermodel.

Lisa Voice, former partner of the late rock icon Billy Fury, is a music publisher and film producer.

Richard Young has been a leading celebrity photographer for over thirty years.

TO MY PARENTS — JOAN AND PETER BAIN HOGG

Any epic requires a cast, extras, crew and production team of thousands and whilst *Idols + Believers* has not required the CGI of *Star Wars* (or received the budget), there have been many people who have worked hard to see its completion. Without wishing to sound like an Oscar acceptance speech, there are those who were there from the inception and whose friendship and faith in the project deserve special thanks.

The book would never have taken shape without the artistic guidance and vision of Gerard Saint, who conceived the title and spent many hours working late into the night with workprints and Laphroaig so that the project could take shape. Ashley Woods, the Don King of the photography world and my brilliant agent, worked tirelessly to promote and produce. Editor Mark Reynolds made my writing readable, saw to it that the words and pictures worked together and has been the voice of sanity during the last months of completion. Sarah Treuer, picture editor extraordinaire, provided friendship, shoulders and reason whilst skilfully editing the photos, honing down and sequencing the project. Mark Edwards, British Photography's secret weapon and my friend and mentor, has been there all along for advice, constructive criticism and guidance. Audrey Jonckheer from Kodak made the whole thing possible with faith, enthusiasm, friendship, transatlantic conversations and by providing rolls and rolls of Kodak TriX, UC, paper and chemistry. Declan Browne is always there through thick and thin, with good advice and humour when it is most needed, and Ken Rhodes' great friendship over many years is equally treasured. Andreas Wisniewski's advice and help in giving me the low-down on all things LA, has also proved invaluable. Henrietta Molinaro came late to this project but in a short time made a profound and vital impact to my life and work.

Many thanks to Kamy Pakdel, Armand de Saint Sauveur and Nadia Cavrel at Éditions Intervalles for having such belief in the project and designing and publishing it so beautifully. And my very special thanks too to those idols, believers and friends who contributed with time and effort such great insights: Chloë Bailey, Sarah Bailey, Alice Braga, Christopher Dennis and Bonnie, Tim Fountain, Anouska de Georgiou, Peter Hammill, Sarah Hirigoyen, Richard Johnson, Dame Vera Lynn, Heather Stewart-Whyte, Lisa Voice, Richard and Sue Young.

Thanks also to Balwant Ahira, Duane Ashurst, Keith Bender, Dave Bennett, Damion Berger, Ian Berry, Marcus Bleasdale, Chris Bowen, Charlie Breaker, Adam Bricusse, Jane Brown, Patrick Brown, Rod Campbell, Vanessa Campbell and Harry, Giulia Carnera, Claudia Cardinale, Juliet and Matt Cestor, Elizabeth Churchill, Laure Coença, Bruce and Catherine Connew, Jo Cuppage, Jake Curtin, Bernie and Steph Davies, Ronald Daley, Ynäie Dawson, Azzurra Della Penna, Jim Edwards, Audrey Eig, Carly Eiseman, Tiziana Faraoni, Lavinia Fernandes, Martha Fiennes, Peter Forrester, Barry Fox, Jean-Michel Frodon, Cornelia Fuchs, Farhana Gani, Jane Gazzo, Bruce Gilden, Lyndsey Goddard, Suse Golleck, Andrea Gothe, Jacqui Green, Stanley Greene, Michael Grieve, Mark Grosset, Stu Hanna, Henry Harris, David Alan Harvey, Nikki and Nolan Hemmings, Carolyn Hill and Greta Carlisle, David Hitchcock, David Hurn, Akiko Ishihara, Tom Jacobi, Colin Jacobson, Guillaume Jan, Allan Jenkins, Meena Khera, Douglas and Françoise Kirkland, Jana Klawun, Inge Kutter, Tom, Adam and Sue Kyffin, Jean-Francois Leroy, Jon Levy, Verena and Jake Lewis, Andrej Liguz, Naomi Lowde, Paul Lowe, Gerd Ludwig, Harvey Marcus, Marie Michelangeli, Mike Mirrlees, Tatsuya Mizuno, Jeanne Moreau, John G. Morris, Céline Moulard, Seamus Murphy, Andrea Murray, Pete Newman, Luisa Nitrato-Izzo, Laura Noble, Nicole Nodland, Edwina Orr and David Traynor, Paolo Pellegrin, Florence Perignon, Pic and Ben, Ken Pocock, Sarah Pritchard, Lord Puttnam, Roger Raglan, Paul Reas, Tom Reynolds, Harriet Rhodes, Françoise Riis, Helena Roman, Paul Ryan, Roman Salicki, Mick Sheldon, Pranvera and Vaughan Smith, Tim Smith, Chris Steele-Perkins, David Strick, Holly Stuart Hughes, Aidan Sullivan, Jo Talbot and Sue Young, Amanda Tessensohn, Sophie Thuaire, Chris Usher, Nicole Vulser, Celia Watterson, Cherry and Roy and Tinka Wilde, Cynthia Williams, Hélène and Oscar Woods. And to the Night Time Tandoori for the many lamb bhuna deliveries throughout the work-printing nights, Blacks and The Frontline Club for unwittingly hosting those last, vital meetings and Jacques and Monique at Altrès restaurant, Perpignan, where the project grew each year along with my happy stomach!

Thanks to Nobby Clarke at Leica UK for supporting this project by speedily repairing my R9s and M6s when necessary and loaning equipment to see the project through; and to Didier Séjourner and Sylvie Lopez at Epson, France, for letting me use their digital cameras at Cannes.

All photographic materials used in this book were provided by Kodak.

Thanks to Lisa, Paul and Bev at Spectrum, Brighton for the perfect colour prints and Stuart Keegan for the beautiful black and whites; and to Jesse Jenkins, Daren Booth and Steve Rose at our print partners Butler & Tanner for their interest, understanding and expertise throughout.

A final thanks to all those whose image appears within these pages: you are the stars and the cast.

ÉDITIONS INTERVALLES

Sales and marketing director: Nadia Cavrel
Art director: Kamy Pakdel
Editorial director: Armand de Saint Sauveur

80 Boulevard Haussmann - 75008 Paris - France
Tel. 33 (0) 1 53 43 83 30 - Fax. 33 (0) 1 53 43 05 95
www.editionsintervalles.com

Picture editor Sarah Treuer
Text editor Mark Reynolds

Printed by Butler & Tanner, Frome, UK
Established since 1850, Butler & Tanner is the UK's leading book and brochure printer,
with multiple awards for exceptional quality.
www.butlerandtanner.com

For information on exhibitions, events and print sales, visit
www.idolsandbelievers.com

In collaboration with AWP

Ashley Woods Promotion
Photographic marketing and sales
www.ashleywoods.com